Brummett Echohawk

Brummett Echohawk

Pawnee Thunderbird and Artist

By Kristin M. Youngbull

University of Oklahoma Press : Norman

Library of Congress Cataloging-in-Publication Data

Youngbull, Kristin M., 1980–
 Brummett Echohawk : Pawnee Thunderbird and artist / by Kristin M. Youngbull.
 pages cm
 Includes bibliographical references and index.
 ISBN 978-0-8061-4826-7 (hardcover : alk. paper)
1. Echohawk, Brummett. 2. Pawnee Indians—Biography. 3. Indian painters—Biography. 4. Artists—United States—Biography. 5. United States. Army. Infantry Regiment, 179th. Company B—Biography. 6. Soldiers—United States—Biography. 7. World War, 1939–1945—Campaigns—Italy. 8. World War, 1939–1945—Participation, Indian. 9. Anzio, Battle of, Anzio, Italy, 1944—Biography. 10. Indian soldiers—Biography. 11. Indian authors—United States—Biography. 12. Authors, American—Biography. I. Title. II. Title: Pawnee Thunderbird and artist.
 E99.P3Y65 2015
 978.004'97933092—dc23
 [B]

 2014050131

Copyright © 2015 by the University of Oklahoma Press, Norman, Publishing Division of the University. Manufactured in the U.S.A.

1 2 3 4 5 6 7 8 9 10

To my mother,
for consistently challenging and supporting me in this endeavor
and in the many other journeys in life

Contents

Illustrations

Acknowledgments

I would like to thank the Echo Hawk family for working with me on this project. David Echo Hawk, one of the first family members I contacted, proved both helpful and encouraging. David's willingness to talk to me about his Uncle Brummett and to show me some of the places around Pawnee connected to Brummett Echohawk's life gave me a better sense about who he was and where he came from. David also introduced me to potential interviewees, including numerous veterans and members of the Echo Hawk family. I must also thank Myron "Hobe" Echo Hawk, Brummett's youngest "brother," who grew up with him and demonstrated an impressive knowledge of Pawnee and Echo Hawk family history. Joel EchoHawk, another of Brummett's nephews, kindly took me to his uncle's former residence, still in the family's possession, and granted me access to Brummett's personal collection of valuable history and art treasures.

The assistance of curator Michael Gonzales and archivist Mike Beckett at the 45th Infantry Division Museum in Oklahoma City has likewise been invaluable. They not only pulled boxes and files and made copies and digital scans of their materials but also assisted with research—allowing me to come into the museum outside of regular business hours, helping me understand and read military maps, locating specific locations referred to in primary sources, and determining whether those sources were accurate. They also shared personal knowledge of Echohawk as a soldier and a friend.

I would like to thank my dissertation committee: Dr. Donald Fixico, Dr. Peter Iverson, and Dr. James Riding In. I also owe thanks to the ASU History Department committee, which provided a substantial block grant enabling me to travel to complete my archival research. Thanks to archive specialists Donna Noelken and Sue Nash from the National Archives in Saint Louis for their help with the reconstructed military personnel file and morning reports. I must also extend thanks to my good friends Jean-Marie Stevens, Lillian Spreng, Peggy and

Tevita Langi, and Bonnie Thompson, who have all aided, encouraged, and supported me in this endeavor. Of course, I also need to thank my parents, my husband, Tyler Youngbull, and my children, Emo'onahe, Israel, and Eli, for their love, support, and patience throughout this process.

BRUMMETT ECHOHAWK

Introduction

> I am a full blood Pawnee. I have lived by the old ways. I have
> used the old ways to fit into the new. I have never attempted to be
> anything else. So what you are seeing now is a part of the old and
> most certainly the new.
> —Brummett Echohawk

This is an ethnohistorical biography of Brummett T. Echohawk. Born
in the small town of Pawnee, Oklahoma, in 1922, Echohawk ultimately
acquired an international reputation as an artist, writer, public speaker,
and actor. He remained active in all of these professions until shortly
before his death in 2006. His story hails back to intertribal conflict on
the North American plains prior to and after Euro-American contact
and the organization of the Pawnee Scouts by the U.S. Army from 1864
to 1877. Brummett Echohawk's paternal grandfather, Howard Echo
Hawk, served as a member of the Pawnee Scouts. For the Echo Hawks,
as for many other Pawnee families, the link to the Pawnee Scouts
demonstrates historical continuity, as successive generations have
participated in military service.[1] Brummett Echohawk served with dis-
tinction in the European theater of World War II. The army recognized
his impressive service with the Bronze Star, Combat Infantry Badge,
Army Commendation Medal, four battle stars, two Invasion Arrow-
heads, and a Purple Heart with oak leaf cluster; and the U.S. Congress
awarded him its Gold Medal.

Echohawk's story draws attention to the social realities of genera-
tions of American Indians, but it also informs the present because he
used his influence to educate and inspire those in his home commu-
nity and the world. This biography examines a life that reflected the
history and values of the Pawnees, as well as other American Indian
people, and the world in which they lived. This work shows how Echo-
hawk took advantage of opportunities to use his Pawnee identity as a
springboard to his career, and used his art, writing, public speaking,
and acting to record history and to educate, rather than allowing dis-
crimination to hold him back.

Not a complete history of the Pawnee people, the 45th Infantry Division, or even the Echo Hawk family, this book reveals, rather, how culture and history influenced Brummett Echohawk, allowing him, in turn, to influence others. This work brings to light the contributions of an extraordinary individual who magnified what he believed to be important cultural values in all his undertakings. His Pawnee heritage, always a critical part of his identity, inspired his actions as a young soldier and as a veteran pursuing his dream career. Echohawk's American Indian background also influenced his engagements as a public figure seeking to educate and inspire those around him.

Not much exists in terms of historiography for the subject matter of this biography. Pawnee history has been largely overlooked in academia, and although Echohawk proved a man of great talent with international distinction, few outside the art world still recognize his name. A respectable body of work documents the history of the 45th Infantry Division, in which Echohawk served, but this book provides his perspective as an American, as an American Indian, as a member of the Pawnee Nation, and as a member of the Echo Hawk family. Little has been done to document Brummett Echohawk's work as a soldier, actor, artist, writer, or public speaker. Echohawk wrote about his World War II experiences, but he did not publish his work before his death. In 1989, a television station in Claremore, Oklahoma, produced a one-hour documentary on his career. Thus, the existing body of work documenting the life and experiences of Brummett Echohawk includes only two dedicated sources, and one of those sources is by his own hand.

Brummett Echohawk's story demonstrates the need for an inclusive American narrative, rather than one that treats American Indian history separately. As a full-blood Pawnee, he may be placed in the realm of American Indian history. His military experience as an infantryman in World War II places his life story solidly in the realm of military history, as does his family's history of military service. His familial origins in the West and his professional focus on the West make his biography a part of western American history. His career as an artist easily places him in art history. His story, ultimately, must be placed in the larger context of American history.

Brummett Echohawk's family heritage set the stage for his lifetime of achievements. His wartime experiences are compelling on the surface, but they also evidence underlying themes relating to American Indian identity, pan-Indianism, and social perceptions of American Indians both at home and abroad. The following chapters track his

trajectory from a talented but formally untrained artist creating combat sketches while serving as an infantryman to a distinguished career artist showing work in high-end galleries and museums and creating exclusive pieces on commission. Echohawk was more than a talented artist, writer, and actor. These fields of work served a deeper purpose. They added substantially to the historical record, educated countless individuals, and demonstrated to American Indians and "mainstream" society that American Indian history and heritage held value. He had the ability to bring important social issues to the forefront with a style that proved inviting, informative, and often entertaining, and this helped his messages spread to broader segments of society. Brummett Echohawk took his personal heritage and life experiences and gave them public meaning.

Echohawk's life experiences revealed the constant intersection of his Pawnee heritage and daily life. The primary sources I consulted focus on what Echohawk and those close to him felt it meant—and means—to be Pawnee in the twentieth and twenty-first centuries. Brummett Echohawk believed that his life proved that American Indians could succeed, given ambition and perseverance. In 1979, he told a group of young people, many of whom were American Indians:

> Always remember . . . Go to school. Use your heritage. To ignore heritage and to ignore history is to be a child forever. Use this. Put it to work for you, and think *real* big. Always remember that the American Indians' contribution to America is America, and that you should use your heritage. If you choose a field, whether it be a writer, or an artist, or a musician, or whatever, prepare yourselves first. Dedicate yourselves to this, and then go at it with all your heart and mind. For if you do not choose, you will have chosen.[2]

Echohawk shared this message throughout his career. His success did not come without diligence, study, and sacrifice. When something challenged him, he did not surrender but persisted even when his efforts yielded limited results. He encouraged others so that they might feel the same sense of accomplishment or satisfaction.

Brummett Echohawk's knowledge of the past enabled him to use his heritage in his own life and make it relevant to others. The grandson of the Pawnee Scout Echo Hawk, he was a warrior, a Thunderbird of the 45th Infantry Division, and an artist, entertainer, and educator. He proudly claimed his Pawnee heritage and knew the history of his people well. This cultural and historical foundation formed an integral

part of his identity. Pawnee history and cultural heritage supplied the subject material for his public engagements, writing, artwork, and the drive behind his military service.

The Pawnees dwelt principally in Kansas and Nebraska beginning around the turn of the seventeenth century. Their communities included nomadic and sedentary elements. They built earthen lodges in proximity to their crops but used lighter and more portable materials when out on extended hunts. They spent part of the year in their permanent settlements and part of the year living as nomads on the plains.

Although this work focuses largely on the martial tradition of the Pawnee people, it must be noted that the military component of their culture was just that—a component. The Pawnees had an organized government, lived as families in organized communities, and followed prescribed religious practices. They lived both as agriculturalists and as hunters and gatherers. Among the Pawnee people, spirituality functioned as an integral part of daily life. Tirawahat, or Tirawa, served as the supreme deity, the Creator. Ceremonies played a central role in the seasonal cycles of planting, growing, harvesting, and hunting. Religious beliefs also informed the healing arts. The sun, moon, and stars influenced religious life as well, especially among the Skidi Pawnees, who placed particular importance on the stars, especially the Morning Star.[3]

The Pawnee people divided into four primary bands: the Chauis, Kitkehahkis, Skidis, and Pitahauerats. Each band had its own respective government led by chiefs, but when all gathered, typically the foremost chief of the Chauis asserted primary authority. The head chief of each band often served as director of tribal affairs. Chiefs did not function as dictators, but as administrators who worked to organize and mediate the needs and activities of their people.[4] Sometimes he made decisions according to his own will, and at other times, typically with weightier matters, he consulted a council. The chief had the responsibility to make decisions that would best benefit his people.[5]

Below the band level, the Pawnee people organized themselves into villages and then into large family groups. Villages often accommodated between three hundred and five hundred people.[6] While out on the plains, the Pawnees used temporary structures much like other nomadic tribes, but in their permanent communities, their earth lodges housed extended families ranging from thirty to fifty people.[7] Important both personally and socially, family held a central place in Pawnee society. Brummett Echohawk once said, "In the Pawnee tribe it is a great thing to be a warrior and a greater thing to be a father, the head of a family."[8]

Although the Pawnees relied heavily on agriculture, they also participated extensively in what became plains horse culture. Historians identify this development in terms of the ways horses fundamentally changed, affected, or became central to everyday life for Native peoples. The acquisition of horses shifted the balance of power intertribally and between the tribes and Euro-American powers and peoples, and the animals themselves served as valuable commodities in trade. Often, tribes traded directly, but because of intertribal competition, a culture of horse stealing grew up around the movement of horseflesh, and a new economy developed that centered on acquiring more horses.[9] Pawnee war parties typically left home without mounts but nearly always returned mounted and leading or driving additional horses. They garnered a reputation as expert horse thieves.[10]

Horses proved invaluable, and many tribes gradually incorporated them into their various cultural practices and activities until they became fundamental to survival on the plains. The increased utilization of horses expanded trade networks, increased availability of goods, and made work, travel, and labor less time consuming. The extra time created by the expedition of movement and chores permitted people to focus on facets of life beyond mere survival. The use of horses also escalated levels of raiding and warfare. The increased prominence of warrior societies is often credited to the development of horse culture.

Indigenous Americans moved around based on their need for particular resources and on their relations with neighboring groups, and prior to European settlement in the Americas, various groups displaced others.[11] Historians, archeologists, and anthropologists supply evidence of such activity. The phenomena of displacement and competition intensified as European and Euro-American settlements expanded and pressures on indigenous populations increased.

By the turn of the nineteenth century, pressure on Native populations had mounted considerably as European and American powers continued to push their boundaries. From day one in colonial America, boundaries were constantly in flux. As "settlement" expanded, "frontier" borders shifted. Expansion always—directly or indirectly—affected the interior. Expansion did not simply result in the redrawing of lines on maps, of course. Rather, the outcome was typically the reallocation of resources, achieved amicably or by force, and the relocation of indigenous peoples. Relocated or displaced populations found themselves encroaching on lands used by others, and the cycle continued as competition for resources and space rippled on. Conflict escalated.[12] The Pawnee experience was no exception. The arrival of the

Lakota people in and around lands occupied by Pawnees is a perfect example of the state of affairs produced on the plains.[13]

Pawnee men maintained an impressive martial tradition, noted by friend and foe. John Brown Dunbar, the son of eastern missionaries, spent years with his parents and the Pawnees in Nebraska and wrote a three-volume work based largely on his own fieldwork and experiences among the Pawnee people. Dunbar wrote regarding the role of militaristic societies and activities among the Pawnee people, "Not only did war furnish an inexhaustible theme of tradition, oratory and song but the proud ambition to gain distinction as a warrior, next to the securing of a living, was with them the most potent active principle of life." Dunbar noted that after the 1833 Treaty with the Pawnee, the Pawnees made pronounced efforts to be more peaceable; however, this varied from common practice.[14] Unfortunately, the Pawnees understood the 1833 treaty as a government promise to protect them from enemies so long as the Pawnee people did not take the offensive. The Treaty of 1833 stated, "The Pawnee nation renewed their assurance of friendship for the white men, their fidelity to the United States, and their desire for peace with all neighboring tribes of red men."[15] This agreement called for the Pawnees to suppress aggressive acts, and, if that proved insufficient to engender peaceful relations, to refer the matter to a mediator appointed by the president. The treaty pushed for amity but did not explicitly offer protection should hostilities continue or erupt.[16] After years of maintaining an anti-aggression policy and suffering heavily at the hands of their enemies, the Pawnee people received from the government an official declaration in 1848 stating that they would not be protected.

In a time of considerable flux, the Pawnee people had carved out a home for themselves on the northern plains and had defended it successfully for nearly a century. By the mid- to late 1700s, a group of newcomers threatened their dominance. This new power to be reckoned with did not consist of a single entity, but of a grand alliance. The powerful Lakotas aligned themselves with the Cheyennes and their allies, the Arapahos. These tribes could and often did fight and handle affairs independently, but when needed, this alliance could wield a staggering blow to opponents like the Pawnees.

The Pawnees generally entered into no such intertribal alliance. To this day, many pride themselves on standing their ground alone against such odds for so long. One might compare a commonly held notion in the Civil War Confederacy to that of the Pawnee people under pressure: "One of ours can whip five of theirs."[17] John B. Dunbar wrote:

"The original conquest of their late domain, and the maintenance of their prestige and position in the midst of jealous and ever active enemies, afford an unimpeachable evidence of their martial eminence." He noted that casualties the Pawnee people inflicted against militarily powerful tribes around them engendered intense animosity toward the Pawnees. The "Pawnee was to them an irrepressible *bête noir*."[18] The problem with so many rivals, regardless whether one accepts the notion that the Pawnees produced superior warriors, becomes apparent when considering the consequences of a war of attrition. Numerical advantages can be effectively employed to grind down and defeat a capable and determined foe.

In fact, some historians suggest that, after disease, the majority of Pawnee losses may be attributed to warfare.[19] Dunbar provided some specific examples of the toll warfare took on the Pawnees: "In 1832 the [Skidi] band suffered a severe defeat on the Arkansas at the hands of the Comanche. In 1847, a Dakota war party, numbering over 700, attacked a village occupied by 216 Pawnees and succeeded in killing 83. In 1854 a party of 113 were cut off by an overwhelming body of Cheyennes and Kiowas and killed almost to a man."[20] Dunbar also noted the slaughter at Massacre Canyon at the hands of Sioux enemies.[21] The cumulative smaller losses added up quickly. By the mid-nineteenth century, the Pawnees had to deal with the sheer number of rivals surrounding them. They fought with Lakotas, Cheyennes, Arapahos, Crows, Comanches, Kiowas, Osages, and Kansas—and they nearly always fought alone.

Although the Pawnee warriors earned considerable respect as fighting men, diseases weighed heavily on the balance of power and, combined with the strength of adversarial alliances, directly affected Pawnee numbers and consequently their ability to defend the vast tracts they once dominated.[22] Diseases such as typhoid, smallpox, and cholera brought by increased contact with Euro-Americans, and passed on from family to family and band to band, ravaged the Pawnee people as it did so many other indigenous communities. Some communities weathered the outbreaks more successfully than others, and those groups gained a distinct advantage when it came to taking or defending homes, families, and life-sustaining resources. According to Lewis and Clark, the tribes along the Missouri (likely including the Pawnee people) had been afflicted by smallpox shortly prior to their expedition (1804–1806). Smallpox hit the Pawnees hard again in 1825 and 1838. The bout with smallpox in 1838 reduced their population from between 10,000 and 12,000 to approximately 7,500 in roughly a

year and a half. By 1847, their numbers had increased to nearly 8,400. Less than ten years later, after another debilitating cycle of smallpox in 1852, they counted only 4,686 survivors. In 1861, the Pawnees numbered 3,416; in 1879, only 1,440.[23] Their numbers continued to decline until after the turn of the century when the birthrate finally overtook the death rate again.

Most American Indian tribes have histories of intertribal conflict prior to European contact. The reputation tribes garnered in colonial and early American history for military prowess often made Native men attractive as potential allies and soldiers. European and American officials often played on intertribal animosities and loyalties, renewing former conflicts and occasionally inciting new ones as needed to recruit sufficient support for their own purposes. As early as 1702, American Indians militarily engaged in a European conflict brought to the Americas—Queen Anne's War. Again, in 1744, European troubles boiled over into the New World during King George's War. By 1754, another struggle between European powers erupted in North America. This time, the very name of the clash evidenced the crucial role played by American Indians—the French and Indian War. "Americans" honed their skills in enlisting Indians for military purposes in many smaller-scale conflicts as well. The pattern of alliances, conflict, and displacement replayed time and again until the western tribes were finally "subjugated" in the eyes of the federal government and most of the American population.

Western tribes, including the Pawnees, were dramatically affected by the growing presence of the army in the West prior to the Civil War, the army's relative absence during the war, and the resurgence of American westward migration after the war. Prior to the Civil War, the government intended for the army in the West to keep the peace between Americans and the Native inhabitants they encountered. Officials designed agreements like the Fort Laramie Treaty of 1851 to limit contact and to reduce strife between travelers and those residing in the lands being traversed.[24] For roughly a decade, the boundaries drawn up in the treaties successfully limited, but did not eradicate, conflict along western travel routes.

Conflict in the West did not end with the advent of the Civil War. Rather, the nature of the conflict changed somewhat. While American westward expansion slowed to some degree, clashes between and among non-Indian travelers, settlers, and tribes continued. The government provided for the organization of militias to maintain order in the West while regular army men funneled east to the major theater of

battle in the Civil War. With regular troops absent, power relations be-
tween whites and Indians shifted in the West, leaving many settlers and
pioneers feeling vulnerable and others believing they could act with
impunity.[25] Thus, historians may depict the rise of state and local mili-
tias during the Civil War as a catalyst for future turmoil in the region.

By the end of the Civil War, American Indian hostility brimmed in
the West, particularly on the plains. Settlers, travelers, supply lines, and
railroads all presented reasonable targets. Most Americans in the West
and those traveling that direction felt entitled to government protec-
tion. Regular troops resumed old positions and established new ones.
The presence of the army served to guard American interests, and, os-
tensibly, to keep the peace between existing settlers, newcomers, and
Native inhabitants. The reoccupation strained the remaining positive
relations between the United States and many western tribes. In this at-
mosphere, some groups—including elements of Lakotas, Cheyennes,
and Arapahos—lashed out by destroying telegraph lines, harassing
railroad workers, and abusing those they viewed as interlopers.

As the United States tried to reduce the size of the standing army,
yet maintain sufficient presence in the West, reorganization became
necessary. Subsequently, in July 1866, the Thirty-Ninth Congress au-
thorized the president to enlist up to one thousand Indian scouts to
aid the army in the West. Congress stipulated that the scouts be paid
as cavalry soldiers. The Act to Increase and Fix the Military Peace Es-
tablishment of the United States of America also addressed the term
of scouts' enlistment. Instead of the three-to-five-year enlistment
expected of regular army soldiers, the government employed Indian
scouts on an as-needed basis. To a certain extent, the measure had to
do with government and military attempts at economy. Why pay for
inactive troops? The new policy also worked to the advantage of the
scouts. Although accustomed to leaving home on hunts, on raids, to
visit other bands, and for trade, American Indians' social structure did
not well accommodate extended absences. Typically, they seemed con-
tent to complete their mission to the best of their ability and return
home to their families and community.[26]

Concerns about assimilation and loyalty permeated debates over
the employment of American Indian scouts and auxiliaries. The most
intense period of debate took place during the 1880s and 1890s as mili-
tary officers and government officials battled over the issues. Certain
camps believed that Indian soldiers could not conduct "civilized" war-
fare, and feared the possibility of allies defecting. Detractors also ques-
tioned whether Indian scouts and auxiliaries would act in the interest

of an entire command rather than fighting as individuals. Some raised concerns regarding whether separate all-Indian units hindered assimilation, or if they should be integrated with regular army troops.

Men like General William T. Sherman, General Philip Sheridan, General George Crook, and Indian Commissioner Francis A. Walker favored continuing the employment of Indian scouts. They often voiced opinions couched in terms of assimilation and "natural" skills such as tracking. Proponents of Indian troops were not necessarily pro-Indian but believed Native soldiers could be used to the advantage of the army. General Sherman, for example, said, "If we can convert the wild Indians into a species of organized cavalry . . . it accomplishes a double purpose, in taking them out of temptation of stealing and murdering, and will accustom them to regular habits of discipline, from which they will not likely depart when discharged."[27] General Crook made a similar statement in a letter to General Sheridan in 1876, stating in part, "One thing is certain, [military service] is the entering wedge by which the tribal organization is broken up, making way for civilizing and Christianizing influences."[28]

Major General Samuel R. Curtis, commander of the volunteer army in the Department of Kansas, positioned himself among the earliest individuals to push for a standing official sanction for continuing the practice of Indian employment.[29] Eventually, the government acted on Curtis's suggestion to employ well-disposed Indian scouts to aid the army in restoring order on the plains. By authorizing Indian troops, the U.S. Department of War expanded its manpower in the West. By the 1860s and 1870s, however, federal policy makers promoted the dual benefits of Indian enlistment: acculturation and a more effective fighting force.[30] Government officials generally accepted the line of argument that encouraged the constructive use of Indians' military skill and ardor while simultaneously working to facilitate assimilationist goals.[31]

The Pawnee people had come into contact and conflict with Americans before, but they did not, as a people, take a direct oppositional stance against the U.S. government or its army. For the Pawnees, the postwar era presented an opportunity to join forces against their enemies. Although Pawnees had little inclination toward alliances in the past, an alliance with the U.S. Army seemed a simple matter of pragmatism. The military needed assistance fighting an angry and formidable foe—the Cheyenne-Lakota-Arapaho alliance. Pawnee men had the opportunity to meet their age-old opponents on the field of battle with the backing of the U.S. Army and get paid to do it. As had happened so many times before in American history, the United States

turned to Native peoples as a means to defeat an opponent against whom the army had realized little success.

Both pragmatism (generally defined as a practical solution to a problem) and syncretism (a term commonly used in studies relating to assimilation and accommodation, to define the practice of selectively adopting foreign practices and beliefs without disrupting one's existing cultural structure) are evident in the Pawnee military legacy.[32] In this context, historian Tom Holm's definition of "syncretism" is particularly useful. Holm argues that American Indians (over time) made use of military service within their own cultural contexts, offering a more general explanation: "In many cases, humans adapt certain alien institutions and forms by filtering them through their own matrix of cultural practices. . . . It does not necessarily follow that, just because a group accepts a new form, it will accept a completely new value system to go along with it."[33] Basically, syncretism does not require one to relinquish existing values, beliefs, or practices to adopt new ones if they fit into an existing framework. Historian Mark Van de Logt's description of Pawnee Scouts' military service fits neatly into the definition of syncretism: "war party in blue." Van de Logt's phrase refers to the continuation of Pawnee martial tradition under the banner of the United States Cavalry.[34] In evaluating the changes taking place in Pawnee life and military activities, pragmatism and syncretism serve as useful categories.

Surrounded on all sides by opposing forces, Pawnees found themselves vying for control over resources and struggling to retain a respectable degree of power.[35] The Pawnees could not accomplish this without an alliance of their own. Having several decades of experience with American missionaries (and some experience with the U.S. government), the Pawnees' critical evaluation of the situation pointed to the army as a practical and strategic ally.[36]

According to the 1857 Treaty with the Pawnee, the United States would serve as an ally and protector should forces hostile to the United States demonstrate aggression toward the Pawnees, but there was a drawback to this arrangement. The treaty required friendship, peace, land cessions, and the establishment of a reservation.[37] The government expected Pawnee people to benefit from increased opportunities for assimilation based on treaty stipulations for a government-built school on the reservation and continued Christian missionary efforts. Although the United States established a military presence near the reservation, it proved insufficient to protect the Pawnees from their enemies—Native or white.

Many scholars now argue that American Indians *chose* to partici-pate in the U.S. military for pragmatic reasons and typically became more involved in a process of syncretism than assimilation.[38] Military service did not necessarily hasten the assimilation of the scouts into white society.[39] Assimilation and acculturation, no doubt a part of the plan as envisioned by many military and government officials, did not always necessarily take place the way officials expected.

The Pawnees stood to gain from military service. Pragmatism and syncretism allowed the scouts to use the U.S. Army in their own way. They fought their old enemies, got away from the reservation, received pay, earned respect within their communities as warriors, and secured the respect of many American soldiers and officials. The leadership of men like Major Frank North—a white man who grew up around the Pawnees, spoke their language, and was familiar with their culture—often permitted Pawnees to observe certain traditions.[40] Recogniz-ing that the scouts openly employed cultural practices on and off the battlefield during enlistment leads one to question whether, outside of uniforms and a more rigid structure of command, Pawnees truly embraced assimilation by serving in the military, or if they deliberately circumvented it.

Historian Mark Van de Logt argues that despite the rhetoric among military officials, the Pawnees' service did little to encourage accul-turation. Instead, in many ways, it reinforced their own traditions. He noted the limited and conditional authority accorded by the scouts to their white officers as a strong indication that the Pawnee men con-tinued operating within their own framework regarding what con-stituted an acceptable leader. More often than not, they fought with their own age-old methods of plains-style warfare—and it was pre-cisely this knowledge and ability that made them so valuable to the army as trackers, guides, and fighting men. They knew *how* to fight the "hostile" tribes. They fought in the manner that suited them, and their officers allowed them to do so. The Pawnee warriors rode into battle with medicine bundles, songs, and painted bodies and horses. They counted coups, took scalps, and divided the spoils of war. Van de Logt concludes, "The Pawnee battalion, then, had all the characteristics of a Pawnee war party."[41]

The Pawnee Scouts served in various capacities over time. In the beginning, General Curtis recruited them to serve as auxiliaries, given the informal status of their enlistment. Approximately seventy-five to eighty left with Curtis for only a few weeks. Due to recent Sioux

depredations, an estimated two hundred to three hundred more wished to join Curtis's expedition against the Sioux, but he did not permit them to do so. The agent at the time, Benjamin F. Lushbaugh, determined that "inasmuch as we had been deprived of the meager military protection which had been previously accorded, I did not deem it judicious to permit them to go, and thus leave the agency wholly undefended."[42] Frank North mustered in (assembled through proper protocol and procedure) the first official group of one hundred enlisted scouts just months later. White officers typically led these scouts, but some of the Pawnee men served in the capacity of officers as well.[43]

When Pawnee men signed on as army scouts, they viewed their unit as an important part of the army, though the government's official position suggested otherwise. The Pawnee Scouts did not see their organization as a mere appendage to the army or regard themselves as pawns of the United States but considered the Pawnee battalion to be a fully functional part of the whole. The Pawnee Scouts knew that they contributed significantly to what they deemed "joint military operations." They may have been working in tandem with the army, but they remained a sovereign people.[44] The relationship between American Indian scouts and the army was approached by the tribes as "a mutually beneficial contractual relationship," which they believed should include a substantial degree of reciprocity. They expected more than pay for their services. In the case of the Pawnee people, their record as scouts ultimately benefitted them during the process of relocation in that they were given at least minimal considerations rather than facing forced removal.[45]

Frank North's group participated in the 1865 Powder River expedition led by Brigadier General Patrick E. Connor.[46] In 1867, the army mustered in another full battalion, four companies, of scouts to guard the Union Pacific Railroad as it was built across Nebraska. Limited to two companies in 1868, the Pawnees continued military service. In 1869, another call went out for a battalion of Pawnee Scouts, which, once again, was reduced to two companies the following year. The U.S. Army did not activate any more scouts until the 1876–77 campaign against the Sioux, and that round of enlistments only allowed for one company of Pawnees.

A different objective dictated the type of work each new organization of Pawnee Scouts did. In some instances, they tracked and fought against raiding Sioux, Cheyennes, and Arapahos. Sometimes, they simply protected railroad workers. In the 1876–77 campaign, their

service added an important element to an existing military campaign. After completing each assignment, under the laws established in 1866, the army discharged the scouts as soon as possible.[47]

Accounts exist of Pawnee chiefs opposing service in the U.S. military and the manner in which officials handled incidents wherein the lives of those who served as scouts were taken or threatened by other soldiers, settlers, or white migrants. In 1869, Pawnee chiefs requested that their young men not be allowed to enlist until a prior matter met resolution. They remained upset because a group of Pawnee Scouts had been fired on by U.S. soldiers as the scouts traveled home after being formally discharged. The following year, the Pawnee agent, a Quaker named Jacob M. Troth, noted that some of the chiefs had come to him requesting that their men not be enlisted because they began to fear the negative consequences of military service. Agent Troth may have created the impetus behind voicing concerns, as he held religious objections to military service and violence. However, the chiefs likely had overlapping concerns, particularly in regard to loss of control over these younger men.[48]

By the 1870s, conditions for Pawnees in Nebraska had become increasingly difficult. They continued to deal with racist and greedy American neighbors as well as hostile Indian tribes. Due to the encroachment of previously displaced tribes, the multiple overland trails through their territory, sport hunting of bison, and other factors, their subsistence base was greatly depleted.[49] Add to this situation varying degrees of assimilation within Pawnee society and an ongoing battle with disease and illness, and one can see a glimpse of what some Pawnees hoped to escape. Many of their people were beginning to seriously consider what Indian Territory or Oklahoma Territory might hold for them—good, bad, or otherwise.[50]

In 1873, adding insult to injury, a large group of Lakotas attacked and slaughtered a small party of Pawnees out hunting buffalo at what became known as Massacre Canyon. This incident devastated the Pawnees.[51] Such troubles were compounded by President Ulysses S. Grant's Peace Policy, which placed a Quaker administration at the helm of the Pawnee Agency. While powerful enemies were granted access to more and better weaponry, pacifist policies among the overseers of the Pawnee Agency limited access to sufficient weaponry for hunting and defense.[52] Many government officials and Pawnees (not to mention land-hungry settlers) viewed this as an indication that Nebraska no longer offered a tenable location for the Pawnee people.

Although at odds over the decision to relocate, and pressed by hunger, disease, government agents, encroaching white settlers, enemy attacks, and an ever-shrinking land base, the Pawnee people had two choices. They could remain in a familiar environment that now offered only a bleak future or travel to a new land with an unknown future. To some, the known future in Nebraska seemed preferable to the unknown elsewhere. In addition to the uncertainty inherent in relocation, many worried about the land they would be forced to leave behind. Landmarks had become central to many of their beliefs and traditions. Relocation meant leaving their homes—the homes and graves of parents, grandparents, and others who had gone before them. On the positive side, the lands slotted for their relocation neighbored their distant relatives and friends, the Wichita people. The relative good standing the Pawnees had with the U.S. government prevented an abrupt, forced removal. Therefore, the Pawnees made their way to Oklahoma Territory in three waves between 1873 and 1875, and the government agreed to pay them for their losses.[53] The arduous trip took them nearly five hundred miles from their Nebraska homelands to stay with the Wichitas until the government formally established a reservation for the Pawnee people.

Relocation solved some problems, but the Pawnees soon found many of their old troubles reemerged in their new home. The government required the Pawnees to share the Ponca Agency with the Ponca, Oto and Missouri, and Tonkawa tribes. All four groups squeezed onto reservations created from a piece of land the government purchased from the Cherokees. The Pawnees now lived a great distance from their longtime enemies, which drastically reduced opportunities for young men to prove themselves on the field of battle. Although the Pawnees had generally survived via a combination of sedentary agriculture and nomadic hunting seasons, Oklahoma's unfamiliar climate made subsistence a challenge, and their new location severely restricted access to what remained of the bison herds. Disease, particularly malaria, plagued the people. Within the first two years of relocation, the poor conditions on the new reservation claimed the lives of nearly one third of the Pawnee Nation.[54]

In the continuation of the 1876 campaign, designed to punish the "hostile" tribes for the defeat of Brevet Major General George Armstrong Custer, the Pawnee Scouts once again lived up to their reputation as a formidable fighting force and a great boon to the army. Regrettably, despite executing their duties well, the Pawnees returned

to pitiable conditions, which persisted for years on their new reservation in Oklahoma Territory. A few managed to find temporary employment with the military shortly after the Sioux (and Cheyenne) campaign. A handful of men enlisted to fight the Utes in the 1880s, although their participation proved extremely limited, and their old commander, Frank North, did not lead them.[55] The Pawnee community continued to show respect to its veterans; however, the reputation and celebration of the scouts and the Pawnee military tradition experienced a noticeable rejuvenation when William Pollock, a full-blood Pawnee, joined Roosevelt's Rough Riders.

In the scouts' world, pragmatism and syncretism operated simultaneously, with pragmatism proving more salient early on; Pawnee warriors, who had fought alone for so long, became interested in allies who possessed numbers and military might that they could bring to bear on their enemies. Over time, however, the need for military allies gave way to a means of cultural preservation, as well as maintaining the honor and prestige granted to warriors within Pawnee society through their participation with the U.S. military. This proved particularly true after the Indian wars in the West.

A significant change in the employment of American Indians in the U.S. military took place in the late 1880s. The arrival of a new commander of the army, John M. Schofield, and a new secretary of war, Redfield Proctor, curtailed some of the debate on the reliability and feasibility of Indian soldiers in the army. The center of the debate shifted away from the practice of employing Indians to the integration or segregation of Indians after these men successfully endorsed General Order 28 in 1891, which authorized "one troop of Indians in each cavalry regiment and one company in each infantry regiment" in the West.[56]

As previously noted, assimilation could not be equated with integration during the height of the Indian Wars. General Crook's familiarity with the employment of Indian scouts and auxiliaries led him to argue for integration. He believed that enlisting Indians individually, as regular soldiers, would help disintegrate tribal organizations and move the individual soldiers down the path of assimilation.[57] In postbellum years, scouts, and auxiliaries generally served in segregated units, but near the close of the nineteenth century, the tide turned. After 1897, the army worked to fully integrate American Indian soldiers into regular white units.[58]

The Spanish-American War presented the first major successful implementation of integration. When Theodore Roosevelt and Leonard Wood recruited for the First Volunteer Cavalry, Native Americans

enlisted alongside eastern Ivy Leaguers and western cowboys. Roosevelt prided himself on the diversity of the regiment. In an article for *Scribner's Magazine*, Roosevelt wrote: "There was one characteristic and distinctive contingent that could have appeared only in such a regiment as ours. From the Indian Territory there came a number of Indians. . . . Only a few were of pure blood. The others shaded off until they were absolutely indistinguishable from their white comrades; with whom, it may be mentioned, they all lived on terms of complete equality."[59]

While "complete equality" may have been an overstatement, the Cuban campaign proved effective. Indian men served with distinction, winning friends among their white counterparts. William Pollock and the other Natives who served in the Cuban campaign and in the Philippines acted as transitional figures for their tribes and the military. They showed that they could succeed in integrated units—conforming to the same rules and regulations as the white soldiers around them.

At the outset of the Spanish-American War in 1898, the Pawnee situation had improved little on their Oklahoma reservation. Despite long-standing conditions of illness and poverty, a number of young Pawnee men raced to enlist to fight for the United States when they received news of the potential conflict. When William Pollock volunteered to enter the Spanish-American War, the official population of the Pawnee people totaled only 706 and continued to wane.[60]

A graduate of the Pawnee Indian School and Haskell Institute, Pollock also attended Kansas State University for two years.[61] At some point after his time in Kansas, Pollock became a member of the local militia, which had been formed by the newly organized territorial legislature under federal law. The first group of National Guardsmen at Pawnee, Oklahoma, formed in 1896.[62] After learning about the sinking of the USS *Maine* in Havana Harbor and being informed of Leonard Wood's volunteer recruitment, Pollock quickly made up his mind to enlist. He traveled the ninety miles between Pawnee and Guthrie, Oklahoma Territory, to volunteer.[63] At least four other Pawnees attempted to enlist at Guthrie; however, recruiters turned them away because they "had too many broken bones, caused by 'busting' broncos."[64] Deemed fit for service, Pollock joined the First Volunteer Cavalry Regiment.

William Pollock left for Cuba a regular soldier, in full uniform with short hair, subject to the same rules and regulations as the other soldiers. The full-blood Pawnee had not been asked to serve as a scout or auxiliary. He did not work *with* the U.S. military; he enlisted as part of it. Pollock served in the Spanish-American war to prove something to

himself and his people. In his own way, he attempted to relive a very important part of his people's past. William Pollock reported for duty May 5, 1898.[65] He used his service as an opportunity to overcome some of the obstacles in the way of many young Pawnee men in Oklahoma Territory. He would earn the right of passage into manhood the old way. From the Rough Riders' camp in Texas, Pollock wrote his friend Samuel Townsend (also Pawnee): "I am not going to predict any or do any boasting, but I'll only say that in the memory of our brave fathers I will try and be like one of them, who used to stand single-handed against the foes. Being the only full-blooded Indian in this troop, I am somewhat a conspicuous character."[66] Pollock befriended the future president, Roosevelt, who wrote from Santiago, "Among the men whom I noticed as leading in the charges and always being nearest the enemy, [was] the Pawnee Pollock."[67]

When Pollock returned home, the Pawnee community organized a celebration in his honor to receive him as a warrior. Pollock later wrote to a friend that while the reception resembled those of old, certain differences existed. For example, tribal members gave speeches in his honor and a young chief offered him a horse in accordance with the old ways. The following day at another gathering he received another horse. The customary name change that typically accompanied a warrior's successful return proved complicated. He explained, "This time they are at a loss and cannot decide upon a name for me, because this is or was a civilized warfare. Had I been with even one Pawnee during this recent campaign he might have caused my name to be changed from the result of some certain disposition or trait of mine while on the warpath. So from these two reasons my name has not been changed."[68]

Pollock had taken ill in Cuba and died shortly after returning home. A funeral service took place in the local Congregational church. The burial combined military protocol and Pawnee custom. The slaughter of his favorite horse over the grave ensured him a mount in the next world. Roosevelt wrote a letter of condolence to be read at the funeral, as he could not attend, expressing deep grief at his friend's passing and noting that Pollock had "conferred honor by his conduct not only upon the Pawnee tribe, but upon the American army and nation."[69]

Pollock's life demonstrated that even at the end of the century a Pawnee could reinvigorate old and valued cultural practices and traditions through military service. His success in government schools and the development of his skills as an artist indicated that one could straddle the divide between old and new and succeed in both. The men he served with and under in the Cuban campaign knew him as "Pawnee

Pollock"—placing the tribe he proudly represented and his name side by side as one. His letters indicated that he realized that although he was fighting in a distant, foreign land he still fought as a Pawnee warrior. Pollock's reference to a name-changing ceremony suggests that he understood the process of syncretism as his people transitioned from independent warrior societies to Pawnee Scouts, and he transitioned from the system under which the scouts operated to a full-fledged member of U.S. military forces. He opened the door. Many followed his example, linking their names with those of venerated chiefs and elders long since passed.

Pawnee men and women have served in the U.S. military in every major military engagement since. While other American Indian peoples have certainly sent men into the U.S. armed forces over the years, few (like the Crows) have the same distinction of being allies from the beginning, rather than formerly defeated subjects. The iconic symbolism of the Pawnee Scouts among their descendants in the late nineteenth century and throughout the twentieth century, "carried forward into a patriotic call for Pawnee men to serve in the US military," writes Roger Echo-Hawk.[70] He suggests that Pawnee military service functioned as a form of community service and a "fundamental element of Pawnee cultural identity." Brummett Echohawk wrote that the Pawnee story "is a story of an Indian tribe that chose not to fight 'civilization,' but to fight for it." He said, "it is a story of a people who love their country."[71]

A Family Tradition

My name is Kit-to-wah-keets So-to-wah-kah-ah. In Pawnee that
means Echo Hawk. This is a full blood Indian name. My grand-
father won this name in the field of battle. . . . The hawk does not
sing. It is symbolic in the Kitkahahki [*sic*] band of Pawnees as a
warrior. A warrior who does not sing. So Grandpa Echo Hawk
won this name and the name hawk and echo were put together
like this: Because he was a man who did not sing of his praises,
like the hawk did not sing, but the people echoed everything he
did, so thus Echo Hawk, a warrior whose deeds are echoed. That
is my name. This is not a stage name. It is a full blood Indian
name and I would like for you to know that. . . . Grandpa Echo
Hawk won that, and we in the family attempt to live up to it. A
warrior whose deeds are echoed.
 —Brummett Echohawk

The story of Brummett T. Echohawk is a family story following four
generations and their experiences as the Pawnee people took up
arms under the banner of the United States Army, lost their home-
lands in Nebraska, relocated to present-day Oklahoma, and adjusted
to new lands, times, and historical circumstances. The genealogy
discussed here presents only a segment of a long line of military and
family men. Brummett Echohawk was the son of Elmer Price Echo-
hawk, the grandson of Kutawakutsu Tuwaku-ah (Echo Hawk), and
the great-grandson of Te-ah-ke-kah-wah Who-re-ke-coo (He Makes
His Enemies Ashamed). Offering a glimpse of those who came before
him—those who set forth the standard by which Brummett Echohawk
felt compelled to live his life—this chapter serves as the beginning
of Echohawk's own story, where he found his beginnings and forged
much of his identity.

In the mid- to late nineteenth century, Pawnee people usually had
relatively small families, primarily because of the challenging condi-
tions under which they lived. John Brown Dunbar, a historian and
ethnographer familiar with the Pawnee people, noted that the average

Pawnee family had around four children. He wrote, "A family of eight children, seven sons and one daughter, was so unusual as to become famous as the seven brothers."[1] The family to which Dunbar referred was a Kitkehahki family that rose to prominence during the latter half of the century. Indeed, Pawnee history refers to the family as the Seven Brothers. The youngest of the seven brothers, Te-ah-ke-kah-wah Who-re-ke-coo (He Makes His Enemies Ashamed), was born around 1829. He married a Pawnee woman named Ska-sah Re-Wah. He Makes His Enemies Ashamed served with the first company of Pawnee Scouts in 1864. Ska-sah Re-Wah's brother served with the second enlistment. Thus, the children of He Makes His Enemies Ashamed and Ska-sah Re-Wah had examples from both sides of the family as their father and uncle fought alongside the U.S. Army as scouts.

In 1873, the new Quaker agent, William Burgess, allowed a party of Pawnees to leave their Nebraska reservation in search of buffalo because, for various reasons, local agriculture and government supplies were inadequate, and meat was needed to stave off hunger.[2] Concerned about too many men leaving at once, the agent only allowed a limited number of Pawnees to go out with the hunting party. He worried that the reservation would become an easy target for marauding Lakota, since the local army garrison had proven insufficient to defend the Pawnee reservation.[3]

After what seemed a successful hunt, the people began the butchering process and events took a grave turn. A large party of Lakota warriors saw the relatively small contingent of Pawnees focused on various duties of the hunt and recognized an opportune moment. They took advantage of their enemy's vulnerability and struck with a vengeance. Brummett Echohawk attempted to describe the battle at Massacre Canyon in an article in which he wrote about a commissioned painting he had made depicting the event. After providing some historical background, he related that "the Sioux swarmed forward with shrieking war cries," and continued with written imagery of the event:

> Forming a line behind their men, young women locked arms, swayed and sang the war song of the Pawnee nation. Now the Pawnee men rode up from the canyon, stripped for battle. The *laket* (leaders) shouted: *Tus Chaticks-Si-Chaticks!* (We are men of men, Pawnees). With horses prancing, they gave the Pawnee war cry: *Kidee didee didee, Kidee didee didee!* Then 250 Pawnees charged into the advancing ranks of 1,500 Sioux. Thundering hoofbeats. Gunfire. Dipping lances. Whizzing arrows. Flashing tomahawks. Coup sticks. War clubs. Slashing knives.

Tumbling horses. Billowing dust. Screaming children. Fever-pitch sing-
ing in the canyon. Dying men. Dying women. Dying children. Dying
horses. Then silence in the August heat.[4]

Approximately 156 Pawnees lost their lives.[5] Conditions on the
reservation that year continued to decline. The agent described the
Pawnees' situation as "worse than ever." "Average" crops, a disastrous
buffalo hunt, and intensifying pressure for land combined against
them.[6] As early as March 1873, prior to the tragedy at Massacre Can-
yon, a small group of Pawnees traveled to Indian Territory and made
peace with the Kiowas as a means of opening the door to serious con-
sideration of relocation. In August, after Massacre Canyon, the people
began discussing relocation more earnestly. In October 1873, promi-
nent warriors Uh sah wuck oo led ee hoor (Big Spotted Horse), Lone
Chief, and Frank White asked their agent permission to move to the
Wichita reservation in Indian Territory. Approximately 250 of their
people followed them, despite the efforts of Chief Pitalesharo (one of
the primary chiefs), who contested their decision to go. Small groups
of Pawnees continued to slip away to join those already on the Wichita
reservation. Those who settled among the Wichita during this time
period, including Big Spotted Horse, continued to enlist as scouts for
the army, and served in the Red River War of 1874.[7]

After their victory at Massacre Canyon, the Lakotas impeded the
subsequent winter hunt in 1873 and raided Pawnee villages in January
1874. Then, to reinforce agrarian and assimilationist values promoting
stronger reliance on agriculture, the Pawnee agent forbade the peo-
ple to organize a hunt the following summer. Making matters worse,
drought and pests caused crop failure in 1874.[8] Increasing numbers of
the Pawnees in Nebraska viewed relocation as an acceptable option.
On October 8, 1874, the Pawnees met in council with government of-
ficials, including Agent Burgess and Barclay White, who headed the
Northern Superintendency of the U.S. Office of Indian Affairs. They
requested to sell their land in Nebraska in return for a place in Indian
Territory.[9]

The decision to move came at a time when the army left the Pawnee
Scouts inactive. While living in Nebraska, the scouts served regularly
throughout the 1860s, but after 1870 the U.S. Army did not employ
them until the 1876–77 campaign against the Sioux, and that round
of enlistments only allowed for one company of Pawnees. Despite
being recently dispossessed by the United States of their homelands
in Nebraska and relocated to Indian Territory, and having suffered

significant loss of life in addition to the loss of lands, in 1876 Pawnee men volunteered to travel north, on foot if necessary, to fight the Lakotas for the army. Many of the men volunteering for service suffered from extremely poor health. Much of the Pawnee community faced typhoid and malaria in the new climate and poor conditions of Indian Territory.[10] The army took the healthiest men until their ranks were full, but many more wished to join them because participation in this campaign against their longtime enemies would provide opportunity for both retribution and a return to their homelands. A sizeable contingent of the men refused by the army followed the column north as far as they could, hoping that somehow they would be allowed to participate.[11] Brummett Echohawk's grandfather, the son of He Makes His Enemies Ashamed, joined the ranks of those accepted for service and allowed to go north with the army. When he enlisted for the Sioux campaign, he used the name Tawihisi (also spelled "Tow we his ee," meaning "Head of the Group" or "Leader of the Group"). His participation in the Sioux campaign added him to the tradition, begun by his father and uncle, of serving in the United States military.[12]

Born around 1855, Tawihisi grew up in Nebraska's Pawnee homelands. He made the trek to Indian Territory as a young man. He knew firsthand the misery his people endured in their last years in Nebraska, and was all too familiar with the poor conditions and suffering they faced after relocating to Indian Territory. When Tawihisi enlisted with the Pawnee Scouts as a young man in 1876, he had the opportunity to return and fight the age-old enemies of the Pawnees in the campaign against the Sioux and Cheyenne. Tawihisi won the name Kutawakutsu Tuwaku-ah, which translates as "Hawk Echoing" or "Echo Hawk" as a warrior.[13] After serving with the scouts, he returned to Indian Territory, where he raised what became a sizeable family. Around the turn of the century, he used the name Kaka Rarihuru (Big Crow), but as the Pawnees underwent the allotment process, he insisted that he wanted his family to use the name he had as a warrior rather than adopt a white neighbor's surname as encouraged by the allotment agent.[14] Thus, he became Howard Echo Hawk.[15]

Echo Hawk's grandson Brummett described him as "just over six feet in moccasin feet," and "ramrod straight."[16] Echo Hawk was one of the old men who still wore their hair long in well-kept braids and maintained a dignified, soldierly appearance.[17] Brummett Echohawk wrote of his grandfather: "He raised horses. Gave many to needy members of the tribe. He also gave horses to his former enemies, the Cheyennes who lived in western Oklahoma. He had two names. One was

Sereh-ree-tahwee, which meant They All Know Him. Echo Hawk was his warrior name. To the Pawnees the hawk was a silent and efficient warrior. The hawk never sings. Such was Grandpa Echo Hawk. He never sang his own praises. But the tribe did. They echoed his deeds and actions. Thus the hawk whose deeds are echoed—Echo Hawk."[18]

Brummett Echohawk once wrote, "I can tell you about the Pawnee Scouts who served the United States government during the Indian Wars. I can tell you because Grandpa Echo Hawk was one of them. . . . Some of the Pawnee Scouts I saw and remembered. Others I knew by reputation. Still others were legendary. . . . Our people held the Pawnee Scouts in great respect."[19] The Pawnee Scouts left an indelible impression on Brummett Echohawk, and he revered these elders all his life. He identified with their stories and wished to add his name to the ranks of great warriors among his people. He admired them as military men—men who fought to preserve something special, a way of life and their homelands. As a young child, he watched how these warriors of the old school navigated the ever-changing world they lived in. Most of them had a tenacious quality about them, even in their twilight years. He wrote about a number of the old men, for he had heard the stories of their younger days, but he knew them as old men.[20]

Brummett Echohawk wrote about some of his experiences with the old scouts. "I knew Dog Chief well," he recalled. "He gave me his old cavalry hat. There was a crude writing on the inside. The best I could make out was 'Simon Adams, U.S. Indian Scouts.' Simon Adams was the name Dog Chief enlisted under when he rode for Maj. North."[21] As a young boy, Echohawk took great pride in that battered gray hat.[22] He also knew High Eagle, once a participant in the 1876 campaign against the Sioux and a fine horseman. High Eagle apparently took an interest in the youth of the tribe. He, and many of the older generation, encouraged the young people to learn and maintain their Pawnee language. Echohawk distinctly remembered an incident when as a young boy at the boarding school he received a silver dollar from High Eagle for correctly answering a "tricky" question in the Pawnee language. High Eagle asked young Echohawk if he wanted money or nails. Echohawk wrote, "The Pawnee words for money and nails are the same except for a slight inflection, depending on the situation. High Eagle carried a few shingle nails in his pocket to make sure we learned correctly."[23]

Pawnee Scout Howard Echo Hawk left his Nebraska home with the third, most reluctant wave of Pawnee people and headed to Indian Territory. Howard had a large family. From family history, federal censuses, and Indian census records, he had four wives (some simultaneously;

the older Pawnees practiced polygamy) and at least fourteen children—many of whom did not survive to adulthood. He married Susan or "Susie" around 1872 in Nebraska. The following year, he married her sister, Annie Keller, but the two divorced. The two sisters belonged to the Kitkehahki band and had a brother named Bromet Taylor. Howard Echo Hawk also married Choorix Taylor in Nebraska, but the date is unknown. Among their children, Howard and Choorix had two sons. Elmer Price arrived on May 18, 1892; Choorix gave birth to his brother, George Thomas, on December 27, 1899. Choorix passed away in December 1902. Howard then married Carrie West around 1903.[24]

According to family history, after leaving Nebraska, Howard Echo Hawk's family belonged to the Kitkehahki camps on the Cimarron River. When the allotment of Pawnee lands began in 1893, rather than immediately settle in the fashion of whites, Howard's family lived for years at a campsite. Howard moved his family into a permanent house around 1920.[25] Taking time to move into a home deemed acceptable by government officials proved fairly common among the Pawnee people in Indian Territory.[26] In the 1880s, officials instructed the Pawnees to cease their old ways of building earth lodges, but their situation made it difficult financially and otherwise to procure the materials necessary to build the type of homes required. So some lived in canvas tipis, and others defied the rules and built earth lodges anyway.[27]

Echohawk related, "The transition for the Pawnees in the 1880s was disheartening." The process by which one was to become "civilized" remained a bit unclear for most. The government made rules that were often impractical; the local agent often did the same. Many officials meant well, but their programs and rules often brought about more frustration than progress. Old enemies of the Pawnee people, the Osages, occupied a reservation directly north of the Pawnees, on the other side of the Arkansas River. Close proximity made Pawnee-owned livestock prime pickings. White rustlers also posed a threat. Agency regulations forbade the Pawnees to retaliate against their offenders. Instead, the best they could do was escort the Osages home and complain about the white thieves. The Pawnees, and other tribes, had run-ins with immigrants as well as outlaws. Although a great deal of land was lost during the general allotment process, many Pawnees worked hard on the lands they managed to retain and found themselves forced to defend their property from time to time. Howard Echo Hawk was no exception. Despite agency rules, Brummett Echohawk described his grandfather as "old school." He was "Chaticks-Si-Chaticks [Men of Men] . . . an old pro from the Pawnee Scouts."[28]

When Howard Echo Hawk's sons George and Elmer reached school age, they, like most other Pawnee children, left home to attend the Pawnee Agency boarding school. Echo Hawk enrolled Elmer in the Pawnee "training" school in 1898.[29] He attended until fifth grade when he, like a number of the older children, transferred from the Pawnee school to the United States Indian school at Carlisle, Pennsylvania, where it is said he roomed for a time with the now-famous athlete Jim Thorpe.[30] He arrived at Carlisle Indian Industrial School on September 11, 1907, and signed up for three years' enrollment.[31] Even though he had first attended the Pawnee boarding school, Elmer's transition to Carlisle proved difficult. In 1882, the government had begun more intently implementing a policy of sending older children away for education, and many students struggled terribly with homesickness. Brummett Echohawk described some of the homesick Pawnee children as "young homing pigeons," who "set off . . . for the Cimarron country hundreds of miles away." Of course, Pawnee children were not the only ones who felt compelled to run. Most often, school officials caught up to the children before they made it very far. Authorities in neighboring towns often aided in the capture of runaways. "I don't know how old my father was then," his son wrote, "but he was one of them that had a strong feeling for home."[32]

Elmer's school records note that he ran away July 13, 1909, and under the column for "special remarks" in bright red ink is the label "deserter."[33] After getting clear of the vicinity of Carlisle, Elmer worked odd jobs to earn his fare home. "When he got home his father raked him over the coals and sent him back. This time my father stayed. He did well. And we in the family always agreed that he did well—for that's where he met my mother."[34] Elmer Price Echo Hawk was officially discharged from Carlisle Indian Industrial School on September 30, 1910.[35]

Alice Jake, the daughter of "Pawnee Jake" or Pee-ah-loo-lee-who-lah-lix-suh and Florence Jake, was orphaned as a small child. Henry Eagle Chief, a prominent Pitahauerat, and his family took her in when she was about ten years old.[36] Alice Jake's application for enrollment at Carlisle, dated August 19, 1905, states that she was fourteen years old at the time and bears the mark of Eagle Chief as the guardian consenting to a five-year enrollment to begin August 24 of the same year. She earned high marks in school and seemed to get along well. She was officially discharged from Carlisle on June 20, 1910.[37] Word of Elmer and Alice's September marriage in Oklahoma made it back to Carlisle where they kept in touch with the superintendent. A small typewritten note taped onto Carlisle letterhead from the superintendent's office

was placed into Elmer's school file. The note read, "We are informed of the recent marriage of Alice Jake and Elmer Echohawk. Both were Carlisle students and their many friends extend to them hearty congratulations."[38]

In May and June 1911, both Elmer and Alice separately responded to a questionnaire sent to former Carlisle students. The form asked a number of personal questions including, "Are you married and if so to whom?" and "Tell something of your present home." It also asked, "What property in the way of land, stock, buildings, or money do you have?" and "Tell me anything else of interest connected with your life." As one might expect, Alice and Elmer answered most questions similarly. They were proud to report. Still a newlywed, in response to the Name question on the survey, Alice responded, "Mrs. Elmer Echohawk was Alice Jake." To the question about marital status she responded, "Yes Sir, To Elmer Echohawk." She reported that her present occupation included housekeeping duties and that she was using her sewing and cleaning skills. Elmer wrote that he worked as a poultry man and farmer and that he had previously (between Carlisle and his present activity) been employed as a tailor in Oklahoma City. Both Alice and Elmer reported being the owners of a house with four rooms. The couple lived roughly a mile and a half from the town of Pawnee, Oklahoma, on a farm.[39]

On July 29, 1911, Alice gave birth to their first child, a daughter named Minnie. Perhaps spurred on by the survey sent out by Carlisle the previous spring, as proud new parents and homeowners, the couple sent a letter to their former superintendent, Mr. Friedman, on August 25, 1912. "Dear Sir;" Elmer began his letter, "We are sending you a picture of our home. We folks are well and enjoying life together." He signed the short correspondence, "Yours Respt., Elmer Echohawk." Elmer Echohawk enclosed a photograph of the couple with their baby in front of their home. The photo was taken from a distance but reflected the pride they felt in their home and property.[40]

Tragedy soon struck the new family. Minnie died on January 21, 1913. In June 1914, Alice gave birth to a little boy. They named him Owen Bruce. Ernest V. "Crip," followed in July 1917. By the time of Delray's birth in May 1920, Elmer had enlisted in the army during the First World War, following the example of his father and grandfather in the spirit of Pawnee military tradition.[41]

The war ended before Elmer could be sent overseas. The entire Pawnee Nation numbered only about seven hundred people, but they managed to send fifty men into active service. For various reasons,

only eighteen saw combat overseas.[42] These men served in various ca-
pacities, including in a Stokes mortar platoon and the 128th Infantry
Regiment of the 42nd "Rainbow" Division.[43] Upon their return home,
the Pawnee veterans of the First World War were greeted in the old
way, with a celebration. Frances Densmore, an anthropologist working
for the U.S. Bureau of American Ethnology, attended this ceremony in
honor of the returned warriors on June 6 and 7, 1919. Although Dens-
more focused on the music at the gathering, she also recorded some
of the other incidents she witnessed. She noted that, as a part of the
gathering, old war songs were sung, some of which had been modified
to reflect the experiences of these newly returned warriors. The revised
lyrics mentioned airplanes and submarines. Densmore also observed
in two different articles that during a victory dance, the mother of a
returned warrior displayed a German helmet he had captured atop
a pole with a knife attached to the end much like a lance, as scalps
had been displayed in times past. "The young man who gave it to his
mother acted in accordance with an old Indian custom in which scalps
were handed over to the women, in whose defense the warriors had
gone forth," she wrote.[44] In keeping with tradition, veterans remained
in high esteem in the Pawnee community.

Brummett T. Echohawk joined Elmer and Alice's family on March 3,
1922. His parents named him for his grandmother Choorix Echo
Hawk's brother, Bromet Taylor.[45] Brummett had limited time with his
grandfather, Howard Echo Hawk. "Grandpa Echo Hawk died when
I was a few months off the cradle board," reported Brummett.[46] Al-
though in many ways Howard Echo Hawk clung tenaciously to the
old ways all his life, he had been successful in some of the new ways
also. "He did well and was respected by his tribe and his community,"
wrote his grandson. "When Grandpa died in his late 70s," Brummett
recalled, "he had money in the bank and his land under cultivation."[47]
Howard Echo Hawk's tombstone contains a small photograph and
crossed American flags and sabers; above his name is inscribed "Paw-
nee War Scout."

Elmer Echohawk gained a reputation in the 1920s as a fighter. This
and bootlegging got him into trouble with the law from time to time.
His wife, on the other hand, had a milder temperament. She loved the
writings of authors like Hawthorne and Whitman, had a reverence for
tribal custom, and knew the Bible inside and out. Alice tried to instill
some of these values in her children.

Like most Pawnee boys of his and his father's generations, Brummett
Echohawk, at the age of five, went to the Pawnee Agency government

boarding school about two miles east of Pawnee.[48] The school was commonly referred to as "Gravy U," for Gravy University, because of the gravy served with nearly every meal.[49] Like most government-run American Indian boarding schools of the day, the school adopted a militaristic approach.[50] Gravy housed Indian children from the first though the eighth grades, until after World War II when ninth grade was included. The school served Pawnee students as well as students from surrounding tribes.

Brummett Echohawk wrote, "Unlike the kids who didn't care for school and ran away, I was different—I was anxious to go." From the time Brummett Echohawk accompanied his parents to visit his older brothers at the boarding school, he felt intrigued by what he witnessed. From his writings, it appears that the playground and multitude of children held the biggest draw. He wrote, "I had never seen so many kids before since we lived far out in the country. This school stuff appealed to me, and I couldn't wait."[51]

On the appointed day, he and his parents pulled up to the school in their wagon to enroll him as a student. Brummett Echohawk remembered being truly excited. He recalled, "I leaped out of the wagon and took off for the new-fangle swings while my folks signed me up. I had myself a ball." From that moment, he maintained his excitement over the swings and playmates—until lights out on the first night. Then a little realization began to sink in. "That night," he wrote, "in a strange bed a hard lump came into my throat. I wanted to go home. I gulped down the feeling when I heard the other kids sniffle and sob. Some of the real homesick ones cried far into the night." For all of his excitement, he had big adjustments to make as early as the first night. Later in life, Brummett Echohawk recalled the terrible, upset feeling he had that night as he wondered, "What the heck am I doing here?" He could remember only one other time in his life that he had felt so low, and that was when he had gone to war.[52]

He made it through the night and rolled out early the next morning with the rest of the children. School officials expected the children to march in line to breakfast. The students made an attempt that first morning, but remained sleepy and became easily distracted. At one point, when the officers' attention was diverted, the children slipped away to the "new-fangle swings." Quickly, they were rerouted to breakfast. Brummett Echohawk remembered all of the children, boys and girls, gathered in their designated sections of the dining hall. He wrote of a "mean looking matron with white hair" and the small bell she rang to give instruction. She rang it at particular times—when the children

were to be seated, when they were to "sing grace," and when they were to exit. Small children had to respond to a stringently controlled lifestyle. Learning to live under such strict regimentation required Echohawk and the other children to make considerable adjustments.[53]

Despite the rough night and the trying first breakfast, Echohawk determined that all would be well when he and the other boys were released for recess. They returned to his beloved swings. He recalled, "School was great. We laughed and had a big time. Then they came and got us. They took us to class rooms. It was a rude awakening." He spent the next four years in and out of those classrooms. When thinking back on his experiences, he did not write bitterly. He recognized that some positive changes had taken place in the system since the previous generation's attendance. He wrote, "Though it isn't now, the school was operated like a military school. I can only imagine what it was like in my father's times. There were good times. And there were bad times."[54]

In describing the school's weekend uniforms, Echohawk wrote, "We wore wool uniforms. A grey tunic that choked you at the neck. The buttons were Army copper like something left over from the days of Custer. The pants had a stripe down the leg like the old time Cavalry."[55] There was a difference, however. These pants "stopped disgustingly short at the knees. . . . And long black itchy stockings—I never mastered the art of keeping them up." He described his school hat as looking both like a military hat and a "miniature train conductor's cap."[56] As for the footwear, he said, "We flattened our arches in heavy government shoes . . . but kept them shiny."[57] According to Echohawk, he and other students took pride in their uniforms and military bearing, despite their discomfort.

Later in life Echohawk wrote, "Saturday . . . was the day when many Indians came to the Pawnee Indian Agency to transact business. Pawnees, Otos, Poncas, Kaws, Kickapoos, Sac and Foxes, Shawnees, Iowas. They came in colorful blankets, shawls, long hair braided in bright colored yarn, eagle-winged hats tipped with a feather and beadwork. Some of the oldtimers wore a dash of paint on their faces; not war paint but family colors."[58] Much took place in town on Saturdays. The elder generation, in their native tongue, called it "the day we come to town to look at each other." People came for groceries and other goods. They were there to socialize and transact business. While in town, they took in the sights and sounds. The old men often met on Saturdays at Wes Rowe's grocery. Brummett Echohawk recalled their conversations reminiscing about days gone by when they rode fine horses and still lived on the plains. Occasionally, he wrote, "When a Model T Ford

clucked by, they stopped talking and scowled at the thing they called 'Smokey Behind.'"[59]

The Pawnee Indian School allowed the children to go into town in their dress uniforms to meet with their families. They could attend the local movie theater, which generally showed "stock westerns" on Saturdays. Inside the theater, schoolchildren interpreted for their elders. Echohawk painted with humor the Western movie experience as taken in by the Indians in attendance. The stereotypical Indian roles played by white men amused the audience. They also noticed the ineptitude (or indifference) of costume designers who clad the "Indian" actors; the all-too-predictable good-guy-versus-bad-guy and pretty-girl plots, and wild Indians attacking hapless wagon trains. Although the Indian families in the theater often got a good laugh, it did not escape them that the films represented something about their place in American society and memory. The world, for Brummett Echohawk, was full of contradiction and irony, but he learned from an early age to see the humor in it, and this served him well later in life.

Echohawk had positive experiences in school, along with the challenging ones, which influenced him later in life. One of the clearest memories Echohawk kept from boarding school was of drawing a picture of Charles A. Lindbergh: "He was my hero then. My teacher thought it was fine. She encouraged me to draw. I did. And I've never regretted it."[60] Echohawk embraced the encouragement he received as an artist and continued to progress.

Scholars argue that the military regimentation found in the boarding-school experience had a direct correlation to the unusually high number of young American Indian men who enrolled in the U.S. military shortly after their schooling.[61] However, during this era, the government began implementing changes in Indian education. The schools began to shift away from Richard Henry Pratt's harsh military approach. The transitions began when President Franklin D. Roosevelt appointed John Collier the new commissioner of Indian Affairs in 1933. The federal onslaught of determined destruction of Native cultures subsided somewhat. Collier helped turn that tide. He promoted Indian education, certainly, but he saw value in retaining aspects of Native cultures.[62] Brummett Echohawk experienced more of the former than the latter.

Brummett Echohawk's mother, Alice, passed away when she lost a battle with pneumonia on January 1, 1929.[63] About the time of Alice's death, Elmer became very ill.[64] Unable to take care of his four young boys, Elmer turned to his brother George for help. The Veterans

Administration (VA) eventually sent Elmer to Arkansas City, where he was diagnosed with a terminal condition.[65] George and his wife, Lucille Shunatona (nicknamed Tootz), took the boys in. They raised them about two and a half miles west of Pawnee in the family home known as "Out West," or "Echo Hawk Place." George and Lucille brought them up alongside their own children as siblings. Their boys were a little younger than Elmer's. George's oldest boy from his first marriage was Alvin George or "Ugh." George and Lucille's oldest boy was Walter Roy, also known as "Bunky," born in 1928. Frances William or "Witty" was born in 1930, followed by Myron Duane or "Hobe," in 1931. The boys grew up claiming one another as brothers rather than cousins. Brummett, being the youngest of Elmer's sons, was closest to George's boys in age. The boys also had sisters, George and Tootz's daughters, Irma and Georgette.[66]

Echohawk's Uncle George was a man of many talents. George had been a successful athlete in school, playing football and basketball and participating in track. As an adult, he was a skilled bronc rider, a champion golfer, and an excellent hunter, among other things.[67] At a very young age, Bunky enjoyed the rodeo like his father, but Brummett and the other boys showed more interest in hunting, fishing, and swimming in the summer. Brummett seemed to excel in all of these things and for this reason was able to take the younger boys out with him regularly. His brother Hobe considered him an outdoorsman, a woodsman. They often rode horses the fifteen-mile distance to the Arkansas River to swim. George and Lucille permitted this because of Brummett's skills and reliability. When hunting, the boys typically used slingshots rather than rifles. In fact, the boys rarely went into town for fun, because they had so much to do out in the country.[68]

When Elmer returned from Arkansas City, he involved himself in the Native American Church and became well again.[69] Elmer began farming cotton during the Great Depression. Although he did reasonably well growing cotton, his family's main support was his VA pension, but when the VA learned of his cotton income, it drastically reduced his monthly pension, so he gave up farming. In 1932, Elmer was chosen to serve as the treasurer of the Pawnee Supreme Council, one of two governing bodies of the Pawnee Nation. Around this time, Elmer married Manuella Good Chief. Manuella already had a daughter named Marcella Smith, and in 1933 she and Elmer had another daughter, whom they named Eleanor.[70]

George, however, continued to care for Elmer's sons and moved the family to Albuquerque, New Mexico, for about six years during

the early to mid-1930s.[71] While there, Brummett's older brothers at-
tended the University of New Mexico, and he went to high school. He
returned with George and his family to Oklahoma but then went to
stay with his father and started attending Pawnee High School. He did
well, and, being both sociable and athletic, he became captain of the
football team in 1939.[72]

In the small town of Pawnee, young men commonly joined the Na-
tional Guard; doing so seemed almost automatic for many. The local
National Guard was a social outlet as well as an economic opportunity.
During the Depression, the added income aided local families. Many
also saw serving in the Guard as an extension of the Pawnee military
tradition. As a young man descended from a line of military men and
a tribe with a proud martial tradition, for Brummett Echohawk, the
National Guard offered not only a social and economic appeal but a
chance, at least in some measure, to follow the path of the men before
him. He joined the National Guard in 1939 while still in high school, a
decision that would set the course of the rest of his life.[73]

Like most people, Brummett Echohawk's background strongly influ-
enced his life decisions. His childhood activities translated into athleti-
cism and the ability to excel in physical endeavors. His boarding-school
experiences helped prepare him for the regimentation of the military.
The time his family lived in Albuquerque exposed him to the world
outside of rural Pawnee, which helped him adjust to new settings when
he left home. His personal experiences, and the understanding of those
who came before him, helped equip him for the challenges ahead.

Taking on the Mantle

In the old days Grandpa Echohawk had to touch the enemy with his hands to count coup. I was in World War II with the 45th Division—Oklahoma's division. It was mostly Pawnee Indians and I too touched the enemy in an effort to live up to the name. Sometimes it wasn't easy, because they were trying to kill you. But again my point is this: Keep your heritage. Look back at it. Make it work for you. Use it as a spiritual increment in everything you do. Whether you know it or not, you as an Indian are an image. You always will be.

—Brummett Echohawk

Executive Order 8530 changed everything.[1]

When the government called upon the National Guard units of Oklahoma, Colorado, New Mexico, and Arizona to mobilize and become a part of the army's 45th Infantry Division, Brummett Echohawk welcomed the opportunity to fight for the United States. In many ways, his experiences reflect those of typical American GIs in the European theater. In other fundamental ways, his experiences differed because of his heritage and his opportunity to serve in a predominately American Indian unit. Echohawk's personal experiences in World War II demonstrated the dual nature of his identity as both American and Indian.

Many young men across the country feared being sent to war. Brummett Echohawk went to his parents in tears fearing quite the opposite—that he might miss the war. The necessary papers were signed, enabling him to join early.[2] "Having heard all the stories, we couldn't wait to prove we were good warriors too," recalled his younger "brother" Myron.[3]

Brummett Echohawk did not complete high school, because he left with his unit when the National Guard received the call to active duty. He worked hard to make up for not graduating, because he did not want to fall be behind academically. In a talk given much later in life, he said that not finishing high school made him feel self-conscious. In an attempt to compensate, he read "Webster's Dictionary once a month

and the Bible every day." He said, "I drove myself very hard doing that. . . . How many people do you know that can read the Webster's Dictionary like you would do a book of the month club? . . . It makes you think." He claimed that this and serving in the army provided his education.[4]

When asked what generation of military serviceman he was in his family, Brummett Echohawk's younger brother Myron answered that he would start with Echo Hawk, his grandfather, who had served as a U.S. Army scout. He said, "He was born out on the plains, so . . . you'd have to say: 'His dad was an Indian out on the plains too,' and go back 600 years if that's the case. So what we do is we just say: 'Our grandfather was a Scout, and that's where we all came from.'" Myron Echo Hawk continued by noting that both his father and uncle had enlisted for World War I, making them the second generation. Their children, Myron and Brummett's generation, became the third generation of U.S. military men in the family. He indicated that calling them the third generation proved somewhat misleading because his grandfather, his great-grandfather, his great-great-grandfather, and so on had also served as military men. He said, "They were all warrior-type out on the plains, you know, but we don't go back that far. We can just go back to my dad's father."[5]

Some of the boys in the family in Brummett Echohawk's generation seemed particularly oriented for war, in part because they grew up in the shadows of the old Pawnee Scouts, hearing the family stories from their fathers who had enlisted for World War I. The boys knew that they came from a long line of fighting men. Brummett Echohawk said his father, grandfather, and all the past Pawnee warriors inspired him to join the military. Also, the elders in the tribe encouraged him and the other young men "to become warriors because they foresaw what was going to happen."[6] He recalled that some of the old ones talked about prophecies, including a belief that as a result of each major Pawnee battle, the tribe would lose only one warrior—the rest would survive. The prophecy had proven accurate since the Indian wars of the 1860s and encouraged some young men considering going to war.

Among the Pawnees, being a warrior earned a man high standing among the people. Brummett Echohawk said of his people, "They don't give a hoot whether you make a lot of money; or you have a very fine job . . . [or] you drive a flashy car." Affluence and riches meant very little to them. He explained, "It's 'What have you done for the tribe and your country?' That's what it amounts to. You have to be a man first . . . usually the requirement of it is being a warrior. Then you have all the

recognition and then the tribe makes a song for you which becomes history. This is where they keep their history—history of their men."[7] For him, and several of his brothers, this ideal seemed a goal worth pursuing.

Brummett's brother Myron added that the stories they heard from childhood about the Pawnees standing up to other tribes taught the boys that "our people must have had *something*" in them that gave them the strength or the edge necessary to endure. Their ancestors continually repelled their enemies, even when facing overwhelming odds. Myron noted, "Our tribe always held their ground and so we say: 'That's where our heritage was [from].'"[8]

George, who raised Elmer's boys after their mother died, used to ask the boys, "Are you scared to go to war?" "No, sir," they would respond. "You're not going to be scared or want to come back here?" George would ask. "No!" Myron said they would answer, "Because we wanted to be like these other guys that served all their military time and did good and got to go to combat." Pawnee pride was evolving into Echo Hawk pride.[9]

Other descendants of Echo Hawk participated in World War II. Brummett's older brother Delray enlisted in the air force at Fort Sill, Oklahoma, on March 4, 1942, and received his assignment to become a part of the 43rd Bomb Group (BG). He earned the status of a true hero on October 18, 1943, when the 64th Bomb Squadron of the 43rd BG participated in an attack intended for Vunakanau Airdrome as part of the 5th Air Force raid on Rabaul's airfields. Due to inclement weather, the squadron did not make its target but hit an alternate target at Cape Hoskins in New Britain. On the return flight, the left wing of Delray's plane began leaking fuel over the Owen Stanley Mountains in adverse weather, and the fuel ran dry over Bootless Bay. The crew was five miles shy of its target at Seven Mile Drome. According to Lawrence J. Hickey, who participated in the mission to Vunakanau, Papua New Guinea, Delray's plane then "skidded into the water several hundred yards from the head of the bay, but flipped over and broke in two when the nose hit a submerged coral reef."[10]

Staff Sergeant Delray Echohawk, one of the crew's waist gunners, escaped the crash with two other men despite his arm and leg being injured. After he surfaced, Delray caught his breath then turned back. He returned to the aircraft twice. The first time, he failed to remove one of the dead. The second time, he dove down and pulled himself along the aircraft until he reached the waist gun opening and grabbed Staff Sergeant Clayton Landon, the crew's other waist gunner, and pulled him

to the surface, thereby saving his life just before the wreckage sank. Delray's hands were badly lacerated in the process, as he had grabbed the torn metal on the plane to pull himself along underwater. According to the pilot, Steve W. Blount, the 43rd BG lost three planes due to inclement weather and fuel exhaustion on that mission. A group of Australians rescued the four men in the water, and shortly after Delray returned to the United States. At the end of the war, Delray emerged as the Pawnees' most decorated serviceman. He earned the Distinguished Flying Cross, the Soldier's Medal, the Air Medal, and multiple Purple Hearts. During World War II, he logged over two hundred hours of combat flight time over the course of fifty-three missions.[11]

Brummett's brother Alvin became the Pawnee tribe's only navy frogman. He volunteered to serve on Underwater Demolition Team (UDT) 21. His team served in the Pacific theater of the war, preparing the way for the safe passage of American ships. Their duties entailed reconnaissance and removing barriers (including obstructing reefs) and sometimes guiding in the first wave of men assaulting strategic beaches in amphibious landings. UDT 21 was one of the teams involved in clearing floating minefields in preparation for the invasion of Okinawa, Japan. After serving dutifully in World War II, Alvin continued to serve as a navy frogman in Korea.[12]

Too young for World War II, much to his displeasure, Myron "Hobe" Echo Hawk watched his brothers go off to World War II and bode his time until he could follow in their footsteps. At the age of eighteen he joined the marines and served with a tank crew in Korea. The stories of his grandfather and the Pawnee Scouts, his father and uncle who signed up for World War I, and the stories his older brothers brought back from World War II strongly influenced his decision to enlist. Myron said, when the United States entered the Korean War, "It was our turn to go, and I said: 'I want to go because I want to be like them guys.'" Myron served from 1950 to 1953. Assigned to the 1st Tank Battalion, Charlie Company, Myron started out as a machine gunner on the tank. He then served at several posts, including driver, gunner, and, ultimately, tank commander.[13]

Pawnee and Echo Hawk family stories about their history and heritage had a great deal to do with why Myron and his brothers served. Myron said, "We've always heard [those stories], so most of us older guys had that thinking of 'We'd make good soldiers, and we want to be soldiers.'" Myron said his older brother Brummett influenced his desire and ultimate decision to enlist. "I couldn't wait to do what [Brummett] did," he said. When the United States went to war in Korea, Myron and

some of his friends from Pawnee wanted "to get into some outfit that [would] ship us over real quick and get into it." Brummett Echohawk trained for years before the army finally shipped his division overseas. The guys from the community who joined the marines had gotten into battle more quickly than the guardsmen in World War II. Myron explained, "That's why a lot of us joined the Marine Corps. Because the Marines are the first ones always. . . . That's the way I always seen it. I didn't want to go into the Army because I thought their training was too long."[14]

When Brummett Echohawk's national guard unit mobilized as a part of the 45th Infantry Division in response to President Roosevelt's call to active duty on August 31, 1940, the government required of each soldier one year's active duty beginning in mid-September 1940.[15] The same September Roosevelt declared a national state of emergency.[16] Unlike many of his peers at the time, Brummett Echohawk had seen at least some of the world outside of rural, remote Pawnee, Oklahoma. His family had spent roughly six years around Albuquerque, New Mexico, and he had had a taste of something bigger. Many of his friends had never left the vicinity of their little town, let alone the county or state. Despite the Pawnee boys' militaristic boarding-school experiences, nearly all of them experienced a degree of culture shock once training got under way for the 45th Infantry Division. In the past, most of them had had limited interaction with non-Indians, mostly with government agents and school administrators. In the military, things proved dramatically different because a good portion of the men in the units that became the 45th Infantry Division came from Oklahoma, a state that hosts of tribes then called home. American Indians represented approximately one-third of the entire division's original enlisted personnel.[17] Colorado, New Mexico, and Arizona also contributed men to the 45th, and each of these states also had significant numbers of Native American soldiers.[18]

Because such a large percentage of the original division was comprised of American Indian soldiers, it provided a somewhat unique opportunity for them to serve side by side with other men from tribal backgrounds. Gilbert "Cheyenne" Curtis, who became Echohawk's first scout, provided an excellent example of how the composition of the 45th Division helped many of the Indian soldiers in the ranks. Curtis said he joined B Company of the 179th Regiment specifically because "it was composed primarily of Pawnee Indians and I felt more at ease with local people of tribal ancestry than I would have any other unit."[19] The Indian troops' time with the other two-thirds of the

division taught them much about an alternate culture and worldview. Training as a part of the 45th became a social learning experience for all, but many of the American Indian soldiers felt they had something to prove—to themselves, and to the world.

At the outset of the war, debate continued over whether American Indian troops should be integrated. By the mid-twentieth century, the reasons for requesting segregated units proved somewhat different than those in the previous century. Although the governmental push for assimilation persisted, some (including some Native peoples) requested all-Indian units for logistical reasons. For example, among some tribes like the large Navajo (Diné) tribe, many people proved willing to serve in the military, but because some communities remained situated in remote areas, not all of those willing to fight spoke English. To prevent the government from turning away capable soldiers because of language barriers, having an all-Indian unit would allow such men to acclimate to a new language and culture and to serve much more readily. Many American Indian men like Gilbert Curtis also found it more comfortable to serve with others of tribal backgrounds. In the end, due to social pressures and military desires for expediency, the U.S. government proved intent on integrating American Indian soldiers with their white counterparts.[20]

Brummett Echohawk later noted that being in the 45th had special significance for him. "My grandfather [Echo Hawk] served in the 45th . . . when it was made up entirely of Pawnee Indian Scouts during the Indian War. He earned the name Echo Hawk . . . and I felt I had to live up to that, too."[21] Being assigned to the 45th meant a lot to him because it presented a unique opportunity to follow in his grandfather's footsteps, not only as a soldier, but as a member of the same unit Echo Hawk and other Pawnee Scouts had served in.

A fellow Pawnee named Philip Gover served as Echohawk's platoon sergeant. The two men knew each other before the war in their home community of Pawnee, Oklahoma. The oldest man in the company at thirty-four years old, Gover already had a family when the Oklahoma National Guard was activated. At the time, he qualified for exemption from service but chose to serve because he felt he had a duty to fulfill. The men in the unit held Gover in high esteem.[22] Phil Gover thought highly of Echohawk's character and respected young Echohawk's dedication and work ethic. In 1940, Gover made Echohawk a squad leader of the 2nd Squad, 2nd Platoon of B Company, 179th Regiment.[23]

Many men of the 45th belonged to companies or platoons that were comprised entirely, or almost entirely, of Indian soldiers. In fact, the

45th contained the highest proportion of Indian soldiers of any division in the army. When the division left for combat, even after its ranks had been infused with non-regional troops, American Indian men made up fully one-fifth of the division's troops.[24] C Company of the 180th Regiment was often referred to as the Chilocco Company because many men in the ranks had attended the Chilocco Indian School in northern Oklahoma. At the time of mobilization, as previously mentioned, Pawnee Indians filled the ranks of B Company of the 179th, hailing from Pawnee, Oklahoma, and quickly earned the unofficial designation of the "Pawnee Company." Initially, the 158th Regiment, a component of the Arizona National Guard federalized along with the Oklahoma National Guard, contained a large number of American Indian soldiers, but the army detached them from the 45th after the United States declared war and sent them to Panama for jungle training. The 158th Regimental Combat Team (RCT) became the famous "Bushmasters" who fought in the Pacific theater. Echohawk referred to the Bushmasters as the "first American Indian specialty" unit. Pawnee soldiers Vergil Fox Howell and Eugene Peters fought as part of the Bushmasters. Echohawk claimed that the army took a good portion of the Native American noncommissioned officers to bolster the 158th and help train the rangers.[25] "They had to be taught by somebody who knew how to do it so they took Indians to do it," he said. "I was taken for demolition, knife fighting and everything else and pulled back again. . . . So in a sense we were teachers for everybody."[26]

The 45th Infantry Division earned the appellation "The Thunderbird Division" because of its divisional insignia. The division's patch consisted of a red diamond with a golden-yellow thunderbird. Formerly, the division had used a swastika-like emblem, an American Indian symbol for good luck, but when the Nazis began using the swastika, the 45th changed its design. Approved by the U.S. Department of War in 1939, and designed by one of the division's American Indian soldiers, the new patch had strong ties to the tribal components of the division. Each of the four sides of the patch represents one of the states represented by the National Guard units. Among many of the southwestern tribes, the thunderbird is a mythical bird with such power that its flapping wings create thunder and its eyes flash lightning, and the thunderbird is said to triumph over all.[27]

Some Americans, and many from other nations, wondered why so many Native Americans willingly served a nation with such a poor track record of treatment of its indigenous peoples.[28] Each individual had his or her reasons for participating in the American military

effort. Financial, educational, and patriotic motivation, as well as military benefits and travel, provided incentive for many; however, historian Paul Rosier describes the influence of dual identity and what he labels "hybrid patriotism" as important factors contributing to American Indians' willingness to join the U.S. armed forces. Rosier explains dual identity as the notion that many viewed themselves as both American and Indian, and did not feel the need to choose between the two, and "hybrid patriotism" as the ability to contextualize military service as a means to defend both traditional values and tribal lands, and particular American ideals and security. Rosier argues that while government-run boarding schools exposed American Indian students to military regimentation and tried to instill in them a sense of patriotism and loyalty to the flag, and proved to have high levels of graduates move into military service, these factors alone did not explain the entire phenomenon of wartime service. Rather, he suggests that "patriotism, nationalism, and international affairs" intersected in the mid-twentieth century, providing a particular lens through which military service could be viewed.[29] Rosier posits that instead of relying on the force-fed rhetoric of boarding schools or government agencies, American Indians found ways to reconcile loyalty to their tribal communities and cultures with support for the United States. Rosier argues that they did so by "imagin[ing] an American nationalism that drew upon rather than destroyed their values, and developed an ideology of hybrid patriotism—both Indian and American—to define the heart of 'America.'"[30] Brummett Echohawk clearly rooted his identity in his Pawnee heritage, but for him a part of that heritage included a long-standing alliance with the United States and willing service under the flag. He proudly identified as a Pawnee Indian *and* an American.

Although officially inducted into active service as a part of the 45th Infantry Division on September 16, 1940, B Company, 179th Regiment remained in Pawnee, Oklahoma, through September 25 on garrison duty. On September 26, the regiment traveled roughly two hundred miles to Fort Sill, near Lawton, Oklahoma, to assemble with the rest of the troops to begin training.[31] Many believed they would be home in a year's time. After several months of training at Fort Sill, the division moved to Camp Barkeley near Abilene, Texas, in February 1941, for its first field training. There, Echohawk attended judo and bayonet school. He excelled in both and served as a bayonet and hand-to-hand combat instructor while the 45th remained stateside.[32] His superiors promoted him from private first class to corporal on April 11, 1941.[33]

Records indicate that by the end of that month, the army shipped him to Veracruz, Mexico, on the USAT *Kilpatrick*.[34] Although the records are incomplete, this is likely when he spent time training the members of the 158th RCT, the Bushmasters.[35]

The 45th participated in the widely publicized 1941 Louisiana Maneuvers, from August 4 to October 4.[36] U.S. Army chief of staff George C. Marshall devised the Louisiana Maneuvers because of his concerns about American troops. He believed that they would be sorely undertrained if called upon to fight. The maneuvers entailed a series of mock battles designed to prepare American soldiers for the war already under way in Europe. Under the direction of Brigadier General Lesley McNair, the August and September exercises involved 400,000 men and about 50,000 military vehicles—the largest mass-training exercises the United States had ever organized.[37] The overall program produced mixed results, but the maneuvers demonstrated that the Americans had some excellent potential leaders and showed where weaknesses existed in order to hone training programs. At one point during the maneuvers, the 179th Infantry Regiment successfully fought off a complete division for three days without assistance. The general staff commended the 45th Division for its performance during the maneuvers.[38]

During the Louisiana Maneuvers, Echohawk had a memorable encounter with then Lieutenant Colonel Dwight D. Eisenhower. According to Echohawk, when payroll needed to be transported, Colonel Ross Ruth would "come and get the Indians" to guard the money. Echohawk was the youngest and felt honored to be chosen. The selected men collected the money in Shreveport, Louisiana, with three vehicles while the Pawnees guarded the area with .30-caliber machine guns. They then transported the cash to Pitkin, in the swamps of southwestern Louisiana, just south of Alexandria near the state's western border. On this particular trip, Echohawk received orders to sit on some footlockers full of money and to shoot anyone who came within a roped-off area surrounding the money. During the night, he saw someone come close. He jumped up and prepared to fire his weapon. He recalled that the man "was wearing a campaign hat with gold acorns and he raised up, staring at this Tommy gun and he flew out backwards and he ran over to the tent and I heard the men laughing." Later, Echohawk said a group of officers turned on some lanterns and took him over to meet Lieutenant Colonel Eisenhower. During the introductions, the other officers continued laughing about the incident.[39]

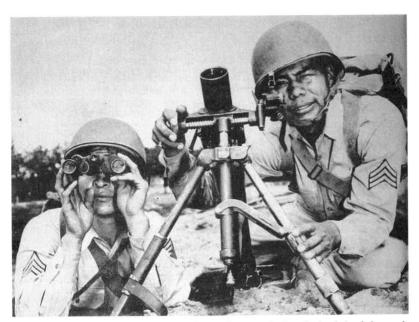

Sgt. Sleeping Rain, Potawatomi *(left)*, and Sgt. Echohawk *(right)* of the 45th Infantry Division practice sighting mortars. The original *Parade* photo appeared in *Indians at Work*, a publication of the Bureau of Indian Affairs (vol. 10, nos. 2–6 [1943]). Courtesy of the Library of Congress.

Echohawk met Eisenhower under very different circumstances on several occasions after that night in the swamp. Each time, Eisenhower recognized him and stopped to talk. The first of these encounters Echohawk mentioned took place at the Art Institute in Chicago shortly after the war. Not long after leaving office as president of the United States, Eisenhower ran into Echohawk in Washington, D.C., when Echohawk visited as a public relations representative for the National Congress of American Indians. Their encounter took place in the Hotel Statler elevator. Surrounded by his men in the elevator, Eisenhower recognized Echohawk, and they started talking. Echohawk related the conversation: "He asked me to come to the lobby and talk with him, so we sat down and he asked me what I had done—what happened to me. And I told him, 'Well, Sir, I went to Africa and all that.' And he said, 'You get hit?'" Echohawk answered in the affirmative. "We talked like two soldiers a long while. . . . he remembered me all those years." Eisenhower said to him, "You almost shot me that day. We could have been without a president," and they laughed.[40]

While the Thunderbirds continued training stateside, the exiled queen of the Netherlands paid a visit. Kenneth Williamson, a soldier in the 45th at the time, wrote about the incident. His comments provide insight in regard to some of the attitudes toward the American Indian members of the 45th as ultra-dedicated and fierce soldiers, as well as on the social relations between the Indian soldiers and some of their white counterparts. When Queen Wilhelmina of Orange-Nassau visited, B Company of the 179th performed a bayonet drill. American Indians still comprised the majority of the company. Williamson spoke of the Pawnee Company infusing the drill with unmatched enthusiasm. He wrote, "With their energetic lunges, they would emit animal-like noises, roars, and wails, that could have put their enemies to riot, even if the exposed directed steel did not. . . . Surely [the queen] must have been gratified that this fury was on her side."[41]

Although the Thunderbird who related the story of B Company's bayonet drill for Queen Wilhelmina seemed impressed with the zeal the Pawnee Company brought to combat training, and certainly to actual combat once overseas, his attitude reflected a less positive view of their cultural activities. He wrote: "These fellows were not far removed from tribal life. They used to irritate the hell out of us by staging tribal dances in their nearby company street that went on noisily far into the night."[42] Clearly annoyed, and perhaps somewhat disapproving of their dances, the man still saw value in the service of the division's American Indian soldiers.

The U.S. armed forces made necessary adjustments in restructuring training for efficiency and updating equipment as they learned of the December 7, 1941, attack at Pearl Harbor. The national push to prepare for war intensified. As Echohawk participated in the increased tempo of military preparation, he received word on February 16, 1942, that his father, Elmer Echohawk, had died. On February 17, the army granted Echohawk a five-day furlough to return to Oklahoma for his father's funeral. He returned to duty on February 23.[43]

In April, the Thunderbird Division transferred to Fort Devens, Massachusetts, for more training. During the time in New England, duly impressed news writers published articles about the supreme value of American Indians as fighting men. A nationally syndicated article, much cited by historians focused on American Indians in World War II, appeared under various titles including "Indians are Best Soldiers in U.S. Army."[44] The article stated, "The real secret which makes the Indian such an outstanding soldier, in [Major Lee] Gilstrap's view, is his 'enthusiasm for fighting.'" Echohawk's reputation for hand-to-hand

combat did not escape notice. The article used him as an illustration of Gilstrap's point: "Sgt. Echohawk, for example, a 126-pound Pawnee, is a Judo expert who, in a rough and tumble battle, could snap the back of an opponent twice his size. Echohawk daily practices taking knives and clubs away from 'enemies'" with great "fervor."[45]

On one occasion, while fulfilling his duties as a hand-to-hand combat and bayonet instructor, Echohawk wrestled with a man significantly heavier than himself. During the match, Echohawk tore a fingernail and subsequently lost his grip. The two men were training on "hard ground," and when Echohawk dropped the man, he landed squarely on Echohawk's stomach, causing internal damage. Sergeant Phil Gover sent Echohawk to the hospital. When he arrived at the hospital on May 5, 1942, medical staff automatically placed him in a ward for venereal disease because the injury caused him to "drain fluids." Upset over his placement because he feared it could mar his service record or result in loss of pay, he had to convince the staff that his condition resulted only from physical trauma. His angry objections upset the staff, and he always wondered if that led to what he considered a poor diagnosis and quick dismissal. The hospital released him to duty on May 7.[46]

The 45th Division acquired a rugged and gritty reputation as it trained around the country, with several town newspapers noting the brawls and other mischief many of the Thunderbirds engaged in when off duty. As a partial solution to poor relations with locals and other units, some officers issued passes less freely, and, in some cases, official orders banned members of particular regiments from particular locales. For example, General Order No. 2, dated August 3, 1942, prohibited all personnel of the 179th RCT from entering a tavern in Teaticket, Massachusetts, called The Beer Barrel.[47] Although they got into trouble in neighboring towns, the Thunderbirds worked hard in training. During their time at Fort Devens, the 179th RCT spent two weeks at Camp Edwards, Massachusetts, training for amphibious landings and assault. The pace and requirements of training demanded a great deal from the men. To keep spirits up, the Pawnees in B Company regularly performed tribal dances for the rest of the division.[48]

One small incident somehow became front-page news in Fitchburg, Massachusetts. Not long after the 45th arrived at Fort Devens, it appeared that Echohawk and a friend, Private Harry Tall Chief, tried to purchase some items from a local merchant with silver dollars. Local merchants refused their silver dollars as legal tender. The article compared this to "the difficulties of the old days of trading posts and wampum."[49] The silver dollar incident turned out to be a stunt, a prank of

sorts, by a group of the Native American soldiers from the 45th Division. Some of Echohawk's friends from the 179th thought it would be a good joke to use his name as part of the gag since he had just landed himself in the hospital after training had gone awry the day before. Robert P. Rice, a Pawnee in B Company, later said that the gag started when a New England newspaper employee approached some of the men because he "wanted a story on Indian soldiers in the big city." Rice said the men invented a story about Indians never "accepting a change of money off the Military Post unless it were in silver dollars."[50]

In June 1942, the 45th Division organized a service detail. Echohawk, along with friends Philip Gover, Grant Gover, Floyd Rice, Ray Purrington, Gilbert Curtis, and Robert Stokes, were among the men from B Company of the 179th RCT sent to represent the 45th Infantry Division in a parade in New York on June 13, 1942.[51] Lieutenant General Hugh A. Drum, commanding general of the 1st Army and Eastern Defense Command, and Vice Admiral Adolphus Andrews, commandant of the Eastern Sea Frontier, led the New York at War Parade, as grand marshal and deputy grand marshal respectively. They marched at the head of 500,000 participants in an attempt to bolster American pride and support for the war effort. Organized by Grover Whalen, the chairman of the Mayor's Committee for Mobilization, the twelve-hour procession up New York's 5th Avenue from Washington Square included more than three hundred floats designed to "show war's causes," and showcase "the latest equipment of modern warfare."[52]

Echohawk and the other servicemen marched in the first of six divisions. Their group represented the regimental combat teams; other groups represented heavy and light tanks, antiaircraft artillery, parachute troops, armored engineer troops, and the other various components organized within the army and other military branches. Heavy equipment and military aircraft made appearances in the parade to show Americans what their tax money and war bonds could purchase and to demonstrate the might of the armed forces. Planners used themes of labor and industry in the parade to show how the entire nation mobilized for the war effort. An estimated 2.5 million people attended what planners touted as the largest parade ever in New York. Notable attendees included King George II of Greece, Premier Emmanuel Tsouderos, Norway's Crown Princess Martha, and President Manuel L. Quezon of the Philippines.[53]

Deliberately selecting American Indian soldiers for the parade promoted the image that Indian Affairs wished to produce among the

general American public—the perception of American Indians as American patriots. The image of Indian soldiers dutifully serving the nation looked good for the government because it showed that efforts to assimilate "reservation Indians into citizens capable of merging into mainstream society" had been successful. Other government offices used the image of American Indian soldiers as part of the propaganda machine to encourage Indian and non-Indian men alike to enlist in the war effort. Tom Holm, a Cherokee historian, wrote, "American Indians, in throwing themselves so unflinchingly into the war effort, seemed to validate the American sense of mission. Indians, after all, had been treated miserably; however, even they were totally committed to the crusade against the Axis."[54] The media also used the image because it sold well. Unfortunately, while the press seemed to promote positive views of American Indians, it also entrenched stereotypes of the "Indian warrior."[55] Although the stereotypes generally praised the instinctive abilities of Indian warriors and seemed positive, the belief that Native American soldiers somehow inherited superior martial abilities put them at risk of receiving more dangerous duties more frequently than others.

In early November, 1942, the 45th Division moved again. This time, it relocated to freezing Pine Camp, New York. Here, as at other posts, the troops found plenty of mischief, particularly when they got into town. The Thunderbirds did not limit their conflicts to scuffles with the locals; they fought among themselves often enough. Echohawk provided an excellent example when he said, "Those Oklahoma City guys would bad-mouth the small-town guys. We'd take our shirts off, step outside, and fists would fly. . . . Our Colonel said if we ever point these guys in the right direction, there'll be hell to pay."[56]

Then on January 11, 1943, at a time when some men feared they would never get into the fight, and others fretted over rumors of being shipped out to battle, the Thunderbirds transferred again, arriving by train at Camp Pickett, Virginia.[57] In late February, Colonel Robert B. Hutchins made an announcement to his officers that answered rumors about whether and when the division would see combat, without providing details. The division embarked on a ninety-five-day intensive training in amphibious operations in preparation for debarkation overseas. The men did not yet know their assigned destination. The army did not divulge that information until later. On March 16, 1943, the commanding general received their assignment. The army ordered the 45th Division to participate in "top secret" Operation Husky—the

invasion of Sicily.[58] As part of the rigorous ninety-five-day preparation, the troops underwent a fifteen-day training to prepare them for the difficulties of fighting in mountainous terrain. During mountain training, Echohawk and the 179th RCT became forest fire fighters for two days when an accidental blaze complicated their maneuvers.[59]

For two and a half years, the men of the 45th Infantry Division trained. Those who had believed they would return home after the first year had more than doubled that time in training and now faced the ship that would take them to an embattled Europe. On May 1, 1943, Colonel Hutchins finally informed his officers that the division was bound for North Africa, but the destination remained unknown to the rest of the men. Then on May 24, 1943, the 179th RCT received orders to report in secrecy to the staging area at Camp Patrick Henry, Virginia, along with the rest of the 45th Division. As of June 2, the army restricted all personnel to the area, and only headquarters could issue passes.[60] Orders for secrecy protected the transport. On June 4, the men traveled by rail to Hampton Roads, Virginia, to board their respective ships. Echohawk and the men of the 1st Battalion of the 179th RCT crossed the Atlantic on the flagship USS *Leonard Wood* along with their commander and his staff.[61] Although U-boats appeared in the vicinity of the convoy, the escorting destroyers and cruisers engaged them. Some of the men watched the distant pursuit of the U-boats from the rails of their ships, but overall the troops enjoyed an uneventful trip with calm seas.[62]

The convoy passed the Rock of Gibraltar on June 21 and arrived in North Africa the following day at Mers el Kébir's harbor near Oran, Algeria.[63] The men stayed aboard until just after midnight on June 25, waiting to participate in the Camberwell Exercise—a practice run of sorts for their first real amphibious assault. The troops had orders to leave the ships just as they would in an actual invasion. After the amphibious landing, they marched sixteen miles in wet shoes to a designated area in Algeria. The officers evaluated the execution of the mock assault as a poor performance. The landings proved messy, and the long march in wet shoes went little better.[64] The men continued to train in North Africa while they waited for further orders.

On July 5, the men shipped out once again. Unlike the many practice runs, this time the landing was their first real combat engagement. That night, the ranking officer of each ship opened the orders and shared them with the rest of the officers. Bound for Sicily, they had orders to land as a component of Lieutenant General George S. Patton's Seventh Army.[65] The massive convoy included nearly two thousand

vessels, with the army, navy, and air force coordinating with each other and with the British.[66] Although the ships got under way smoothly, the weather turned after July 8, creating rough seas. Early on the morning of July 10, 1943, Operation Husky, the invasion of Sicily, began. At that point, the assault was the largest amphibious operation in history.[67] The 179th RCT had orders to land two miles north of the town of Scoglitti, then capture Scoglitti, Vittoria, and Comiso Airfield.[68]

Dark skies and rough waters set the stage for chaotic landings. Boats crashed; some sank and some sustained damage beyond repair. Ramps lowered too early required men to make it through the water to shore. Men scrambled to reorient and organize themselves as units after platoons, companies, and battalions became separated or landed on the wrong beaches. Initial opposition proved lighter than anticipated. Training prevailed, the troops successfully took the beaches, and men eventually rejoined their assigned organizations. Echohawk's transport to shore carried his sapper team of forty men and a full-blood Choctaw medic they called "Medicine Man."[69] Echohawk provided the following account:

> I landed in the first wave in Sicily—Scoglitti, Sicily—when the allies landed from North Africa. I landed with an all-Indian unit. We Indians landed before the paratroopers, and landed before the British. We had to knock out pillboxes. I came to shore with 26 pounds of TNT. Another Pawnee had 40 pounds of TNT on his chest. We had 15-inch bayonets. We had 25 feet of Bangalore torpedoes. And the Navy set us off in the wrong place. My point here is . . . even though that I was very scared, which made me human, I lived up to those words; men of men, a warrior whose deeds are echoed.[70]

The 179th RCT, just like the other units, reorganized, cleared its assigned portion of the beach, and proceeded toward its next objective. For Echohawk and the 1st Battalion, this meant taking Scoglitti. The town was captured along with twenty-five enemy soldiers with little opposition.[71] As regimental historian Warren Munsell put it, the 1st Battalion practically "ran down the coast, sweeping aside road blocks, smashing pillboxes, wiping out machine gun nests, and dropping off squads to clean up isolated resistance pockets."[72] Mission accomplished.

The 3rd Battalion took Vittoria.[73] The Italians, for the most part, surrendered quickly. The Germans presented more staunch opposition, but proved far fewer in number than the Italian troops.

In his memoirs, Echohawk noted that in the first three days of fight-
ing, particularly the bitter clash around Comiso Airfield, he "destroyed
the enemy holding the strong point with a grenade and bayonet. I
counted coup like a Pawnee warrior."[74] The act of counting coup mat-
tered immensely to him. He aimed to fulfill the requirements of an
American GI, while working simultaneously to acquit himself as an
honorable Pawnee warrior.

Echohawk and the Pawnees with him became members of the Paw-
nee Warrior Society formed by soldiers in World War I, including
Frank Young Eagle and Walter Keys.[75] These men served with other
Pawnees in Company E, 1st Oklahoma Infantry during the National
Guard's campaign against Pancho Villa from 1916 to 1917. They then
served as members of C Company, 142nd Regiment, 36th Infantry Di-
vision and later transferred with other Pawnees to the 165th Infantry
Regiment of the 42nd Rainbow Division when they arrived in Europe
during World War I. As members of the 42nd, these young Pawnees
participated in every American offensive of the war.[76]

In Sicily, Echohawk served as one of the youngest sergeants in his
company. He told the story of rushing a two-story building occupied
by Germans with another Pawnee named Corporal Leading Fox. The
corporal went through a side window, and Echohawk went through a
door with his Thompson submachine gun. On this particular occasion,
Echohawk had been nominated for the job by his platoon sergeant,
Phil Gover, who told him, "Brummett, you go in that door, and we'll
back you up." Once at the door, Echohawk said he "let 20 rounds go."
As he remembered it, "We shot up the whole place like John Wayne
would do . . . and I recall we captured a German Captain and sent half
his German soldiers to the Happy Hunting Ground." Once inside with
the German force effectively neutralized, he saw a drawing board in
the middle of the floor. He recalled, "And on the floor was drawing
paper and pencils . . . and I picked up this drawing paper and I began
drawing. This was in July 1943, and ever since then I drew pictures of
the British, of the German soldiers, of the British Empire troops, and I
wrote on the back of a mess kit, using a mess kit for my easel, stand or
whatnot. And I made accounts of what we did."[77] Echohawk generally
carried his sketches in an empty cylinder-shaped, waterproof 60mm
mortar carton that fit inside his pack. When circumstances permit-
ted, he made two nearly identical sketches. He kept one for himself,
and gave the other to the subject of the sketch. Despite his attempts
to protect and keep his work, he lost much of it during the course of
the war.[78]

Echohawk spent much of his time on patrol. Lieutenant Colonel Glen Lyon noted that both Brummett Echohawk and Phil Gover "excelled in all their combat endeavors but were most proficient and proud of their inherent expertise in all types of patrolling. Consequently, they were called upon to lead such missions—much more than their fair share."[79] Historians recognize patrol service frequently assigned to American Indian soldiers based upon "inherent" or "natural" ability as indicative of commonly held and widely promoted stereotypes. Field commanders, regular GIs, and many American Indian soldiers embraced the stereotypes promoted by the media. Historian Tom Holm points out that most American Indian soldiers generally performed the same assignments as everyone else, but officers often selected them to perform particularly dangerous duties because of their ethnic background. Holm notes that stereotyping "gave Native Americans a degree of status in the military, but it also endangered their lives." Holm labels this type of thinking as "the Indian scout syndrome," and points specifically to the statistics for walking point, long-range reconnaissance, and killer teams.[80] It is important to note, however, that American Indian soldiers performed such duties both under orders and as volunteers.

Many of the patrols Echohawk led had official sanction, but not all. Confirming regular patrols with World War II army records often proves extremely difficult, if not impossible. Finding official documentation for rogue patrols becomes even more challenging. Often, the only corroboration possible comes from multiple primary sources containing similar claims. Such is the case with many of Echohawk's patrols. An interviewer connected with the 45th Infantry Division Museum once asked him about his duties as a forward scout. Echohawk responded: "We weren't exactly forward scouts. We were infantry all day and night. We did our own, you might say, own patrolling. We took the initiative all the time." Sworn statements from officers and men in his company support claims about his patrols behind enemy lines.[81]

After the war, Echohawk and men from his squad claimed that their patrol work made them the first Allies to reach the north coast of Sicily. Although this remains unclear in the official record, numerous depositions and signed affidavits relate the same story. As often happened, an all-Indian unit went out on patrol. According to accounts, the patrol went over the mountains using game trails and light from the night sky. They alternately ran and walked to make good time while protected by the darkness. When Echohawk told the story, in his typical fashion, he incorporated a bit of humor, which reflected friendly intertribal rivalry employed to keep spirits up among his men.[82] He said,

"We had a Cheyenne with us, and he said 'Cheyennes can run down a horse,' and we said, 'Pawnees can run down six horses, and after that we chase women.'"[83]

When the troops reached the coast, Echohawk recalled, "The Great Spirit was working for these Indians, for laying right there at the coast was a hand car and the Italians had two bicycles rigged up to pedal the hand car." Echohawk broke up the patrol. He left part of his men behind near the rail station and took a group of his Indian soldiers on the handcar. His group headed for a nearby town. Outside the town, still occupied by Germans, he instructed his men to pull their pant legs out of their canvas leggings, to turn their M-1 rifles upside down, and to pull mosquito netting over their helmets to make them look more like the German camouflage version. He then instructed his men to enter the town. He said, "I told the guys, 'Walk like we own the town,' so we just walked right on by."[84]

A large German force occupied the town in addition to Italian troops preparing to move out as they extracted their forces from Sicily. As Echohawk and his men strolled through town, a German officer spotted them.[85] Echohawk said, "He looked at our feet and he looked at my chevrons, and he saw the . . . gold thunderbird on a red diamond. This German couldn't believe his eyes, and he touched the driver in this little Volkswagen Mickey Mouse car. He told him to go around the block."[86] Luckily for Echohawk and his men, the German officer had difficulty turning around quickly because the jeep was part of a convoy.[87]

Before the jeep could return, Echohawk and his men slipped into a movie theater.[88] Once inside, the men simply informed the theater attendant that the Americans had taken the town and handed him American invasion money. They stayed in the theater long enough to watch a film more than once while they hid out hoping to avoid the searching Germans outside. When they felt they were in the clear, the small group of American soldiers made their way to the town square, where they reportedly pulled down the Nazi flag and replaced it with a wine bottle containing a note that read: "This town captured by Pawnee Indians." After this, they headed out of town, pumping the handcar. They received fire as they crossed the bay on the edge of town but kept pumping their way back to their platoon. The patrol had ventured approximately sixteen miles behind enemy lines.[89] Even under fire on their way back to the rest of the platoon, the men sang celebratory stomp dance songs.[90] As he recounted the event in later years, Echohawk wrote, "We always said that Indians have more fun than anyone."[91]

In a similar escapade, Echohawk took a patrol about ten miles deep into enemy territory with the stated mission to locate panzer concentrations in the vicinity of San Mauro.[92] There the patrol entered the town late at night and hid out in a cathedral next to a German headquarters station. They gathered intelligence but did not limit their activities to that alone. "We walked boldly among enemy soldiers in the dark, observing armor and troop movements," Echohawk recalled. His patrol then sneaked into a dark house, where they found slumbering German soldiers whose bread and wine the Americans promptly confiscated for their own packs. "Before leaving," he wrote, "we took one of our grenades, pulled the pin, held the safety lever then stuffed it into one of their field packs. The tight squeeze secures the safety lever until the contents of the pack are removed. Our calling card."[93] According to Sergeant Robert M. Stokes, who served with Echohawk, the men biked about four miles to the next town the following day, and "de-horned" a mined bridge along the way. A New Yorker named Arthur La Carte interpreted between Echohawk and a Catholic priest, "who was surprised to see Americans." The priest, according to Stokes, told them about the Germans in the area. They returned to Allied lines with the information gathered.[94]

On July 31, 1943, the 3rd Division relieved the 179th RCT, and soon the 45th Division, then located outside of San Stephano, withdrew from the fight. Withdrawal from the front lines ended Operation Husky for the 45th Infantry Division.[95] The 179th rested near Cefalu, Sicily. They had a chance to bathe, swim, eat real meals, and attempt to regain their strength. Bob Hope even put on an outdoor show for them.[96] At Campofelice, Hope performed along with Francis Langford and Jack Pepper. "Sitting among a sea of GI's, in a hot sun and on a barren hillside, I could not help but admire Bob Hope," Echohawk wrote. "It sure felt good to laugh again."[97]

On June 27, 1943, only a short while after the Bob Hope performance, General Patton addressed the men of the 45th Infantry Division in a now-famous speech. He gave the men of this National Guard unit high praise. Echohawk sat in the front row on this occasion, though he recalled that he could only understand some of the speech, as Patton's voice was high-pitched, making him hard to hear clearly. He did catch the part where the General said of the 45th Division, "Born at sea and baptized in blood . . . your fame shall never die." He then heard one of the Pawnee sergeants follow this statement with "*Now, kudoo rah chitrah* [Agreed, now all is good]." Echohawk explained the statement as "an old-time Pawnee phrase used after a War Chief has spoken in

council." As Patton left the stand, an officer pointed out Echohawk and some of the other American Indians in the unit, and Patton responded something to the effect of "You men have a proud heritage." Echohawk thought to himself, "That we have; for here history repeats itself." As a young man, Echohawk recognized the historical significance of this encounter. He saw a link between himself and the men with him and the Pawnee men who participated in the Oklahoma and Texas National Guard Divisions during Pershing's expedition into Mexico after Pancho Villa in 1916. In that same expedition with these Pawnee soldiers was George S. Patton, Jr., then only a young lieutenant with a bright future.[98]

Orders moved the 45th Division to a new, less inviting location near San Nicolo L'Arena on August 20 while the troops continued to rest.[99] Then the army detached the Thunderbirds from General George S. Patton's Seventh Army and reassigned them to Lieutenant General Mark W. Clark's Fifth Army under the VI Corps.[100] Why? Another amphibious operation. Only this time, the army slated a portion of the division to stay behind. The 179th RCT joined two battalions from the 157th (another Thunderbird regiment) and the rest of the 45th Division's artillery battalions. The remainder of the 45th stayed in Sicily for the time being.

On September 7, 1943, the troops shipped out for the next invasion. Once it was under way, as had been the case when leaving North Africa, orders were unveiled. Destination: Italy, to participate in Operation Avalanche. Orders for Sergeant Echohawk and the 179th RCT depended on the situation created by the initial assault. The 179th had orders to serve as the Fifth Army's "floating reserve," to be dispatched to whichever area encountered the strongest resistance.[101]

During Operation Avalanche, the Allied amphibious invasion at Salerno, Italy, the elements of the 45th Division participating in the invasion did not hit the beaches first. Instead, the 36th U.S. Division along with the 46th and 56th British Divisions and special commando and ranger units made the initial landing and began the fight ashore.[102] This wave of the Italian invasion planned to land at Salerno, approximately forty miles south of the city of Naples, and work its way north to seize the Bay of Naples to secure a supply line for Allied troops in the Italian campaign.[103] The Sicilian invasion was preceded by an artillery barrage from the destroyers to help wear down resistance and pave the way for the troops coming ashore. The ships provided no such preliminary assistance at Salerno. The Germans, already alert, watched for their arrival. The Salerno landing had to be done quickly and quietly to

avoid divulging the location of the landing troops. The troops would receive naval support only after the invasion force made it ashore.[104]

September 10, 1943, two months after Operation Husky's amphibious assault, the troops of the 179th RCT aimed for a beach near Salerno.[105] They anticipated strong German resistance. The 36th Division had sustained over five hundred casualties on its first day. As in Sicily, most soldiers experienced chaotic landings. Under attack from the air and from the shore while landing, the 179th RCT suffered casualties before it ever reached the beach. Nevertheless, Echohawk's B Company all made it safely ashore at "Beach Blue" south of Paestum, Italy.[106] When Echohawk made it to shore, he had only his rifle and helmet. He had to discard his equipment and sketch paper to make it out of the deep surf.[107] Echohawk recalled that while the regimental command attempted to organize on the beach, he heard laughter from the Indian soldiers. "The laughter seems out of place in this life and death situation; such as it is, I remember it." He soon learned the source of amusement. "Upon hitting the beach . . . a Cheyenne Indian charged from the surf carrying a lance decked with Sicilian chicken feathers. He drove the lance into the sand, gave a war cry, then shouted 'Christopher Columbus, we are here!'" Clearly, he intended the gesture for the Native American component of the landing forces—a humorous stunt aimed at easing the tension and producing smiles and laughter.[108] As it finished organizing on the beach, the 179th received orders to march and attack northeast along the Sele River and to take Ponte Sele and the high ground to the northeast. The troops had an assignment to take and hold the hills east of the town of Eboli.[109] This plan put Echohawk and the rest of the regimental combat team in an extremely precarious position. Because of a quick and effective German response to their presence, they became cut off, bound on either side by two rivers, completely surrounded and left unsupported and under fire from two panzer divisions near Persano.[110] The 179th RCT endured heavy shelling by the German forces, and concussion ruptured Echohawk's eardrums.[111] According to historian Flint Whitlock, "Rarely does one hear about the other, major effect of an artillery explosion: concussion. When a steel container packed with several pounds of explosives detonates within yards of a human being who otherwise may be shielded from the blast and fragments by being below ground or behind a stout wall, the effect of the concussion is liable to cause the person's lungs to literally burst inside the chest."[112]

Some of the tanks maneuvered to the rear of the 179th, ravaging C Company and placing B Company in great peril. Echohawk's lifelong

friend and fellow member of the 179th, Charles Johnson, reported: "All at once, we heard a whole bunch of tanks. 'C' Company, in reserve, had sat down in the street and taken their packs off. About eight or nine tanks came up suddenly with ten or twelve guys on each tank, and just annihilated the whole company just laying there in the street behind us. And then they kept running around us."[113] As the tanks continued to circle the remainder of the 179th RCT, one of Echohawk's fellow Pawnee sergeants, Floyd "Flop" Rice, remarked, "Now I know how them white guys felt when we were circling the wagons."[114] B Company stayed in the fight with its antitank bazookas.

The battle earned the appellation of the "Persano Trap."[115] The men fought long and hard to get out. Echohawk wrote that the fighting at Persano became truly chaotic. At one point when the 179th fell back, its battalion commander specifically called for the Indians to attack Persano, which they did—with bayonets. The troops recaptured the town, but without armored support, German tanks and infantry recaptured Persano. Exhausted, Echohawk and the men of the 179th tried to catch their breath. Then one of the Indian sergeants rallied the men by saying, "They are tough. But tough enemies make us better warriors!"[116] The 1st Battalion made another bayonet charge. Echohawk recalled that as the troops mounted this charge, the war cries of numerous tribes sounded throughout the ranks. Their charge took Persano again. The men fought in a "building to building then room to room" contest with the Germans.[117]

Details of the battle for Persano made an indelible impression on Echohawk's mind. By now, he had seen a good share of combat, but Persano held some particularly disturbing memories. He recalled the approach to Persano, when B Company had to pass through the carnage of C Company: "Trees along the road have been hit by shell fire. Tank tracks swerve in and out of the ditches. In the ditches are C Company dead, run over by forty ton tanks. Some bound with bandages. Perhaps, helplessly wounded. Crushed. Gruesome sight." Echohawk saw the remains of a second lieutenant who had been blown apart and then crushed by a tank. He recognized the lieutenant as a friend from demolition school at Cape Cod. Then he saw a dead Native American soldier. He knew the man—a Comanche from C Company. The Comanche had been soaked with gasoline—his hair still burned. A bloody knife remained gripped in his hand. The destruction along the approach to Persano proved very unsettling for Echohawk and the men in his company. He continued to recognize numerous corpses along the route as friends.[118]

As it entered Persano, B Company came upon another appalling scene. Two dead men occupied a shell hole. Echohawk knew both of them—a Choctaw named Dan Quick Bear and a medic named Benjamin Sweeny (also part Choctaw). Their positions in the shell hole evidenced the manner of their death. Sweeny wore an armband and steel helmet marked with the Red Cross and had gauze and sulfa powder in his hands. He had clearly been treating Quick Bear, who had a bandage around his chest and no helmet. Echohawk described the medic's helmet as being "riddled with bullet holes." As for the patient, he wrote, "The top of his head and chest show that he was hit by automatic fire. Both men were killed at 'powder burn' range. Killing a Medical Aid man is bad. Killing a wounded man is worse—especially an Indian. We are alive with hate. We wade into them. . . . From nearby: an Indian war cry and semi-automatic M1 fire. . . . Above the rumble of the Panzers, I hear Germans shouting 'Hands up, Joe! Hands up!' A Pawnee answers, 'Kits-pe-oos!' (shit). There is a hot exchange of gunfire. Fighting becomes savage."[119]

At this point, Echohawk again recalled hearing the various tribal war cries rising from the fray. The German tanks fell back, and B Company took advantage of the opportunity to regroup, but the fight continued when the Germans counterattacked.[120] Then the din stalled out for a time. B Company captured a number of German prisoners, but the soldiers captured by Echohawk's men appeared to be fresh, not weary, troops. He described them as arrogant and inclined to irritate their American captors while they awaited the rescue that they believed would come soon. One of the Indian sergeants, annoyed with the prisoners, informed the Germans that their captors were "Indians—American Indians." After a moment, one of the German captives registered the message and passed it along. The prisoners now gaped at their captors with a new sense of alarm. The message had the desired effect.[121]

Some of the men decided to play a mind game with the Germans. Echohawk described it as off the cuff, but nearly scripted. In an attempt to frighten the Germans who had been so smug only moments before, one of the men, a Comanche, let out a "blood curdling yell," drew his knife, and proceeded as if about to scalp one of the prisoners. Another Indian sergeant "rescued" the intended victim, exclaiming, "No! No! No scalp um!" Echohawk recalled that a corporal then entered into the ruse as he helped to restrain the wild Comanche. A brawl between the American Indian actors ensued while the German screamed hysterically and clung to his hair. The other captives watched in terror. At length, the soldiers brought the Comanche assailant under control.[122]

"With no trace of arrogance," Echohawk wrote, "these soldiers of 'The Master Race' lace their hands behind their heads, sit down and huddle wide-eyed. One of them bleats, 'Geneva Convention. Geneva Convention.'" The American soldiers had almost finished with their production, but they let two military policemen—a Sioux and a Pawnee—escorting the prisoners in on the fun before parting ways.[123] Echohawk believed his unit's composition affected German morale because German prisoners reported their fears of being scalped.[124]

In a similar situation, another unit in southern Italy struggled to maintain order and discipline in a prisoner of war camp for German and Italian soldiers. To solve their problem, they requested a brief transfer of a small contingent of Native American soldiers to the containment area. The Indian soldiers supposedly convened with an officer, assessed the situation, and agreed to his plan. They spoke in their tribal dialects, glared at prisoners, and rubbed prisoners' hair as if considering taking it for themselves. They remained stationed at the camp for a short time, and disruptive behavior on the part of the prisoners diminished considerably.[125]

The 45th Division's reputation preceded them. Known in the states and in Europe as the "Cowboy and Indian" Division, their enemies did not take lightly the possibility of a confrontation with such a force. Back in the states, New York's *Watertown Times* published an article that talked about the "capers" of the 45th in New England before they had shipped out. The article read in part: "They were fighting men. Woe to anyone who fell in their path. Now if it is true they are in Sicily, they will find conditions to their liking. If Gen. Eisenhower wants Catania taken, let him shove the 45th into battle. They will deliver any town, mussed up perhaps, but thoroughly conquered." Those German prisoners believed their captors posed a very real threat. Field Marshal Albert Kesserling said, "The 45th is one of the two best divisions I encountered." Americans speculated the other division he referenced was the 36th out of Texas.[126]

Hitler himself reportedly admired the martial tradition of American Indian tribes with warrior societies. In the post–World War I era, he purportedly proclaimed that "The most dangerous of all American soldiers in the Indian. . . . He is an army within himself. He is the one American soldier Germany must fear." Much like the American press, which adulated the martial reputation of Native Americans, the German press "combined appreciation of American Indian culture with an awareness of Indians' fighting skills in a modern context."[127] Apparently, General Karl von Prucht's assessment of American Indian

soldiers' performance in World War I proved similar. He reportedly concurred with Hitler that the Indians proved the most dangerous American soldiers, saying the Indian "is an army within himself."[128]

Brummett Echohawk took his heritage and did his best to use it well as a soldier preparing for and fighting in World War II. He felt a strong sense of patriotism as an American and a strong connection to his Pawnee heritage and felt no need to choose between the two. By serving honorably in the U.S. Army, Echohawk and his brothers could become warriors among the Pawnee people. He saw value in his family and tribal martial traditions and felt that American Indian soldiers had much to contribute to the military.

As a young soldier, Echohawk could see his personal connection to Pawnee and family history. His grandfather and father had worn the uniforms of the United States. The Pawnee Scouts had served as part of the 45th Division during the conflict with Pancho Villa. Patton had also served with the Pawnee Scouts in the expedition against Pancho Villa and had spoken to Echohawk and his friends of the value of their service in Sicily. Echohawk and other Pawnee soldiers joined a warrior society brought to life by Pawnee soldiers in World War I. Echohawk also made himself a part of the history that unfolded in World War II through his fighting efforts and also though his artwork.

Stereotypes of American Indians as warriors became rampant during the World War II era, and the media used men like Brummett Echohawk who excelled in their military training to promote the stereotype and to garner general support for the war. Echohawk's participation in the New York parade and Major Gilstrap's description of him as a hand-to-hand-combat expert in the nationally syndicated article about the virtues of American Indian soldiers in the U.S. Army offer examples of how the media drew Echohawk into the larger phenomenon generated by government officials and the press. Generally, he embraced the idea of American Indians as exceptional warriors. He willingly went out on long-range patrols behind enemy lines and played on German fears of Indian soldiers. Although he served in a predominately Indian unit, per U.S. policy, Echohawk also served among non-Indian soldiers. He accepted that, as an individual, he served as a representative for American Indians. As he once said, "Whether you know it or not, you as an Indian are an image. You always will be."[129]

By joining the National Guard and then serving as a member of the 45th Infantry Division, Brummett Echohawk knew he could continue the military legacy of the Echo Hawk family and the Pawnee Nation. He also had the opportunity to prove himself a warrior in the eyes of

his family and his people. When he became a soldier, he took on the mantle of those who had gone before as warriors, scouts, and soldiers of the United States. His Uncle George used to explain to his boys that going to war meant that they could come home and hold their heads up. No one could talk down to them or speak poorly of them, because they had proven themselves by going into battle.[130] Echohawk also had the opportunity to help show the rest of the nation, and Europe, what American Indians could do—what a grandson of army scout Echo Hawk could do. He had an intense desire to live up to the family name.[131] Brummett Echohawk's service record provided him with a sense of accomplishment for the rest of his life. In his mind, the opportunity to fight in World War II meant he had a chance to truly become Chaticks-si-Chaticks and to represent his people and his country.

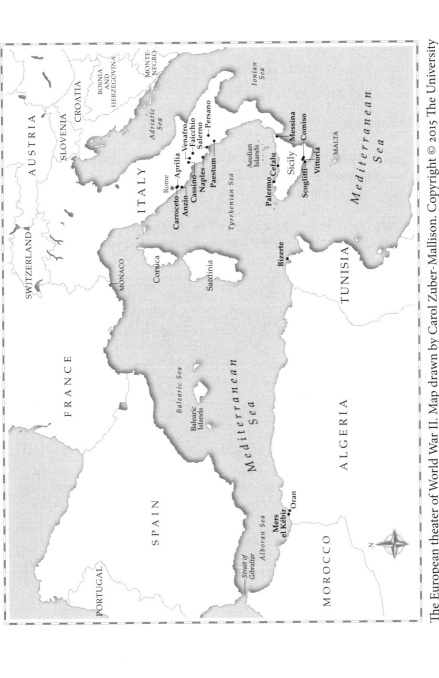

The European theater of World War II. Map drawn by Carol Zuber-Mallison. Copyright © 2015 The University of Oklahoma Press.

An American Soldier, a Pawnee Warrior

If I had it to do over again, I'd fight even harder. Those who think patriotism is old hat should try a steel helmet.
—Brummett Echohawk

Having trained for nearly three years in the United States as part of the 45th Infantry Division, and having made it through North Africa, Sicily, and southern Italy, Brummett Echohawk became a seasoned soldier. Although he had been injured numerous times in battle, the damage done proved insufficient to make him leave his unit on the front lines. A severe concussion affected his hearing and caused internal damage, but he persisted. His sense of duty, his determination to prove himself a true warrior, his camaraderie with the other soldiers, and his faith in the Creator, came together to bolster him throughout the war. All the while, he continued sketching—making a record of what transpired.

During Operation Avalanche, in the Salerno sector at Persano, Italy, Chauncey Matlock and Brummett Echohawk led their respective platoons to storm a building during street fighting. In the process of taking one of the buildings and capturing the Germans inside, they inadvertently rescued an American from Oklahoma City named Humble who had previously been captured.[1] Pleased to see the Pawnee rescuers, Humble told them that he had given the Germans some laxatives under the guise of sharing chocolate. He also claimed to have told his captors that his division was "a wild bunch of cowboys and Indi'ns," warning them that his unit would get them.[2]

Echohawk and some friends entered another building, where they encountered a woman in an upstairs room overlooking a street where they had just been hit by an artillery barrage. The woman spoke English and tried to engage Sergeant Echohawk, Sergeant Grant Gover (Phil Gover's brother), and Sergeant Louis Eves in conversation. Echohawk recalled that although the woman acted friendly, the men instinctively

distrusted her. When she inquired about their numbers and whether they had tanks, the men chose not to answer. The woman claimed that the man in the room with her was her deaf father, but the Americans remained suspicious. "*Chust-tit ta-kah kiwuh-kuh*" (The old white woman is a fox)," Grant commented to Echohawk without looking over. "*Ah-hu, rah ruk, tut,*' (Yes, I noticed)," he answered.[3] Fortunately, the Pawnee language allowed them to communicate openly despite the woman's understanding of English.

After taking a look around the room, Grant pulled out a coin and flipped it onto the hardwood floor. As he suspected, the "deaf" man turned in reaction to the sound. Upon closer examination, Gover found a cabinet and opened it, "revealing a microphone, radio transmitter and wires leading to the window." The woman's window provided a perfect vantage of the street, and they believed she had been directing the German artillery fire down on their unit. Gover destroyed the radio, and they sent the woman to the battalion for further questioning. According to Chauncey Matlock, friend and fellow member of the 179th RCT, the room where they had discovered the woman was hit by an 88 mm (German antiaircraft and antitank artillery round) and destroyed only minutes after they found her. Matlock recalled, "The three Sergeants emerged from the rubble with white plaster dust on them. None suffered wounds. All three Sergeants were Pawnee Indians from Pawnee [Oklahoma]. I am certain that this close hit made Echohawk's condition [the effects of concussion, including hearing loss] worse."[4]

At the Salerno beachhead, Echohawk's squad held a trail near the Sele River. British tanks passed through their position, then returned. Echohawk indicated that his men, exhausted from relentless fighting since their landing, failed to see the British return, so when minutes later, eight or nine more tanks came up the trail, they did not recognize them as German tanks until they came close enough to see the black crosses on them. They had to act quickly.[5]

Echohawk stood up and shot the man standing in the turret of the lead tank. This gave the Germans pause. They pulled back briefly. Accounts indicate that the German he shot wore earphones, so he may have been a tank commander. He had not seen the Americans in the ravine full of cactus until Echohawk stood to take his shot. At his word, most of Echohawk's men beat a quick retreat in search of locations offering better cover, as the ravine offered none. He and four others remained in the ditch. One of the men, Hugh Cox, had an antitank grenade launcher with a single round. When the German tanks came

again, Cox and Echohawk held a position at the head of the trail and hit the tank at close range. The German tanks withdrew once more.[6]

Echohawk quickly sent Alfred R. Wentzel (a transfer from an artillery unit) back with instructions for artillery fire, since they had no radio. During this time, the German forces concentrated 88 mm antiaircraft and antitank artillery fire on Echohawk and his men. Although Wentzel reported the German tanks, the officer to whom he reported "did nothing." One American tank destroyer did come up to help, but heavy German fire drove it back.[7]

Still trying to hold off the German tank advance, Echohawk remembered seeing a burned bridge on the Sele River with dead American engineers lying nearby with antitank grenades. He ran to the bridge, stuffed his shirt full of the grenades, and returned to where Cox could fire on the tanks again. They held the only approach through the ravines, which meant the tanks had to cross in single file before they could attack the American forces behind Echohawk's men. Benjamin B. Bisbee and Gilbert Curtis assisted Hugh Cox and Brummett Echohawk. Bisbee and Echohawk crawled to a knoll in a forward location to the right of the trail to monitor the German tank activity. Curtis covered the others with his M1 rifle. These four men then came under American artillery fire—a 105 mm howitzer barrage. They continued to move closer to the German tanks, hoping to get a better position for the antitank grenades.[8]

Then, about half a mile away, a larger German tank appeared on a hill next to a stone house. The men suspected the tank on the hill to be a German Tiger tank because it was significantly bigger than those to their front. Echohawk ordered his men to form a chain and spread out so they could relay directions for artillery fire. The subsequent fire caused the larger tank to withdraw.[9] Once this tank retreated, the men came under .50-caliber machine-gun fire from an American tank destroyer as they tried to return to their own lines. The American gunner mistook them for panzer infantry. Echohawk recalled that as they attempted to make it back, "everyone was screaming 'cease fire!'" as he waved and pointed at his chevron hoping someone with binoculars would see.[10] The German 88 mm fire continued while the American .50-caliber bombarded them. The American gunner finally noticed the Thunderbird chevrons and ceased his assault.

The concussion Echohawk suffered from the heavy fire further aggravated his hearing problems.[11] In fact, his first scout, Gilbert Curtis, noted that at Faicchio, Italy, they fought in heavy timber and used "a lot of Indian sign talk," but at one point, Echohawk had "crawled to me,

face to face, nearly. This was unusual, for under fire we never 'bunch up.'" Curtis attributed this unusual behavior to Echohawk's damaged hearing.[12]

Allied forces captured and surrendered the town of Persano three different times before they truly gained control. After the third Allied retreat, two panzer divisions attacked the 179th RCT. Echohawk and his men found themselves in a position with only two alternatives: be overrun or stop the tanks. "This is when two riflemen [Echohawk and Curtis] stopped 9 tanks and prevented the beachhead from being over-run," recalled their company commander, Colonel Glenn Lyon. "The troops give primary credit to Echohawk and are of the opinion he should be awarded the nation's highest honor. It is my opinion this was service above & beyond the call of duty and I recommend Sgt. Brummett Echohawk be considered for the Medal of Honor."[13]

Day and night, the Germans kept pressure on Echohawk and his compatriots in the 1st Battalion. Finally, on September 12, 1943, they received some relief as other elements of the 45th and additional U.S. forces moved in to assist. Fighting intensified again on September 12 and continued through the night. Pressure became so intense on the beachhead that navy ships went on standby in case evacuation became necessary. General Troy H. Middleton, who led the elements of the 45th in Operation Avalanche, feared evacuation would mean death for all. He reportedly responded to the suggestion by saying, "Put food and ammunition behind the 45th. We are going to stay here!" His statement reputedly proved to be a defining moment—a turning point in the fight for the Salerno beachhead.[14]

On September 14, the Germans made their most powerful push against the Allies: an attempt to drive them back into the sea. As the 179th fought to maintain its precarious hold on the beachhead and its position across the Sele River from German forces, American navy ships approached and opened fire. Most, if not all, of the men suffered from concussions produced by the navy barrage.[15]

Echohawk indicated throughout his life that prior to his combat experiences he had been familiar with religion but had not been particularly spiritually inclined. Combat changed that. He had a new sense of the fragility of life and the spiritual balance of his life and the world around him. As an adult, he found ways to incorporate Pawnee religious beliefs and practices with Christianity in a way that worked well for him. Under the most trying circumstances, his Pawnee religious heritage and his Christian instruction came to play an important role in his life. Echohawk described spending a terrible night in a foxhole,

then peering out at dawn to see the toll the night's fighting had taken on the landscape around him. As he took in the devastation, Echohawk noticed the morning star over the mountains to the east. He wrote that among the Pawnee people, "'Opirit,' the morning star," symbolized new life. "'Opirit,' a messenger from God, signals the coming of a new day." He responded that morning on the battlefield by holding up a hand to "receive God's blessing," and "give thanks for life; for I truly appreciate life now."[16]

Historians have credited World War II with increased religious activity among American Indians. For some, increased contact with Christian practices brought them closer to Christianity. For others, ceremonies for safety or purification increased faith in the ways of their traditional people. Prayer became common practice among many American Indian soldiers, even when it seemed that no immediate danger loomed. Some explained that they prayed to give thanks and to receive guidance. Their prayers and ceremonies drew the attention of their fellow soldiers. On occasion, the Native soldiers performed ceremonies for their entire units.[17] Reportedly, the Indians in Echohawk's division performed a ceremonial "war dance" for the division at Fort Patrick Henry before departing for North Africa.[18]

As a soldier, Echohawk calculated risk and took some chances. He once explained to a friend that he may have calculated risks somewhat differently than others because of a certain faith he had in an old Pawnee belief. Once the men of the 45th Division knew they were going to war, Echohawk and some friends apparently visited one of their tribe's spiritual figures, who told them that of the group, one would be killed in war. The others would return home. According to Brummett's account (as related by a close friend), one of the friends died almost immediately after landing in Sicily. Echohawk understood his friend's death as an indication that he would make it home. Michael Gonzales, friend and fellow military man, said, "In Brummett's mind, this was a pass. 'Okay, one of the four of us is gone; I'm going to go home. I'm not going to be killed in this war. I can do anything I want and get away with it.'" Echohawk later realized that he had not been promised he "wouldn't get all shot to pieces," only that he would not be killed.[19]

In addition to the experience with his friends, Echohawk considered the Pawnee legend that "one Pawnee warrior will die on the Warpath for every major Pawnee battle." Echohawk referred back to the experiences of the Pawnee Scouts and of Pollock, who had died of illness related to his service in the Spanish-American War. He noted that in the Mexican Border expedition, the Pawnees did *not* lose one man but

suggested that this was only because they did "no real fighting there." In World War I, a Pawnee died in action from poison gas.[20]

Echohawk said they did not view the One Warrior legend as a curse or anything negative. He compared it to a large tree falling in a forest to provide for saplings. He wrote: "Death is part of creation. One life goes that another may live. The Old Ones tell us this. . . . No life is really wasted. We accept this." Echohawk took chances on occasion because he believed he could make a difference without getting killed. He fully intended to live up to the standards of Chaticks-si-Chaticks. He explained, "In the modern world we sort of joked about it—who would be the man? All of us were hit time and again, and we lost one man."[21]

Under heavy artillery fire, Echohawk and the 179th RCT went toe-to-toe with the 16th Panzer Division and prevailed. By that night, it became clear the crux of the German offensive had been destroyed.[22] When the 36th Division relieved the 179th RCT, the 179th counted 38 dead, 121 missing, and 363 wounded and evacuated, but the Allies had secured the beaches of Salerno.[23] Thus the campaign for southern Italy began. Much difficulty lay ahead in the Italian mountains. The Allied forces pursued the Axis forces under the most perilous conditions. The Germans subjected them to sniping, booby traps, mines, precipitous paths (when paths existed at all), burned bridges, strafing and bombing from the air, and pockets of enemy resistance left behind to hamper them. The Allied forces also had to deal with inclement weather, which made the mountainous terrain even more dangerous.

Echohawk often took patrols out. In fact, Medal of Honor recipient, friend, and fellow member of the 45th, Ernest Childers, ran into him one night during the invasion when both men had been sent out on reconnaissance patrols in enemy territory. The men stopped and shared information before moving on.[24] Men on such patrols frequently encountered one another in the night, and American Indian soldiers commonly led or composed significant portions of those patrols. Echohawk recalled, "At night we Indians patrol and prowl behind the German lines. By day we slug it out for the next objective. We do not always count coup."[25]

Echohawk and his comrades later told a story about a night patrol through German lines. They made it to their objective without incident. On their return, they stopped short of their lines for a brief rest. Comfortably close to their own positions, they put down their weapons and relaxed against a stone wall. Suddenly, the men heard voices speaking German coming along the other side of the wall as a German patrol returned to its lines along the same route. Most of the group had

the automatic impulse to lie still and silent and wait for the Germans to pass because the enemy had caught them off guard and they did not have their weapons ready. "That wouldn't have suited Brummett one little bit," said his friend, Michael Gonzales,

> so [Echohawk] leaps up, and he whips this Bowie knife out, and he lets out a war whoop. He leaps over this wall and charges into the Germans. They scattered. . . . He keyed in on this one German soldier who's carrying a machine gun. Machine guns are heavy. He figured this would slow this guy down. They're running down a slight incline, and the guy's got this machine gun over his shoulder as he's running, and he glances over his shoulder, and he can see Brummett. . . . He saw a red Indian chasing him. He threw the machine gun down to get better speed. Brummett caught him anyway and dispatched him post haste.[26]

Echohawk then ran back to the wall where his men still stood. Many of the startled Germans had dropped equipment near the wall before beating a hasty retreat. Echohawk's sudden action had surprised his own men too. In the time that it took for them to register what had happened, stand up, and ready their weapons, most of the Germans had exited the area, and Echohawk had already embarked in hot pursuit of the German fleeing down the hill. One of his friends later reported that Echohawk's actions that night "scared the hell out of me." He went on to say, "I don't know why. I should have known Brummett was going to do it." Once again, Echohawk caused his friends to wonder why he would take such risks, and once again, his belief that he would make it home had influenced his decisions.[27]

As elements of the 45th Infantry Division advanced on Faicchio, Italy, in October 1943, Echohawk suffered a severe concussion from a German mortar shell on October 10. With his platoon in the lead, and his squad on point, the men of B Company moved through a heavily wooded area with vineyards. They received machine-gun fire from the left front and quickly took cover. Echohawk led, followed by Privates Gilbert Curtis, Gilbert Cervantes, and Ray Purrington. Then came the B.A.R. man and the rest of the squad.[28] Curtis later noted, "As First Scout, sometimes, I led. At times Purrington led. Most of the time Echohawk led, especially when the shooting started."[29] They crawled up a rise—a farmer's ploughed furrow. Upon hearing mortars, they lay low to the ground, and soon German mortars exploded around them from over three hundred yards away. A vineyard, roughly two

hundred yards wide, lay approximately seventy-five yards in front of them. Echohawk moved ahead in hopes of finding a place for his squad to cross. As he made his way down the slope, he took cover along the foundation of an old house with tall grass helping to conceal the wall. He engaged in small-arms fire with men in the woods before German 88s opened fire on his unit. Echohawk returned and reported that they could cross the vineyards to the woods. He felt they would be protected by a terraced slope which they could use as cover to move on the German forces.[30] Echohawk described the incident:

> I ran, zig zagging. I had to slow and stoop under grapevines strung on a wire and fence posts. The handle of the bayonet on my pack snagged a strand of wire. It yanked me back. Then a mortar shell exploded in front of me. I caught a blast of concussion in the face. I fell backward. The rest was reaction—I ran back, thinking I was hit. I veered left, not wanting to draw fire on the rest of the Squad. I made my way to a low eroded wall with brush. I laid there with my ears ringing and stomach "rattling."[31]

Echohawk's platoon sergeant reported: "I saw him hit. . . . I saw Echohawk running to cross the vineyards. His men attempted to follow. A shell exploded close to Echohawk. It looked like it hit him. He made it back to a low wall and brush at my left. He laid down, mud-splattered."[32] The mortar had dropped "at a high angle" and submerged in the mud before it exploded. In fact, Echohawk later attributed his ability to walk away, and likely his survival, to the mud. He believed that if the ground had been dry, the hard pieces of earth would surely have penetrated and killed him. A medic named Lindsay checked Echohawk over. Phil Gover assisted. Despite being hit by strong concussion, the medic did not "tag" him because he had no visible wounds.[33] Echohawk stated simply, "We were short-handed. I kept going."[34]

Echohawk's friend Sergeant Charles "Hook" Johnson got hit the same day in the same area. A German machine gun fired on his platoon as they patrolled the area near the vineyards outside of Faicchio. The first machine gun burst hit him. He made it back, and a medic named Boling attended to him. While Boling worked, Johnson looked over and saw Echohawk. Johnson speculated that the same German machine gun that hit him had turned its fire on Echohawk's men.[35]

Echohawk reported that the violent concussion hit caused him to drain fluids, aggravated his hearing, and did a real number on his

stomach. Men around him reported concerns for his safety because he could not hear incoming 88s or small-arms fire. He watched the men around him, and when they ducked or hit the ground, he did the same.[36]

Phil Gover wrote that a day or so later, the troops attacked Faicchio in the early morning hours. Being near Echohawk's squad, Gover remembered that Echohawk could hear but was "not as sharp as he usually was." As the troops entered a densely wooded valley, the weary troops stopped to rest. Echohawk and Gover sat in the brush drinking from their canteens when they saw heavily armed German soldiers close by. Gover wrote: "I shouted to our men to shoot, but they were slumped behind a wall and couldn't see. The Germans did not see us until I shouted. All Echohawk and I had in our hands were canteen cups. We grabbed our weapons and chased the Germans on foot. Then the Faicchio Battle started. The battle lasted about three days in this wooded valley."[37]

Second Scout Ray Purrington related a dramatic episode in the same area. He recounted, "A German machine gun fired on us from a heavy underbrush and wooded area. . . . [It] was approximately 15 yards in front of our Squad. . . . Though Echohawk was hurting, draining fluid and could not hear well, he and Curtiss [*sic*] destroyed the machine gun." Purrington recalled Echohawk throwing a grenade, which got caught in a tree, nearly hitting his squad, but which inflicted heavy damage on the Germans. "Echohawk was practically under the muzzle of the German machine gun," he noted. The squad suffered tremendously.[38]

During the battle at Faicchio, Gilbert Curtis recalled: "I saw Corporal Leading Fox and Sgt. Echohawk with bayonets chasing German soldiers. . . . Philip Gover, of Pawnee, gave chase on the right." Curtis continued, "Then we went on combat patrol up a mountain to our right to try to flank them while the Battalion fought in timber below. I recall asking Echohawk if he could hear all right, he answered something like 'off and on.'" Curtis described the eventual retreat of the Germans and the types of fire the patrol received. He noted that fire from the German 88s seemed particularly bad. Curtis recounted numerous similar experiences wherein the men in Echohawk's patrols, and Echohawk in particular, suffered from the effects of concussion.[39] Curtis reported that, despite Echohawk's damaged hearing, "he executed his duties as a Squad leader, and more. That night, dug in, he mentioned having a slight drainage but otherwise felt okay. Medics were busy as we were losing a lot of men, killed and wounded."[40] Gover went on to describe both Echohawk's character and his medical condition:

After bad concussion hits, Sergeant Echohawk never shirked his duty under fire. There were dire situations of battle when Battalion Medics evacuated no one unless he was severely wounded. In heavy casualty sectors, a soldier hit by concussion could suffer internal injuries then go undetected by hard-pressed Platoon Medics. With a concussion hit that broke no bones or [that] drew [no] blood, I doubt if Echohawk could have been evacuated then. At the time the 45th fought in Southern Italy there was no rotation or rest for an infantry soldier; and there were few replacements. Battle-wise men like Brummett Echohawk were hard to come by.[41]

Finally, on October 18, the 157th RCT relieved the remainder of the 1st Battalion of the 179th RCT after forty-three continuous days of combat. The battalion's losses already doubled those incurred in Sicily. They suffered 133 killed, 619 wounded, and 157 missing. The total number evacuated reached 978—more than 50 percent.[42]

The new commanding officer, Colonel M. R. Kammerer, ordered the 179th back to the line with directions to take the high ground over the Volturno River and to assist in taking Venafro, Italy.[43] The Battle of Venafro became one of the larger, more widely publicized conflicts of the early campaign in Italy. Echohawk's regimental combat team played a crucial part in the fight. The overall plan to break through the German Winter Line, a network of defenses set up with the intention of holding back Allied forces throughout the winter, required taking Venafro. The 179th also led the way for the 45th Division in capturing Lagone.[44]

Echohawk took a patrol across the Volturno River in November 1943. The goal was to scout enemy positions. In order to do so, the men had to scale a steep mountain in the dark to get behind Axis lines blocking the mountain pass. At dawn they "shot the place up," taking the Germans by surprise, killing several and capturing prisoners. They cleared the mountain.

On another scouting patrol, Gilbert Curtis related the following about Echohawk's activities and health:

I went on Echohawk's patrol across the Volturno river at night to a town, which I think was Venafro. Coming back Echohawk stopped to urinate. Then he said he was not draining stuff but his pants were slick from it. I remember it because it was then he told us to "freeze" because we were in a minefield. Then Echohawk got down and found "bouncing betties" with trip wires. Some mines were hidden under "cakes" of dry manure.

Down flat he tried to find a safe path. He had to hurry cause the sun was coming up. We were afraid of being spotted. We were scared our own tanks and artillery might fire on us like they did at Salerno. We got out of the minefield and to the Volturno. I heard Echohawk make a joke that he was going to wash his shorts and pants in the river.[45]

The effects of severe concussion hits plagued Echohawk the rest of his life. Some of the symptoms, like damaged hearing, became permanent. The drainage issues only affected him periodically but proved much more debilitating.

In early November 1943, Echohawk found himself again in the mountains of Italy. The Germans laid down heavy fire in an attempt to annihilate Echohawk's platoon north of Venafro. A German shell crashed into a tree above his squad. The shell exploded, reducing the tree to high-velocity, splintered projectiles. Echohawk's position at the front of the squad saved his life. Because he was nearest the tree, he said he came "within a small arc of comparative safety." The *Tulsa Daily World* reported that "the full brunt of the deadly shrapnel sliced through every other member of the squad." The blast rendered Echohawk unconscious. When he awoke, he began coughing up blood. He took inventory of the number and degree of injuries he incurred. His platoon had retreated, leaving him alone on the ridge. He chose not to wait for the army mules, which came up the mountain after dark to collect the dead and critically wounded. His pain drove him to find a way off of the ridge. When he finally located a medic on the mountain, the man told him he had to wait to be taken down because the accuracy of German fire made a daytime rescue much too risky. "I was afraid I'd bleed to death lying around up there, so I told the medic to shoot me full of morphine and I'd walk down," Echohawk recalled.[46]

Pumped full of pain-killing medicine, he headed down the mountain. He passed out several times along the way. Once he awoke to hear Germans conversing close by. This time, he chose to remain still until they passed, then he continued his journey down the mountainside. He finally reached a battlefield aid station, where he passed out once again only to awake in a field hospital farther back from the action. He spent a short time in an evacuation hospital, where medical personnel removed the shrapnel and bandaged his wounds. The morning after being treated, an officer and an enlisted man entered the hospital tent carrying with them a cardboard box. In a "hasty impersonal manner," the officer read a statement about the men being wounded in action. Then the enlisted man made his way down the aisle placing small blue

boxes on the foot of each bed where many of the soldiers remained asleep. The two men left Echohawk's tent, and he heard the same quick address in a neighboring tent. He recounted opening his box to find a Purple Heart medal. He recalled being located near two injured German soldiers. He wrote: "Except for their muddy jack boots, they were covered up and asleep too. They pick up the blue boxes and open them. They look at me, puzzled. I look at them and shrug my shoulders. . . . And this was how I was 'decorated' with the Purple Heart Medal for being wounded in action . . . and so were two German soldiers." The army then transferred Echohawk to a hospital near Naples, and from there to a military hospital in North Africa.[47]

While recuperating in the 33rd General Hospital near Bizerte, Tunisia, Echohawk became aware of a call issued for enlisted men between eighteen and twenty-one for fighter pilot training. He decided to apply. At the beginning of January 1944, he procured letters of recommendation from Captain Harlas Hatter (179th RCT), Lieutenant Colonel Earl A. Taylor (179th RCT), and Second Lieutenant William Robertson.[48] Military officials denied him the opportunity to enter flight training. Years later, he wrote his friend, then Colonel Harlas Hatter, "I was told I made the highest grade—but, because I was a Sergeant in a 'hot outfit, the 45th'—I was refused. So I went over hill [AWOL] and made my way back from Bizerte, Sicily, Naples—and to Anzio to join the 45th. Hell, I am a Thunderbird, and that's that!"[49]

An encounter with an old friend from his unit in the hospital in North Africa added to Echohawk's desire to return to his unit. The friend had been wounded a few weeks after Echohawk and described to him the dire conditions of their unit as the fighting continued in the Italian mountains. He informed Echohawk that their friend Philip Gover had been severely wounded also. After two months in the hospital, he realized that he had not received any mail. He began wondering if his unit had any idea that he had been evacuated. He felt ready to return to his unit and talked to hospital officials, but they refused to grant him discharge. Doctors told him that he had not healed sufficiently and could not yet return to combat. Rebuffed by hospital staff, Echohawk took matters into his own hands. The condition of his friends, and stories about what had ensued during his absence, along with a story in the *Stars and Stripes* about a landing at Anzio, strongly influenced Echohawk's decision to go AWOL to return to his unit.[50] He waited for dark one night, sneaked out of the hospital compound, and headed north. Sometime during the night, an Arab driving a "three-wheeled German velocipede" gave him a lift, and he made it to the

coast by dawn. "I jumped into the sea and took a bath," he later told a reporter, "and then figured I'd better find Bizerte. That was a staging area for Sicily and Italy and I figured I could hop a plane." Having found a hiding place at the edge of the Bizerte airfield, Echohawk waited until he saw a combat-ready plane preparing for takeoff. He bolted toward the plane, "jumped inside the hatch," and stowed away to Sicily.[51]

"We got to Sicily sure enough and I hopped out just as they cut their engines," recounted Echohawk. "Boy was that a Keystone cops chase!" He hid behind some barrels until he saw another plane about to take off and stowed away once again. By the time the plane landed in Naples, MPs anticipated his arrival and took him into custody. The MPs and an officer, he recalled, escalated the incident because they wanted to impress the crowd. The officer charged Echohawk with being "out of uniform," scolded him for being "dirty," and announced that he would be charged as a deserter. When Echohawk tried to explain, the men clubbed him for impudence. Not one to stand down in such a situation, Echohawk fought back and managed to escape into the streets of Naples. Once free, he located Bill Mauldin, a Thunderbird compatriot, who allowed him to hide in his apartment. While holed up, Echohawk showed Mauldin some of his battle sketches and received a positive response.[52] This meant a lot to Echohawk, because Mauldin had already established himself as a professional artist.

After leaving the relative security of Mauldin's apartment, Echohawk got arrested near the Naples Harbor, but the confusion of an air raid led to another escape. Arrested again, Echohawk tried once more to explain that he only wanted to get back to his unit. Again, his explanation was dismissed. He wrote:

> There are officers behind me with billy clubs. Glaring at me, the officer asks what nationality I am. I answer, "Full blood Pawnee Indian, Sir." He bad mouths Indians. He calls me a dirty, yellow deserter. I think about what all us Indians have been through: landing on the beaches of Sicily and Salerno, and the rest. I think of the Commando training at Cape Cod where I, along with other Indian sergeants taught bayonet and hand to hand fighting. I show anger and tighten my fists. The Military Policemen jab me in the ribs with night sticks and tell me to stand at attention. One clubs me. I turn and fight. In a bloody brawl, I maul six MPs and the officer. I land in a "tough" stockade where the wire is "juiced" to electrocute a man. I am ordered to stand at attention where a heavy 30 Cal. Machine gun is trained on me. I am told that they will throw the book at me. I am bruised and bloody. My whole body aches.[53]

Securely bound and in the custody of the MPs, preparing himself for the worst, Echohawk believed he was bound for Leavenworth. He said, "The MPs just could not believe anyone would go over the hill in order to get INTO combat. It seemed simple to me. . . . I just wanted to get to my outfit."[54] Despite the disbelief his captors exhibited, his desire to return to his unit proved relatively common. Men in various hospitals often decided to "extract themselves early" in order to get back to their units. The wounded men recovering behind the lines in relative safety, in comparatively clean conditions, and with three meals a day frequently felt guilty knowing that their friends, men who had stood with them in combat, still fought under terrible conditions, risking their lives on the front lines. Unlike most men who could hitch a ride or two on the steady stream of vehicles continually taking supplies and men to the front lines, Echohawk had to find a way across the Mediterranean and then on to Anzio.[55]

Echohawk's future appeared bleak at best when out of the crowd emerged his saving grace. He later wrote that "the Great Spirit, Tirawah" must have been with him, because Colonel Raymond McLain, an officer in the 45th Infantry Division, walked by and recognized him. Echohawk said, "He knew me by name and when I told him all that had happened, he really burned those MPs. . . . I was given official Army help the rest of the way to rejoin my outfit." After giving Echohawk a hot meal, McLain shook his hand and sent his regards to the "Indians at the front." The colonel gave him money and passage on a transport ship headed for Anzio.[56]

When Echohawk made it back to his unit, all of his personal effects had been prepared to be sent to his family in a little brown bag. His unit had no idea what had transpired. They believed he had been killed on that mountainside. Echohawk battled for two decades with the U.S. Department of Veterans Affairs to get things cleared up because the army declared him dead on November 6, 1943, and his records became lost in North Africa and remained so for years. Echohawk maintained possession of that little brown bag as a memento.[57]

The majority of the 179th RCT spent Christmas of 1943 in the mountains. Then, between January 1 and January 5, 1944, the unit moved back from the front lines for rest as other units moved into place. They had just completed sixty-six consecutive days committed in combat—a U.S. record for the war up to that point. With a brief two-week respite, the regiment learned that it would not return to the mountains but instead would prepare for another amphibious assault. The Thunderbirds sailed for Anzio, Italy, as they embarked on Operation Shingle.[58]

Most of the fleet landed at Anzio on January 24, 1944. Anzio did not immediately appear overly imposing, but the officers and their men quickly realized that the marshes they occupied would be difficult to survive. In fact, flying shrapnel hit Echohawk, wounding him again, the day he arrived at Anzio.[59] The German Luftwaffe proved one of the most immediate threats during the Allies' time at Anzio. Initially, the Germans made day raids; however, when those proved too costly, they transitioned to night raids. After January 27, Allies kept the skies clear during daylight, but the Germans' pilots made deadly, terrifying nightly assaults.[60]

In the cold of January, as Echohawk made his way back to his unit from North Africa, he noticed that soldiers in Naples and rear units had new winter uniforms. They had waterproof, wool-lined bib over-alls with overcoats. He also recalled that they had overshoes, and re-portedly long-john underwear and winter socks. This attire made good sense given the seasonal conditions, but when he reached the front lines at Anzio, he learned that only one new winter uniform had been issued for every platoon—one for every thirty-six men. His platoon sergeant wore the overalls and gave the jacket to the B.A.R. man. Echo-hawk and the others suffered in the cold wearing the same uniforms they wore when they had come ashore at Salerno in September 1943.

Winter temperatures, which stayed below thirty-two degrees for over a month, combined with regular precipitation, and the swampy terrain complicated things further. Typically, the men resided in two-man foxholes, and each had a blanket and "shelter half."[61] At times, it became so bad that men chose to forgo the relative security of foxholes and trenches filled with freezing water to sit outside, huddled in rain-coats exposed to enemy fire. Men died doing so. Many suffered frost-bite, including Echohawk.[62]

On January 28, 1944, the 179th RCT received orders to take up posi-tions south of the Mussolini Canal Bridge along the west bank in order to protect the right flank of the beachhead. The men moved on the following morning. Their location along the Mussolini Canal limited their activity primarily to patrols. The 179th continued to experience shelling, and the aerial threat persisted. Restricted activity lasted until February 1, when the unit rejoined the rest of the 45th Infantry Divi-sion near the center of the beachhead forces. All the time they waited, the Germans massed their forces and improved their positions on tac-tically defensible high ground.[63]

Echohawk remembered Anzio vividly. "I remember the whole shooting works because we were the bulls-eye. Imagine all those

people packed in on a narrow beach with the Germans above us where they could hit anything. . . . Everything was dug in on the beach. I was bombed out twice when I was in tent hospitals on the beach. . . . We fought day and night. There was no rest and there were no back up troops," he recalled. "They bombed us at night and during the day they shot at us." Under these trying circumstances, Echohawk managed to sketch what he saw and to protect many of his drawings.[64] In fact, he found that drawing felt therapeutic—a welcome diversion from the chaos and a way to ease his mind.[65]

German forces took advantage of the terrain, focusing the mass of their forces behind Carroceto, in Aprilia, Italy, often referred to as "the Factory."[66] The Germans held the high ground, which provided excellent vantages for observing the Allied troops and allowed them to lay down devastatingly accurate artillery fire. Behind the German-occupied buildings at Carroceto, roads ran south and southeast. German tanks used these roads to protect the flanks. Below this sort of U-shaped wall of German forces, down on the beaches, the Allied forces lay trapped on a flat, swampy beach with minimal vegetation.[67] Life for the Allies closely resembled the trench warfare of World War I.[68]

The 45th Division spent roughly five months at Anzio. The men spent much of their time in a virtual stalemate punctuated by periods of intense activity. In later years, the men from Echohawk's unit talked about the nighttime terror he became for the enemy. His longtime friend Michael Gonzales described the stories the men from Echohawk's unit told him about Echohawk's exploits. As the skies darkened each night, Gonzales recounted,

> Brummett would give a war cry . . . and he took nothing with him forward but this immense bowie knife, and he would spend all night in the German trenches killing Germans and taking scalps. . . . Now this is what his friends told me. He would return at dawn, covered in blood, carrying these trophies. He would go down to the beach, wash off in the salt water, put his uniform back on, return to where he was supposed to be and fall asleep. Ultimately, his little raids into the German trenches became so notorious with the Germans that he'd give his war whoop, crawl across, and there would be no Germans in the trenches. They would leave. So he moved down, over to [a neighboring regiment] and he started over again, but he quit giving the war whoop.[69]

Although scalping may be particularly unsettling by mainstream standards, both then and now, it is important to recognize that it was a

long-standing, respected battlefield practice among many American Indian tribes and may have been carried forward by American soldiers who had strong ties to traditional backgrounds. Echohawk's reputation, as perpetuated by his fellow soldiers, helps explain how American Indian soldiers garnered a frightening reputation that was effectively employed against enemy soldiers.

In a related story, one night as Echohawk neared the Germans' forward trenches, he saw a man, barely visible in the dark, who had fallen asleep. The man had his helmet on and still held his rifle as he slumped against the side of the trench. Echohawk crawled behind, and quickly dispatched the soldier. As Echohawk continued his nightly prowl through the trenches, he came to a sharp turn and followed it a distance. He came to a deep pit dug in the trench, which housed a tent-like structure. Likely, the hole had been dug to prevent light from being seen inside, and the tent helped protect its occupants from shrapnel. He figured the structure must have served as some kind of headquarters or forward command post. He crept up to the tent and carefully lifted a piece of canvas to peer inside. The post appeared to be vacant, but it contained a table with a burning candlestick. Without entering, Echohawk tossed the fresh scalp onto the table and left. Certainly, those Germans thought twice about the security of their location when they returned to find the grisly proof of an enemy presence close at hand.[70]

According to the 179th RCT's history, "in a belated effort to seize the factory," the British 168th Brigade attacked a much larger, better-equipped, and defensively well-located German force time and again. The majority of men from the 168th lost their lives as they bitterly fought for the Factory.[71] On February 10, the 1st Battalion of the 179th RCT received orders along with two companies of the 191st Tank Battalion "to relieve the British and strike at the enemy around Carroceto and Aprilia." The army scheduled the attack for dawn on February 11.[72] Under the leadership of Colonel Wayne L. Johnson (1st Battalion) and Major Merlin Tryon (3rd Battalion), the men of the 179th RCT headed for Aprilia. They did not know at the time that the Germans had intercepted a radio message and knew they were coming.[73]

The Allied assault was preceded by an aerial bombardment on February 10–11. At 6:30 A.M., Brummett Echohawk and the rest of the men in the 1st Battalion of the 179th under Johnson led the attack on Aprilia *without* the tanks they had been promised. By 10 A.M., they had made forward progress but had to fall back for a time to resupply after expending all their ammunition. As they advanced again, Companies

A and B approached the Factory under extremely heavy fire with no cover. Some of the men from B Company made it to the corner of the village, fixed bayonets, and charged. Then they heard the tanks. Panzers had been hiding in Carroceto. The German tanks paved the way for hosts of German soldiers. The men of the 45th were forced to fall back.[74] One man in the 1st Battalion, 179th HQ Company recalled: "The Germans just beat the holy hell out of us. We had to retreat or, as the Army calls it, we 'withdrew.' Our battalion moved back a thousand yards and there was less than a company left in the whole 1st Bn. Less than 200 men."[75] Echohawk's personal account was similar. He recalled, "There were four of us left out of 190. Four Indians left."[76] The tank support promised to the 179th RCT for the assault arrived two hours late. The tank battalion, too, became badly battered. The fight continued into the night with artillery fire raining down on the 179th with deadly affect as the troops tried to reorganize the survivors for another attack on the Factory.[77]

At 3:53 A.M., the remains of the 1st Battalion attacked again. The men made it to the Factory walls again with the aid of I Company. They fought with fury, but again the German panzers and their legions of infantry proved too much. After another staggering blow, the Germans forced them back, and they took up defensive positions.[78]

On February 12, 1944, Echohawk was severely wounded again.[79] "I led five bayonet attacks," he said. "My last bayonet attack was at Anzio. I got hit nine times in that rush of 75 yards."[80] On that day, Sergeant Echohawk and Sergeant William H. Lasley, a Potawatomi from Fairfax, Oklahoma, received orders from their captain to lead the charge against the Factory. The assignment rattled Echohawk somewhat because he had just made it back from two months in the hospital after suffering serious injuries. Although B Company of the 179th RCT had started out full of Indians (mostly Pawnee), Echohawk noted that by this time he had become one of only "a handful of Pawnees left."[81] Company B lost many to injuries, illness, or both.

Twenty-three years later, Echohawk wrote about the events of that day, beginning with the morning advance. He described following the lead of Sergeant Lasley through heavy mist. He wrote: "I have 13 men. The company follows. . . . We enter a ploughed field. It is flat and muddy. This is bad. Bad. Bad. Now silhouettes of buildings and tall chimnies rise above the mist. The Factory! My heart pounds. I feel like a target."[82] Under heavy fire, the men pressed forward. They stopped for cover near a road within about seventy-five yards of the Factory walls. Echohawk recalled, "We face small arms fire but charge

head on, yelling, shooting and flashing bayonets. At 50 yards a big German in a long overcoat breaks and runs. . . . I jump eight shots at him on the run. This Pawnee keeps up 'war cries.' Another German comes out and I send him to the Happy Hunting Ground fast. It is a wild 75 yards." With this charge, the men captured thirty-five German soldiers.[83]

Echohawk described the action at the Factory walls. The men who made it across the flat plain took the front buildings and continued the fight that Echohawk described as having "the fury of a flash flood that dashes itself into violent whirlpools and isolated eddies." Echohawk continued:

> Behind, our men fight and claw for every yard. Before we can gain a firm hold on The Factory, the Wehrmacht roars back. We fall back to the road.
>
> Above the din Bill [Lasley] shouts, "Eck, get everybody together, and let's go get 'em again!" We do. And more men gain The Factory. It becomes a wild fight.
>
> The Wehrmacht pours more men into the struggle. The Factory slips away from us again.
>
> I see men blown to bits. Every square yard seems to erupt with thunder.
>
> 88s gut the earth. I think of anything to keep from cracking: high school football, the Pawnee pow-wow, stomp dances, Bob Wills, anything.
>
> My hand and leg bleed.
>
> When the barrage lifts, I hear Bill calling. . . . He is splattered with mud and shows no fear. . . . The Potawatomi says, "Get everybody that's left, and let's go back up. Come on, Ecky, let's go get 'em. Right now. We can do it!"
>
> I say "Okay" and give the Indian yes sign.
>
> Bill smiles. . . . "Come on, Brummett, we can do it. Keep the guys between us. Keep contact."
>
> Only 11 of us whoop it up and charge. On the right. . . . Bill yells and peppers away with a Tommy gun. I fire into the buildings. Machine gunfire . . . mows us down. I dive for a watery cowpath. It is inches deep, but enough. I struggle backward like a crawdad. I make it back to the roadside ditch. My sides heave like an eared-down bronc. I hear the mortar shells. They rustle like dry leaves then explode where Bill and the men are down.
>
> Tears come.[84]

The situation continued to deteriorate. The men lost the Factory again. Echohawk narrowly escaped both death and capture. After spending the night hiding waist-deep in water in a culvert covered in ice, he made it back to his lines where, as the last remaining senior sergeant, he received orders to advance again. He had already been hit in the right hand and right leg with shrapnel and still bled from those wounds, and his right hand had become frostbitten because he had lost his glove when he sank in the mud during the night march preceding the first attack. He followed orders anyway. The second day's attack failed.[85]

It is no great wonder that the 179th, regardless of its best efforts and impressive resolve (particularly when embarking on the second morning's assault), failed to take the Factory. As one regimental historian put it, the odds of the 179th RCT's success "were 1,000 to 1 against it before it jumped off [the first morning]. For the Allies, unwilling to commit their reserves, were poking at the German stronghold with one unit at a time!"[86]

After the failed offensive on the second day, Echohawk finally received medical attention. While in Hospital 15 on the beach, he touched up some of the sketches he had begun in battle. He made a record of his experiences at Anzio to that point. After a stay of roughly ten days, he returned to his company.[87]

As the Allies dug in again, life continued to be exceptionally difficult on the Anzio beachhead. The Germans still controlled the high ground and had the Allies under full and constant observation, forcing them to attempt all activity in the dark hours and to return to foxholes before daylight. Soldiers rarely find life in a foxhole pleasant, but because the Anzio beachhead was primarily marshland, those foxholes proved soggy, miserable places to live. Frigid temperatures only made the situation worse. Later in life, when Echohawk spoke of Anzio, he generally spoke of crawling through the Italian mud.[88]

One incident related by the men of B Company highlighted Echohawk's efforts to silence three German machine guns raking Allied troops from a building across from their trenches along the Mussolini Canal. The men of B Company faced more than the three strategically placed machine guns if they wanted to leave the trenches. Off to one side, in a depression, sat a tank, most likely a Mark IV, with a machine gun mounted near the tank's main gun. The tank's occupants swiveled the turret left and right, scanning the open area between the American trenches and the German machine gunners perched on the second floor of a building facing the Americans. After watching

the tank for a time, Echohawk decided that if he waited for just the right moment, when the tank turret reached a particular position, he could outrun it and reach the building housing the machine guns. The men around him told him he would have to be crazy to try it. Nevertheless, when the tank turret reached his calculated position, he jumped up and ran across the shell-pocked, debris-filled area with tank fire in hot pursuit.

Echohawk made it into the building. Once inside, behind the first door he found a store of five-gallon drums of gasoline. He stepped back and fired his Thompson submachine gun into the barrels, causing them to leak. Confident the machine gunners upstairs could not hear his fire over their own, he proceeded upstairs and systematically knocked out the German machine gun crewmen. About that time, an artillery barrage came down on the building. He bolted to exit the building. He knew it would only take one hot piece of shrapnel to ignite the gasoline downstairs. As he approached the stairs, a German soldier, also in a hurry to exit, appeared beside him heading down the stairs. According to the story, the two soldiers looked at each other as they ran shoulder to shoulder down the stairs, but Echohawk reacted first. By the time they reached the bottom of the stairs, Echohawk had killed the German soldier. As he exited the building, he checked for the tank, but it had pulled back. The tank may have been the object of the artillery barrage. Somehow, he made it back to his men in B Company. Despite his success, the men still believed Echohawk might be a little crazy.[89]

Brigadier General Ed Wheeler, a longtime friend of Brummett Echohawk and fellow member of the 45th Division (though in years after Echohawk left the military), recalled that Echohawk had proven himself one of the Pawnee's great war heroes. Echohawk discussed the role of the 45th Division, and his personal role, in the 1944 invasion of Anzio, and sketched for Wheeler an image of the attack against the Factory in which he depicted himself at the front of the charge.[90] Eventually, Echohawk received a Bronze Star for his role at Anzio's Factory.[91] According to Wheeler, the following portion of Echohawk's story is not commonly known. After the assaults on the Factory, German SS Panzers overran and captured the survivors of Echohawk's unit. The Germans placed Echohawk on a troop train with other prisoners to be transported north to Germany. At the time, the Americans controlled the air, making it necessary for the German train to make continual stops to hide in tunnels while proceeding north. Once Echohawk

realized that the floor was constructed of wooden panels, he managed to pry an opening in the floor, working as the train made noise, without drawing too much attention. Echohawk dropped through the opening he created and rolled to lie quietly near the tracks in the dark tunnel as the train pulled away. The German guards stationed on top of the cars failed to see him next to the tracks in the dark. Once the train left, he began a cautious trek by night back to friendly lines. According to Wheeler's recollection, Echohawk escaped alone.[92]

On February 16, 1944, German forces initiated a powerful offensive to drive the Allies back to the sea. Once again, like at Salerno, B Company of the 179th RCT lay directly in their path. The German attack proved staggering—artillery, panzers, infantry—and the Allies' air support remained grounded due to inclement weather.[93] The intense clash lasted roughly three days, as the Germans challenged the Allied hold on the beach. In the end, the Allies halted the German drive to the sea.[94]

On the last night of intense fighting, concussion from an artillery round knocked Echohawk unconscious and partially buried him in the mud. A Sioux MP woke him and dug him out the following morning. His physical condition had worsened.[95] His wounds from November, re-aggravated by the recent fighting, began to open up and bleed again. A Pawnee friend visited with him, using the Pawnee dialect in an effort to comfort him until he could be taken to the evacuation hospital. Echohawk truly appreciated the gesture.[96]

Beginning on February 20, 1944, the Allies made no concerted efforts to attack German forces. The German forces did not make another push against the Allies. The stalemate lasted for some time.[97]

At the 93rd Evacuation Hospital near Carroceto, Echohawk continued to sketch. Using Red Cross writing paper, he sketched events of the battle, soldiers, and nurses. He met and befriended a nurse assigned to his ward. They became close, but she died in an air raid that inflicted heavy damage on the hospital. Echohawk recalled, "During air raids, she did a good job of calming the wounded men in her ward; some of whom had nerves already shot. A brave young woman. I'll never forget her." Evacuated to the 17th General Hospital near Naples, Italy, he said he "tried to blot out the nightmare that was Anzio."[98]

In the hospital near Naples, Echohawk continued to sketch. While there, he met the movie star Madeleine Carroll, who assisted the Red Cross. (She also visited the 92nd General Hospital located right next to the 17th Hospital.) During one of her visits, she noticed his artwork

and began bringing him actual drawing paper. He also encountered his battalion commander at the 17th General Hospital, and shared with him his sketches. Again, he received encouragement. "With the efforts of my Battalion commander and Madeleine Carroll . . . my front line drawings were 'discovered' by American newsmen."[99]

The 17th and 92nd General Hospitals in Naples were accidentally bombed in an air raid during late March 1944. During the raid, Echohawk survived by wearing his steel helmet and taking cover under his bed. Many in the hospital were less fortunate.[100] Echohawk wrote, "Having sustained a concussion hit that left me with internal injuries and a slight loss of hearing at a village called Faicchio; and having been hit through the leg and foot at Venafro then getting it again through the leg and hand at Anzio, I was sent back to the States. Shortly, I was furloughed home to Pawnee, OK."[101] Once recovered from his wounds, Echohawk received orders assigning him to an ordnance depot in Detroit, Michigan.[102] The army officially discharged him on August 15, 1945, at Camp Chaffee, Arkansas.[103]

Although Echohawk returned to the United States after an extended stay in several hospitals, the men who remained at Anzio continued fighting. On May 11, 1944, Operation Diadem began at exactly 11 P.M., with the support of eleven Allied divisions. A massive undertaking, the ultimate goal of Diadem was to break through (and cripple) the Gustav Line.[104] As part of the plan, once Diadem began, the Allied troops at Anzio would attempt to break through the "iron ring" of German forces surrounding Anzio—an operation called "Buffalo."[105] The siege at Anzio had lasted for 125 days. At 6:30 A.M. on May 23, 1944, Operation Buffalo began the move to end that siege.[106]

From the 45th's first taste of combat, and on through Sicily and southern Italy, Brummett Echohawk filled his tales full of heroics and valor but nearly always inserted a healthy dose of humor too. For example, Echohawk enjoyed relating stories about taking towns from the enemy. He said, "Whenever the Pawnee Company took control of a town or village, the men immediately lowered the enemy flag and replaced it with a wine bottle touting, 'this village taken by Oklahoma Indians.'"[107] Echohawk used to talk about doing things like this after the war while attending dances and other events.

The disproportionately high level of American Indian service in World War II is now a well-known fact. The treatment of these soldiers has received mixed responses. Many believe that the proportion, per capita, of American Indian combat deaths can be directly attributed

to stereotyping (though not necessarily prejudice). The high fatality rate among this particular group of soldiers resulted not only from American commanders' misperceptions of Indian capabilities but also due to the Indians' willingness to accept the most dangerous combat assignments (often given based on the stereotypes of Indians' inherent military prowess).[108]

Listening to Brummett Echohawk, one hears a twist on many historians' analysis of the prevailing stereotypes. Although he recognized certain stereotypes in movies and compared them to his personal experiences in war, he made light of the errors in popular perception. He noted, for example, that in the movies, Indians never fight at night. "I wish they'd have told us that in Italy," he joked.[109] Echohawk related the incredible service of American Indian soldiers this way: "To us, a fight was personal. We weren't going into it like soldiers in a parade. . . . We didn't fight due to discipline, we fought due to a sense of dedication. We knew we had a job that had to be done, and we did it." He went on to relate the great challenges they confronted because of their reputation. He recalled, "Once we were ordered to climb straight up a cliff in total darkness. Well, none of us had ever climbed a mountain in our lives, but somehow we managed." He considered difficult missions, such as penetrating enemy lines to attack from the rear or climbing cliffs in the dark, complimentary: "We took pride in being asked to be first. It was like being the best ball carrier on a football team. We always got the call."[110]

Echohawk truly believed that American Indians made exceptional soldiers, arguing that they were conditioned to be good soldiers. He said everyone could swim, everyone could shoot, and everyone had a good sense of direction. When he spoke of "having a compass in their heads," he meant that Indians had been taught how to pay attention to winds, landmarks, stars, and general terrain in order to get to a designated destination and back. Echohawk thought that their method of going behind enemy lines as a group and returning individually (since they all trusted that each man could get himself back) proved much safer than other patrols that tried to return as a group. He believed that successes on patrols and under combat situations came from a sort of common sense he felt the American Indian soldiers possessed. He also credited friendly intertribal rivalry for their great achievements. When members of various tribes got together, he explained, members of each tribe made a point to try and outdo the members of other tribes. Further, Echohawk believed that humility played a role in their successes.

There was no need to "cuss and talk dirty" or to "scream and shout" as others did, Echohawk claimed. Those in leadership positions did not flaunt or abuse their authority. He said, "In a sense we didn't have discipline. We only had what you might call a dedication. . . . For instance, I was a Sergeant and I never told anybody these things and we never differed in opinions. We had something to do and a place to go." He noted that in other units, men complained and sometimes tried to get out of assignments. "With an all Pawnee unit and the Creeks and other tribes . . . you knew it had to be done and you would do it."[111]

Together, Echohawk and some of his Native American compatriots felt, Indians had the capacity to do more than typical units. Certain characteristics from their backgrounds tended to help them work together successfully. The use of tribal languages among the men kept information from the enemy, and Indian signs proved useful in combat and patrol situations when vocal communication became difficult or dangerous. Shared cultural practices lifted morale. The methods of issuing and receiving orders often differed. These and other traits and practices set the predominately Indian units apart in Echohawk's mind.[112]

Echohawk spoke of meeting with a number of former German soldiers in Germany in 1976 who talked to him about fighting the "Red Indians" and the Texans. One man described the differences between fighting the Russians and fighting the Americans. The German maintained that the Texans fought like "crazies." The Texans, he said, would stand and fight and keep coming at you. Echohawk recalled the Germans commenting, "but the Indians you never saw them but they were behind you and it was too late." One German openly told Echohawk that between the Texans and the Indians (referring to the 45th and 36th Divisions), the Germans really had their "hands full."[113]

Echohawk's excellent military record, at times, verged on the incredible. His nieces, nephews, and others admired him as a great storyteller. As they grew older, they began to question whether his tales were fact, fiction, or perhaps a mix of both. They received assurances that the accounts were truthful. Eventually, someone asked Echohawk's old sergeant and good friend, Phil Gover. A highly respected individual in the community, Gover confirmed that all of the stories Echohawk related—from liberating towns to training commandos in hand-to-hand combat or being called on secret missions or raids penetrating deep behind enemy lines—were true.[114]

Michael Gonzales first met Echohawk at a division reunion shortly after accepting a position as curator of the 45th Infantry Division

Museum in Oklahoma City. At the time the two met, Gonzales knew that Echohawk had a reputation as both an accomplished artist and veteran of World War II. After several hours of visiting, Echohawk began talking about his World War II days. Gonzales recalled:

> He began to tell me some stories, and quite frankly they were unbeliev-able. I thought: "Well, the old guy is stretchin' the blanket a little bit. You know it's been 45, close to 50 years since the end of World War II, and . . ." You know, like most guys will pump up their story a little bit. Then I met some other fellows the following evening who had served with Brummett. I don't mean they just served with him, I mean they were shoulder to shoulder with him. They were in the trenches with him. And the topic of Brummett came up, and I said, "Yeah, he told me a couple of stories that are just fantastic," and this one guy said: "Did he tell you about the time . . ."[115]

Echohawk's old comrades confirmed *seeing* all of the exploits Echo-hawk had talked about and more. Gonzales noted that although many of Echohawk's stories seemed fantastic, and perhaps even crazy (some of the men he fought with believed he may have been crazy), in actu-ality he acted under a somewhat different understanding of various situations than many of the men around him. Often, his actions di-rectly related to his belief in the prophesy of the religious figure in his home community, which he understood to mean that he *would* make it home.[116]

Even though Brummett Echohawk may have, at times, appeared reckless in his activities, his men respected him. In signed depositions and in casual conversation the men in his unit spoke highly of him. Gonzales explained,

> There was a lot of jocularity about him. When he was in a good mood he had a tendency to be quite verbose. He had a really captivating smile, and a laugh you could hear a half mile away. That kind of thing always draws attention to a guy, particularly when you're in a situation . . . like combat. You can think of a million and one places you'd rather be right at that moment than where you are, and if you've got a guy like Brum-mett who can crack a smile and crack a joke at a time when nobody's thinking about smiling or joking, it's a guy you want to have around you. I've had more than one guy that served with him during the war tell me that. They said, "When everybody else's morale was low, we'd all be sitting around staring at our boots and Brummett would say

something and make everybody laugh." You always want a guy like that around you.[117]

Statements from Echohawk's men further extol his character. Chauncey Matlock pointed out that Echohawk never made excuses; even when in very poor health, he always did his job.[118] Edward J. Hewett, who served in Echohawk's squad, also noted Echohawk's service despite injuries and related health issues. He believed that Echohawk had been "a truly outstanding soldier exemplifying the highest traditions of the Great United States Army." Hewett also said that Echohawk "was always close to his men, undoubtedly one of the best liked and most knowledgeable non-coms in the entire outfit and, as a result, I doubt very much if anyone who soldiered under him would ever forget him, not only as a fine non-com, but as a friend to [*sic*]." Hewett's high praise extended to Echohawk's character, not just as a soldier, but as a man. He said that in the toughest times, Echohawk "stood out like a giant beacon of light in the dark skies."[119] Robert Stokes also served with Echohawk during the war, and added to the claim that Echohawk continued to fulfill his duties and more even when injured and suffering from poor health. Phil Gover supported this claim as well.[120] Ray Purrington said the same and noted that other men would have jumped at opportunities to be sent back from the front lines, but Echohawk remained where he was because he knew he was needed. Purrington claimed that after serving under Echohawk for three years, he could "certainly vouch for his character."[121] Gilbert Curtis made statements supporting these claims of toughness and character and closed a sworn statement with the words, "This is the only way I can speak for the man who was my Sergeant in combat."[122] Wayne L. Johnson, Echohawk's battalion commander stated, "I have always found Sergeant Echohawk truthful and trustworthy. I consider him to have been one of the outstanding soldiers in the 179th Infantry, if not in the entire 45th Infantry Division."[123]

Furloughed home, according to Pawnee tradition, Echohawk and two others were recognized and honored as warriors. They were further honored when leaders of the Ah-roos-pakoo-tah Warrior Society ceremonially bestowed them with new names. Echohawk described the event: "Patriotic, the Pawnees stand. As the flag is raised to the top of a pole, the singers and drummers sing the Pawnee flag song. In fine beadwork, buckskins and eagle feathers, the Chiefs and patriarchs stand erect though some are bent with age. In new Khaki uniforms, we three Thunderbirds stand at attention." As the ceremony continued, a

chief talked about one of the Pawnee soldiers lost in the war. Then the chief "repeats an old-time phrase, 'Tus-la-pedah-hu' (We must have love for our people)." The chief closed, saying, "Don't mourn our Men of Men who died on the Warpath. But be glad that such Warriors lived. Let there be tears of honor; not tears of sorrow. Now let us dance the War Dance of Victory to honor these three men who proved themselves to be true Pawnee Warriors: 'Chaticks-Si-Chaticks,' Men of Men." Then Phil Gover, who lost his arm in Italy, led the dance. Floyd "Flop" Rice, also wounded in the war, followed Gover. Echohawk followed Rice. Echohawk wrote, "I had always wanted to be a true warrior. . . . I swell with pride at being honored as a full fledged Pawnee warrior."[124] Brummett T. Echohawk earned the Purple Heart with Oak Leaf Clusters, a Bronze Star, the Army Commendation Medal, the Combat Infantry Badge, four battle stars, two Invasion Arrowheads, and a Congressional Gold Medal.[125]

When the Pawnee veterans of World War II returned to the Pawnee tribal community, they were well received. The World War I veterans organized a large homecoming event in 1946 that included a parade through the streets of Pawnee as "B Company marched in formation."[126] Dances, feasts, and music followed for a full week. The homecoming remains an annual event to which members of the Pawnee community look forward each year. Each summer they organize the Homecoming Powwow and parade in conjunction with the national celebration of the Fourth of July, a fitting time for Pawnee people to celebrate their veterans, past and present. As historian Paul Rosier said of the World War II veterans, "Serving the United States and their Indian nations with distinction and honor, American Indians defended their right to be both American and Indian, representing that right as the promise of American life while the United States engaged the world in the twentieth century."[127]

As with most veterans, the crucible of World War II turned out to be a formative experience in Brummett Echohawk's life. He successfully proved himself both a patriot and Chaticks-si-Chaticks. Serving in the 45th Infantry Division gave him an opportunity to fight alongside, influence, and learn from many who shared tribal backgrounds, and many who did not. Echohawk developed a deeper sense of spirituality while in the war. He shared a bond with the soldiers he fought beside, but particularly with other American Indian soldiers. He made use of his heritage during the war and found that his language proved valuable in particular situations, as did Indian sign language. Echohawk employed a less common brand of leadership because he felt no

need to act above his men. He also counted coup as his grandfather had during the Indian wars of the American West. Pawnee history and beliefs helped bolster his confidence that he would return home and inspired his battlefield conduct. Echohawk took his Pawnee heritage to the battlefields of World War II and returned home with a new sense of accomplishment and direction.

"Art is long and life is short"

As an artist I always felt that I had a desire, I had something in-side my breast that forced me, tugged me by the nose and chin to draw. When I was growing up in Pawnee, I used to draw on bleached logs, and I'd draw on the inside of bark. I drew horses and Indians. And when my dad went to town to buy meat from the local butcher shop, the man at the butcher shop used to de-liberately wrap the meat in two paper sacks. . . . One for the meat, and one for . . . "little Brumet." . . . And he would always want me to draw pictures. . . . This was my start that I could remember I was putting things on paper. I believe this was a gift. I never had formal training in art until I got out of service. Sometimes the Lord moveth in strange ways.

 —Brummett Echohawk

Echohawk's career as an artist derived from his ability to turn a seem-ingly unimportant wartime experience into an opportunity to do something he truly enjoyed. When he and Corporal Leading Fox led the charge against the German-held building in Sicily in the summer of 1943, Echohawk had no idea that what he found inside would alter the course of his life. The drawing materials he found abandoned on the floor of that building offered a foundation for his later career as an artist. He recalled:

[E]ver since then I drew pictures . . . of the German soldiers, of the British Empire troops. And I wrote on the back of a mess kit, using a mess kit for my easel. . . . And I made accounts of what we did. . . . I kept drawing. I made several sketches in the field. I had an unusual distinc-tion, of course, being right in hard nose infantry. . . . After a while I was always drawing things. . . . And one day the war correspondents found my drawings and published them. I felt it was a great thing. Again, I felt it was the Great Spirit trying to give me a message.[1]

At one point, the army confiscated Echohawk's combat sketches, likely because they did not paint a flattering picture at a time when the United States armed forces needed to maintain support for the war effort. After the war, the army returned some, but not all, of his sketches. The *London Sunday Mirror* later published the returned sketches and lent some to the Imperial War Museum in London for an exhibition called *Faces of War* in 1969. A number of Echohawk's drawings also showed in West Germany.[2]

The stateside publication of Echohawk's battlefield sketches, nationally syndicated and printed in eighty-eight newspapers around 1944, came as a welcome relief to veterans and military families tired of the upbeat and cartoonlike imagery they saw regularly in the media. Those who knew wanted the rest of the American public to realize the hellish situation soldiers faced. A newspaper article, "What We Should Know," embodied these very sentiments.[3] It quoted Senator James M. Mead relating the dose of reality Americans needed to dispel illusions they had about the war: "What the devil do the folks back home think this war is like?" he asked. "If they could see what one of those blockbusters does, in real flesh and blood," then people at home might begin to understand what their men endure overseas.[4]

"What We Should Know" clearly pointed out to readers that Echohawk's work furnished a much-needed, realistic depiction of the war, and stated that the publication of Echohawk's combat sketches "must be the answer to a GI's prayer. For here are soldiers as they really are, seen by a man who sketched them as he fought with them . . . haggard, dirty, unshaven, dog tired. He shows us the dead and wounded; the recruits, tense and nervous; the veterans already wise in war." The article continued, "They aren't pretty pictures, but they portray the fighting GI as he wants to be portrayed."[5] Brummett Echohawk's combat art became "the war's first actual battle sketches to be drawn by a frontline infantryman" and published stateside.[6] Echohawk's personal sketches affected thousands.

Newspapers generally published the sketches with captions including informational tidbits to aid readers. For example, the caption might include the location of a particular battle the drawing depicted, information regarding the event being portrayed (e.g., capture of German prisoners or preparation for an assault), a note regarding which units had been involved in a particular incident, or even an analysis of the sentiment depicted in the images. Echohawk presented an accurate visual portrayal and understanding of soldiers' conditions and experiences. Nearly every newspaper running the images described

Sergeant Echohawk, within the limited space for image captions, as a "full-blooded Pawnee Indian," even though the sketches illustrated the war and not Pawnee or American Indian culture.

The Newspaper Enterprise Association syndicate published at least twelve of Echohawk's combat sketches in 1944. Drawing captions included "Death Shares a Ditch at Bloody Anzio," "Forward Under Fire," "Pinned Down by Snipers," "Battle Trophy" (also labeled "Straight from the Front"), "Double Trouble at Anzio," "Ready to Roll at Anzio," "Anzio Advance," "Listen—Here Comes Jerry!" "'Kamerad!' at Carroceta," "Sad 'Super Man,'" "Action at Anzio," and "First Stop for the Wounded." Portraits of soldiers Echohawk made while he was in the hospital or when he had opportunities to rest for any amount of time appeared initially in the *Detroit Free Press* near the end of 1944. Among the published sketches, British infantry, men of the Scots Guard, East Indian Gurkhas, an African Auxiliary Pioneer Corps soldier from Bechuanaland, South Africa, a Ceylonese soldier from the Royal Army Service Corps, a French Moroccan "Goum," a Japanese American soldier, and a Greek infantryman were all represented.[7] The published portraits provided American readers a deeper realization of the diversity among soldiers. They reemphasized the truly global nature of the conflict at hand. When possible, Echohawk had many of these portraits autographed by his subjects—including German prisoners.

Young Echohawk lived in the moment, focusing primarily on getting through the war. Then one day in a foxhole, his friend Ed Hewett looked over some of the sketches while Echohawk cleaned them of mud and debris. Most of the sketches had been drawn on Red Cross paper from the hospital or on German sketchbook paper Echohawk had confiscated from prisoners and the dead. When Hewett asked him what he planned to do with his life, Echohawk had no ready reply. Hewett told him, "I believe you ought to be a teacher or an artist."[8] The idea of becoming a professional artist had never occurred to him.[9]

After Echohawk returned from Europe, the army stationed him at the Office of the Chief of Ordnance in Detroit, Michigan. There, he attended the Detroit Society of Arts and Crafts, and this period of Echohawk's life witnessed the beginning of his formal training as an artist.[10] He recalled, "I went to see a legitimate artist to gather the facts of how it was to be an artist. He painted me a grim picture. So I went to another artist, and he told me the glories of being an artist." Echohawk determined to pursue a career in art, but first he had to determine where to go to get the best education.[11]

With minimal income and no real help from the Veterans Administration, Echohawk struggled to pay for schooling. He could not use the GI Bill because the army officially listed him as killed in action in November 1943 and lost his records for two decades. Echohawk could only count on $17 a year as part of an annuity promised to the Pawnees by the 1857 treaty with the government. He contacted the Bureau of Indian Affairs and the Department of War but failed to receive any response. He turned to friends who lent him money.[12] He finally spoke with Ed Hewett once more and obtained the name of a contact in the navy, who helped him acquire an American Indian scholarship to Dartmouth College, a school originally founded in 1769 for the purpose of educating American Indians.[13] As an Ivy League college, Dartmouth failed to offer the kind of focus on art Echohawk sought. When a reliable source told him the Art Institute of Chicago had the world's best art school, Echohawk resolved to attend.[14]

Echohawk recalled acting on his decision to go to Chicago, saying, "I went home and got my medicine bag and my extra pair of shoes, my beads and my Army traveling bag, and I bought a ticket and went to Chicago to go to the Art Institute." He arrived with $20. He had no Social Security number, no job, and no idea that a school as large as the Art Institute required an application or that students had to register. School officials turned him away.

Echohawk began loading baggage at the train station for approximately 50¢ an hour. Then, after thinking about the matter some more, he returned to the school to speak with the dean. He asked why he had been turned away. Echohawk recalled,

> I gave the dean a *tremendous* song and dance. Oh man, I always thought I should have gone into politics after that. . . . I told the dean, "I'm a full blood Indian. My name is Echohawk," and I explained it. I said "I fought in North Africa and *dreamed* of coming to the Art Institute of Chicago, and I crawled in Italian mud and *dreamed* of coming to the Art Institute." I said, "At Anzio I pulled out a grenade and I threw it and ran with a Tommy gun . . . and I *dreamed* of coming to the Art Institute of Chicago." The dean put his hand up . . . and he [wiped his forehead]. . . . He said, "Mr. Echohawk fill this out and we'll get you in tomorrow."[15]

Echohawk spent three years, from the fall of 1945 to the end of summer 1948, as a student at the Art Institute of Chicago.[16] He freelanced here and there as he could, trying to make ends meet, but those proved lean years for the young artist. He worked hard to support himself

and to stay in school. During one week, he recalled visiting fifty-five different art directors, trying to get a job creating small cartoons. He received fifty-four "nos." On his last attempt, however, he landed a job. He sold eight peanut cartoons to Planters for $1,000. His persistence paid off.[17] Echohawk later found work as a staff artist for the *Chicago Sun-Times*, the *Chicago Daily Times*, and the *Chicago Herald American*. He also worked as a television announcer for WBKB Chicago. He recalled, "I helped write the first format for the *Tonight Show*. As a matter of fact, I was the first host on the *Tonight Show* followed by Jack Lescoulie."[18]

Echohawk kept finding odd jobs to stay afloat. He moved to New York, where he worked in the television industry and continued with his artwork. He acknowledged, "I did not once think that I could come out and hang a shingle and become a successful artist. . . . I knew the road ahead was hard. I would stop, break off, and work somewhere. Then I'd paint and start again." Trying to find work, as well as time and opportunity to paint, proved a constant battle, but he drove himself to continue. "I only had desire," he said, "burning desire."[19] Echohawk recalled: "I went to New York and starved for a while, and I became a TV announcer up there. Again the Indian name came up like magic." He told a story about being asked about his last name by the television producer. He proudly explained to the man that he was a Pawnee Indian. He later credited his name for helping draw his superiors' attention at work.

Although Echohawk continued to grow as an artist, it took time to get noticed by the right people. Painting remained his passion, but he did other art-related work for ad campaigns, cartoons, and grocery ads to keep food on the table and a roof overhead.[20] He could do the work, and do it well, so he found creative ways to do what he loved. He later recalled that "as a fledgling artist, I did just about everything to stay afloat."[21] Life for the artist continued to be financially challenging.

Echohawk began working as a professional artist at a time when many artists and connoisseurs stepped back to reconsider and redefine the field of Indian art. Echohawk resolved to avoid what might be considered the stereotypical Indian art of his day. Experts writing on the subject described Echohawk this way: "An enigma to the Indian art world, Echohawk refuses to follow the normal Indian artist pattern, seldom allowing his paintings to be shown in the traditional Indian art expositions. He paints in the educated classic style which has no relation to the stylized Indian art designs of symbols and forms currently favored in the popular market."[22] In examining the evolution of

Echohawk's career, one may gain an appreciation of his significance in this context. In 1964, a special edition of *Nebraskaland* included a co-authored article that formally addressed the issue of defining "Indian art." The authors addressed the need for an unambiguous definition of the seemingly loaded term, questioning whether it referred to the subject matter alone, or to the individual creating the art. The lack of a clear-cut definition, they claimed, led to confusion and frustration for both artists and connoisseurs. They questioned the validity of the term "Indian art" and noted that the issue was not simply one of semantics but that the success or failure of many artists could hinge on interpretations of what the label really meant.[23]

The *Nebraskaland* essay discussed the works of six contemporary Indian artists, including Brummett Echohawk, whose works ran the gamut in terms of subject matter and style. The article duly noted his education in highly respected institutions and stated that "his style and technique" did not reflect "any particular preconceived 'Indian artist' label," despite the fact that much of his work depicted American Indians and the American West. The authors recognized his impressive ability to employ numerous techniques and styles in his work.[24]

Echohawk believed each of his paintings should tell a story, convey a message, impart a particular feeling, or serve as part of the historical record. He rejected the limitations attached to the "Indian art" label.[25] He wanted to take his classical training and merge it with his cultural heritage and his sense of history and place. Echohawk considered himself an Indian artist, because he *was* an Indian creating art, but he refused to accept the label. He called himself a "historical artist," or a "fine artist." While extremely proud of his Pawnee heritage, he wanted to be recognized for his abilities and the quality of his work rather than be pegged for a particular style or genre before people ever took a critical look. "I am not an Indian artist, I am a fine arts painter. . . . I'm a realist painter who is an Indian—there's a difference."[26]

The way Echohawk marketed himself differed significantly from the way he felt the term "Indian art" *should* be interpreted. He once told a symposium audience that he believed the so-called authorities on art held "myopic" views of art. He argued that Indian art "is where your heart is if you're an Indian." He continued, "Really. Only you as an Indian can paint what you do." He encouraged American Indians interested in the field of art to get involved in research and to ask questions of their elders. He felt that style had little to do with whether or not something qualified as Indian art. Echohawk made a joke, saying that whatever an American Indian did in terms of art must be Indian art

for the simple reason that it was made by an Indian. "For one thing," he said, "It's not Russian art—right?"[27]

"Light, colors, and spirit—that's what I paint," Echohawk told a journalist with the *Tulsa World*. "You have to show the spirit in the painting, because the spirit lives forever. A painting should be an investment, and it should move you, and move you, and move you. . . . That's why I do impressionistic landscapes—I am painting the spirit of a picture, not a picture of a picture." On more than one occasion he said that if people just wanted a pretty picture to look at, they could go buy a calendar.[28] Although Echohawk maintained a preference for impressionism, his reputation rested more on his realistic paintings.[29] Echohawk compared himself to Rembrandt, but others compared him to Frederic Remington and Charles Russell because of his realist works. This, like the "Indian artist label," bothered Echohawk.[30]

Echohawk had very particular ideas about what did and did not qualify as art. He had high standards and impressive ambitions. He worked in nearly all forms of art (including stage and film acting), but much of what he did fell into the realms of cartooning, illustration, "historical art," and fine art. He told a magazine writer, "I take the time to study . . . to research my subjects. . . . I have always loved history as a part of the total art scene. And I have always loved art. I was born to be an artist."[31]

Using art as a means to record history was certainly not a new idea, but the way Echohawk went about it, and the times in which he operated, made his efforts notable and distinctive. Historically, most cultures without written languages used images to make records and to convey information. Among American Indian populations, examples abound. A few of the more obvious examples include wampum belts, winter counts, petroglyphs, and pictographs. Although the mediums changed over time, Native peoples still maintained traditional art forms. Echohawk intentionally parted from the more conventional styles of American Indian art of his time and employed a European-influenced approach.

Echohawk took issue with artists whom he judged superficial. Those he called "faddists" irritated him. Although he occasionally had exhibits at various galleries, he preferred the private market. As a general rule, he also avoided art groups. He concluded that too many artists joined such organizations for strength and credibility rather than working hard to make their pieces artistically sound. Echohawk believed that many of the faddist artists painted "in riddles." That is to say, he felt they created pieces with little meaning because they did not

connect with reality.[32] "Those are just expressions that the public has to decipher," he said.[33]

Echohawk believed deeply that art should stand the test of time and that artists should produce work worth preserving. He explained, "Renoir and Rembrandt painted simply, their works exuding warmth and life which have lived for centuries while the works of fad painters have fallen by the wayside and decayed."[34] If Echohawk's subject matter held significance, and he did all in his power to capture it truthfully, his artwork would last. He hoped his work would survive not only physically, but that it would enlighten and inspire those who viewed and studied it.

Brummett Echohawk believed the field of art remained wide open. He encouraged others to pursue it. Plenty of room existed for new artists. Echohawk recognized many forms of art that he believed to be worth working toward. He said, "Art itself is like the American Indian. It has many faces. Art is not just one thing." Echohawk thought that the world was full of art that most fail to recognize. He saw art as an integral part of daily life. Artists design homes, office buildings, prints on clothing, book covers, vehicles, and grocery ads. He said, "The wheels of progress of mankind would grind to a halt if it were not for an artist."[35]

Echohawk contended that painting the American West "makes me deeper in what I am, because I enjoy research." He maintained that research creates knowledge, which feeds the imagination, and an artist must constantly feed the imagination to keep creativity from drying up. He asserted, "You should have a dialog with your canvas, so when your canvas is done, it should say something to the people. It should make them cry, or make them very sad. Or you can make them feel the wind blowing around the buffalo hunt. This is what you are. You are an artist, and always remember that art is older than the written language. . . . It is a communication of beauty."[36]

Truthfulness, accuracy, and a great deal of thought and planning formed the heart of Echohawk's work.[37] He dedicated himself to accurate portrayals of historic events. When painting scenes of the American West, he wrote, it "is a project of intense research, as well as a venture into time." Echohawk emphasized the importance of research: "I turn over every stone at that stage of history. I check weapons, dress, horse gear, the works. Attention is paid to the soil, streams, trees, vegetation, rocks, and seasonal dress of Mother earth. I check weather reports and try to hit the same kind of weather that prevailed during the historic happening."[38] He strongly believed that his dedication to

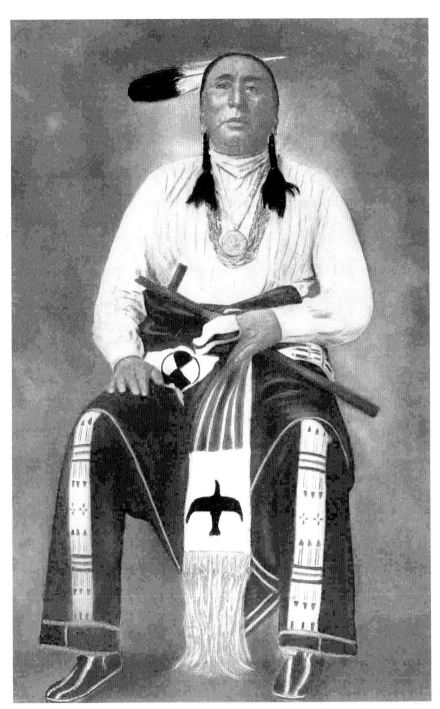

Howard Echo Hawk, by Brummett Echohawk. Courtesy of Myron Echo Hawk.

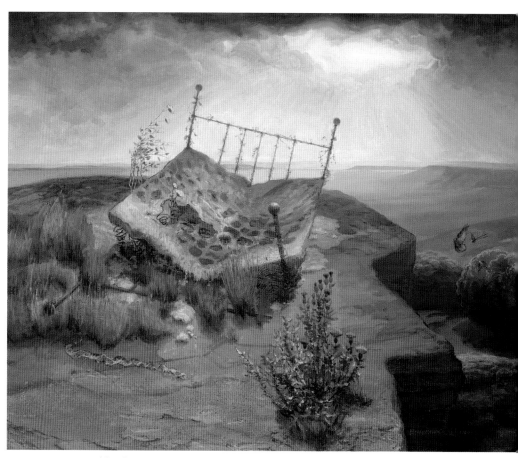

A Bed for the Great Spirit, by Brummett Echohawk. Courtesy of Joel EchoHawk.

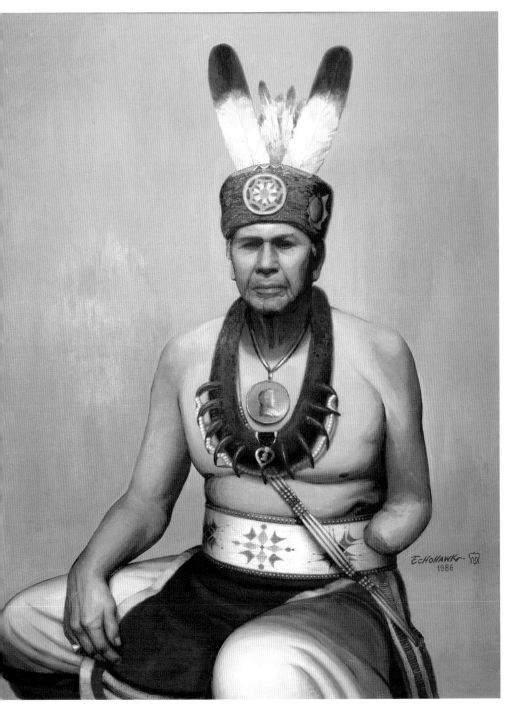

Sgt. Philip Gover—Pawnee Thunderbird, by Brummett Echohawk. Courtesy of Joel EchoHawk and the 45th Infantry Division Musuem, Oklahoma City.

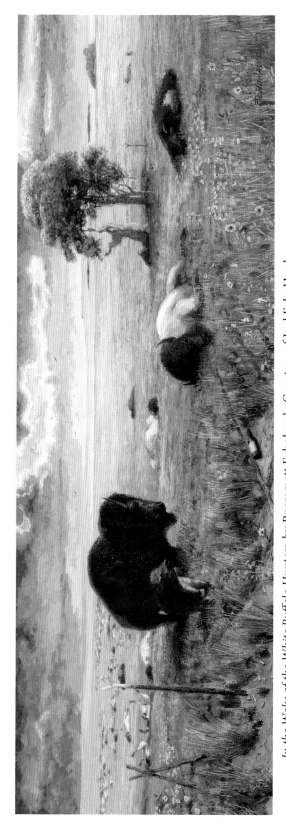

In the Wake of the White Buffalo Hunters, by Brummett Echohawk. Courtesy of Joel EchoHawk.

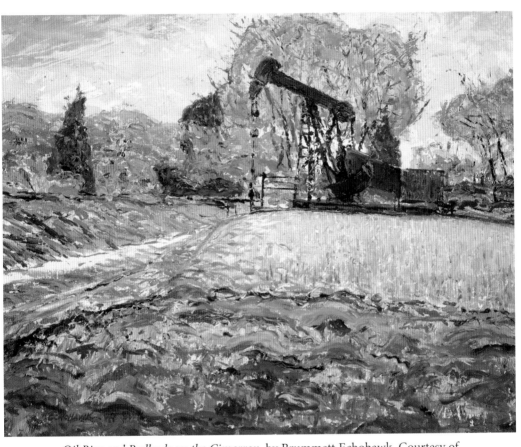

Oil Rigs and Redbuds on the Cimarron, by Brummett Echohawk. Courtesy of Joel EchoHawk.

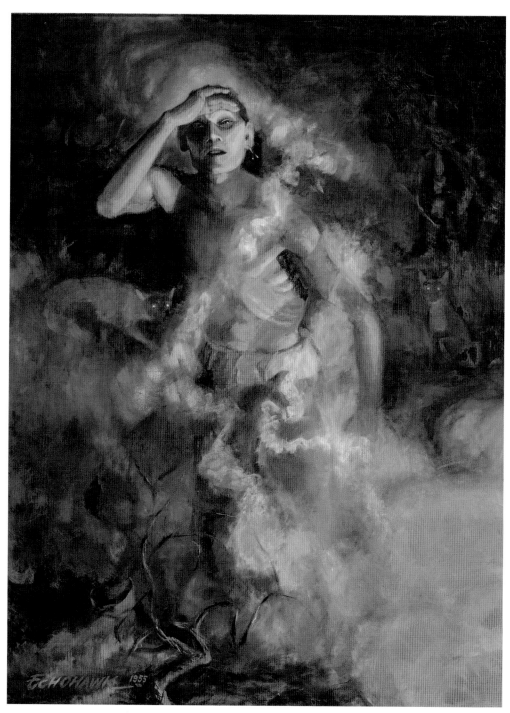

Kitsa-Hootuks, by Brummett Echohawk. Courtesy of Joel EchoHawk.

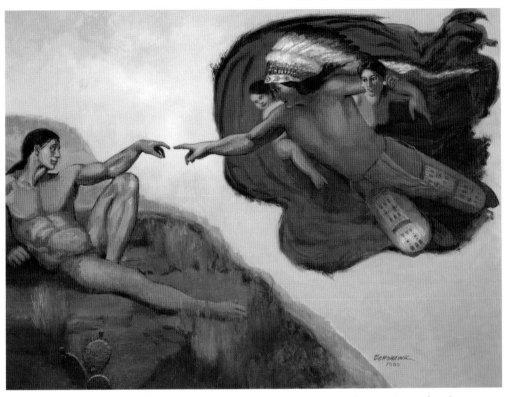

The Creation of Adam, Revisited, by Brummett Echohawk. Courtesy of Joel EchoHawk.

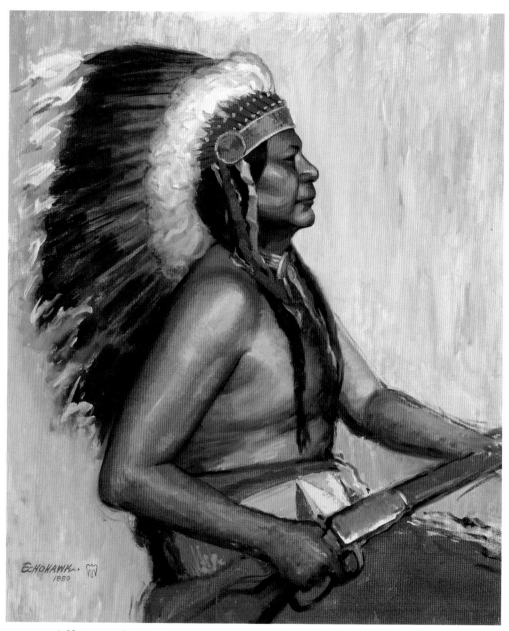

Self-Portrait, by Brummett Echohawk. Courtesy of Joel EchoHawk.

authenticity gave his life and career "public meaning." Through his efforts to get the details right, he had the ability to influence the public's understanding and perceptions of his subject matter. He understood that artists and writers who depicted historical events without doing sufficient research often perpetuated inaccurate portrayals and stereotypes. "I paint the truth. And when I write, I do the same thing," he said.[39] Once in an article about a painting he made of Massacre Canyon, he wrote, "I tried to capture this—Massacre Canyon—on canvas for all time."[40] He felt that history should be recorded both in paintings and in writing.[41]

Echohawk followed the path forged by American Indian educators like Acee Blue Eagle, Woody Crumbo, and Dick West, who directed the Indian art program at Bacone College from the 1930s to the 1970s. As the Indian art market developed in eastern Oklahoma, these instructors taught their students to use research as a tool to improve their artwork. Research included talking to family members and tribal elders. When students still believed they needed more information, they could turn to the library filled by their instructors with anthropological, historical, and ethnographic works on American Indian tribes. The more accurate their work, the better, particularly for purposes of competition, credibility among their Native and non-Native audiences, and professional success.

Blue Eagle, Crumbo, and West all developed reputations as painstaking researchers. They did much of their research in the library at Bacone as well as among the tribes, in museums, and in archives near and far to ensure the accuracy of their work.[42] Some critics questioned the authenticity of their work because they used research as a tool. For decades, the use of research as a tool in creating artwork was viewed with skepticism, and detractors fostered the perception that authentic portrayals came only from innate ability and personal experience. As Echohawk confronted the idea of what constituted Indian art, he faced similar issues regarding "images of Indianness and non-Indians' definitions of what constituted traditional Indian art."[43]

Echohawk favored working on oil paintings. He used oils in his impressionistic landscapes and in his realistic portraits and historical pieces. His unique oil painting techniques, despite his postwar formal training, drew attention throughout his career. A palette and bowie knife served as his primary tools. An article in the *Saint Paul Dispatch* furnished helpful information regarding Echohawk's background and art styles. Don Boxmeyer noted Echohawk's unusual use of the bowie knife in his painting process when he wrote, "It's been a moon or two

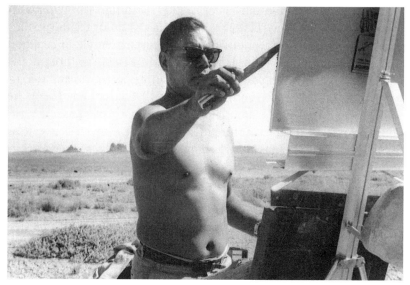

Echohawk painting with his bowie knife. Courtesy of Joel EchoHawk.

since Brummett Echohawk lifted a scalp with his big Bowie knife," instead employing his knife in the pursuit of art. He quoted Echohawk's explanation for the atypical tool: "My knife can turn the color better than a brush. . . . It gives me a feeling for the subject, and its very massiveness and weight is an asset."[44]

Echohawk began using his knife as a painting tool quite by accident. One day while painting, he dropped his paintbrush in the sand on a riverbank. He did not have a backup brush, so he turned to the hunting knife he always carried. He said, "I found that I could use it naturally, with great effect." After that incident, he made regular use of his bowie knife when painting.[45] Michael Gonzales, Echohawk's friend at the 45th Infantry Division Museum, once asked Echohawk if the knife he used for painting was *the* knife from Echohawk's stories—the knife he used in the war. Echohawk responded in the affirmative. Indeed, the knife Echohawk used to paint was the same knife he used in combat during World War II.[46]

Echohawk adapted his classical training as he used his bowie knife to create a variation on Van Gogh's palette knife technique. The knife allowed him to create particular textures and to "trap light," better than more traditional tools.[47] He sought to master a technique wherein he could "freeze the translucent light in his paintings." He explained, "I'm working to perfect that sense of movement in my paintings. . . . I call

it the fourth dimension in art." The *Tulsa World* ran an article that clarified Echohawk's fourth dimension: "It is the same dimension . . . that is evident in classical music. . . . Echohawk is working to bring the same tonal ranges, crescendos and fortissimos to his canvases, via color, light and design." Echohawk told the reporter, "I want to be able to take a color and add thunder and bounce to it. . . . I want my work to come to life. Toulouse Lautrec was touching on it. Van Gogh came very close."[48]

An example of Echohawk's attempts to capture light in his oil paintings, particularly his impressionistic paintings, shows clearly in an image he painted of an old cemetery nestled in a wooded area near Vian, Oklahoma. After looking over the burial ground, he determined to paint it with the light of dawn. He anticipated that "when the first shafts of sunlight came through the leaves, the leaves would turn yellow and it would give a halo effect and a spotlight effect on . . . the older tombs." Echohawk described the cemetery as a mix of old tombs, which resembled small houses with wooden doors. Fifteen-inch stones marked the more recent graves. In order to determine if the light would show as anticipated, and to capture it on canvas if it did, he spent the night in a neighboring pasture. He got up before dawn and made the necessary equipment preparations. As the sun rose, Echohawk recalled, "Shafts of sunlight broke through," shining on the house-like tombs, gravestones, and wildflowers. "You had the feeling," he said, "that the sun is coming up and new life is beginning, but here's just the opposite now. Here's an old, old cemetery and the only thing that shows any kind of life at all are the beautiful flowers . . . a red growth of flowers."[49]

The cemetery painting attempted to capture the contradiction between the rays of morning light and fresh wildflowers and the quiet solitude of the burial ground. He used the bowie knife, as he often did, to capture the light with his paints. Echohawk said that with the proper technique, one could use color to "design the light" in a painting. He believed that one could create a canvas that released light the same way energy is released and that the light would begin to "break into prisms." Ultimately, he wanted to achieve a painting that emitted a feeling of "shimmering sunlight . . . passing through the forest and hitting this lonesome little cemetery."[50]

In the early 1950s, Echohawk began to research Custer's campaign that led to the Battle of the Little Bighorn in 1876. He wanted to create twenty to thirty "life paintings" depicting what transpired. He planned to begin with the troops' departure from Fort Lincoln, Nebraska, and

to capture the events preceding and including their demise on Custer Hill and the end of the battle. He aimed to complete the research and paintings in time for the one hundredth anniversary of the event in 1976. Echohawk did not complete the project, due in large part to inadequate funding. He even made a trip to Washington, D.C., to raise money for the endeavor. However, he said, "I was not up on the art of 'grantsmanship,' nor was I a politician. But art demands that I not stand still."[51]

In 1955, Echohawk traveled to Kyle, South Dakota, to visit an aged Sioux chief named Iron Hail.[52] The ninety-three-year old Sioux veteran was one of the last living witnesses of the Little Bighorn Battle, which saw Brevet Major General George Armstrong Custer lead his troops to their defeat at the hands of combined Lakota and Cheyenne forces. Iron Hail spoke "old Sioux," not English, so his grandson served as an interpreter. Echohawk and Iron Hail also used sign language to communicate. Iron Hail had been about fourteen years old at the time of the Little Bighorn Battle and had ridden with a group of teenagers carrying bows and arrows escorted by adults armed with guns to the site of the battle. Iron Hail told Echohawk that he remembered it being near noon when his group reached the battleground. By then, Echohawk related, "The dust was flying, and the Sioux warriors were shooting at the ground, which meant the battle was over." Echohawk completed eighteen different charcoal drawings of Iron Hail. In the 1980s, a private collector donated one of the drawings to the Gilcrease Museum's permanent collection.[53]

Countless books and artworks portrayed the Battle of the Little Bighorn and the fall of Custer. The history of the campaign leading up to the battle intrigued Echohawk, so he researched the event extensively because he felt something worthwhile could be added to the record. As late as 1989, he still wanted to complete an entire series documenting Custer's final campaign. Echohawk described his painting *Hunter's Moon*: "I'm showing Custer laying there with a bullet hole in the temple and one in the heart . . . and of all things, Custer had a smile on his face when they found him." He speculated that Custer fell among the first of the soldiers with the chest shot. Custer's soldiers dragged him to the top of the hill and continued fighting until the battle ended. Basing his conclusion on Custer's smile, Echohawk believed that the head shot came later, after Custer's death. Either shot would have been fatal, but Echohawk deduced that the heart shot, much like heart attacks or seizures, caused the general's face muscles to contract, creating the appearance of a smile. He credited rigor mortis for preserving the smile

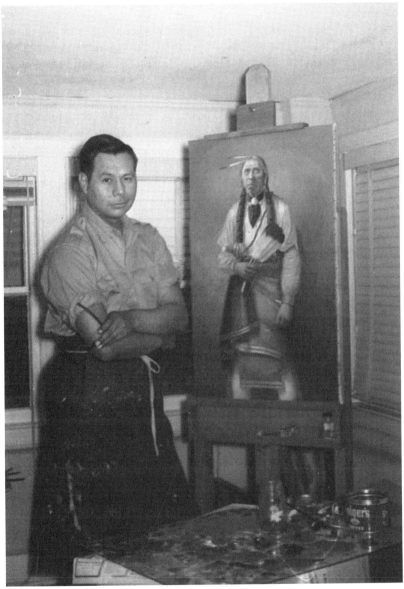

Echohawk painting history. Courtesy of Joel EchoHawk.

and freezing Custer in a position propped on one arm. In the background of the picture, Echohawk painted a full moon, because according to history, a new moon came out that night following the battle.[54]

In 1968, the Amon Carter Museum of American Art in Fort Worth, Texas, included two of Echohawk's Little Bighorn pieces as part of a

larger Custer exhibit. The tempera paintings *Custer's Luck* and *A Bullet for Yellow Hair* represented only a small portion of the work Echohawk had created on the subject. The museum exhibit resembled what Echohawk intended to achieve with his own series, but he still hoped to assemble an exhibition composed entirely of his own work.[55]

Echohawk's work garnered increased attention by the 1950s, and his reputation as an artist grew; however, Echohawk occasionally became frustrated by limited sales based on his chosen subject matter. He was as dedicated to his work in the early years as he was in his later years, yet most of his early work did not sell. Echohawk concluded that people did not buy his paintings because they did not have the historical or geographical knowledge to appreciate them. "Number one, they were not aware of Oklahoma history," he said, and "number two, they were not aware of the Pawnees." Despite this, he continued painting and doing other work. He felt that one could not afford to sit back and wait for a buyer, but that a true artist had to depend on inspiration and keep working. Only by continually working could one continue to improve.[56]

As a freelance artist, Echohawk had to work in various venues. In 1949, for example, he illustrated the article "There Were Two Sitting Bulls" by respected author and historian Mari Sandoz, which appeared in McCall's *Bluebook Magazine*. A few years after the publication of that issue, Echohawk wrote the author to thank her for the truthful representations she provided of American Indian people and asked if she remembered him as the illustrator. His letter began a string of correspondence. The two had much in common. She grew up around American Indian peoples as her father had been a pioneer on the Nebraska frontier. Once she established herself as a reputable historian and writer, Sandoz found success writing about what she knew best—the Great Plains and the tribes residing there.[57] Early in their correspondence, Sandoz asked Echohawk if he would be interested in illustrating two juvenile books she wanted to write. He answered in the affirmative, but other work required her to delay that project. Echohawk visited Sandoz in New York when he was in town for a few weeks in October of 1952. While he and Sandoz had a cordial and productive visit, Echohawk felt somewhat disappointed in the true purpose of his trip. He later wrote Sandoz: "I didn't accomplish much in the way of free lance illustration while I was in New York. Not enough time. I am not the best. And I am not the worst. I'll have my day."[58] He continued to illustrate for others and for his own work throughout his career,

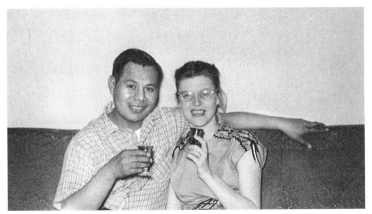

Brummett and Mary Francis Echohawk. Courtesy of Joel EchoHawk.

including the books *Prisoner in the Circle* by Mygatt in 1956 and *Young Rider of the High Country* by McGough in 1994.

Wherever Echohawk lived, he worked hard and found a degree of success, yet he always wanted to return to Oklahoma. After living in Chicago and Detroit, then moving to New York as a freelance artist, Echohawk moved to Dallas to work as a commercial artist. In 1950, he attended a sketching class at the Philbrook Art Center in Tulsa, Oklahoma. In the class, Echohawk met his future wife. Mary Francis McInnes, born September 25, 1922, in Mangum, Oklahoma, was about the same age as Brummett. In 1952, Echohawk moved closer to home to establish residence in Tulsa, Oklahoma, and marry McInnes. Although Mary did not pursue a career in art as her husband did, she still enjoyed art and continued sketching throughout her life. She was well liked by Echohawk's family and friends. She enjoyed community service and gave much of her time to cancer associations. She also helped organize events like Christmas parties for American Indian children. Mary was very supportive of her husband's work and often traveled with him as he went about his business. At times, she used her own artistic abilities as a means to supplement the couple's income. Occasionally, she even modeled for his paintings. He always maintained that she was an inspiration.[59]

Echohawk worked as an artist for a Tulsa oil company in the early 1950s before deciding to pursue a full-time career again as a commercial artist.[60] Years after returning to Oklahoma, he said, "I feel this is a very nice place to be and I've always wanted to come back." Even when he lived elsewhere, his subject matter often came from his roots

in Oklahoma. He recalled being acquainted with artists in New York who painted scenes of city parks and sidewalks. His response: "What's wrong with painting the blue stem grass of the great Osage Nation? What's wrong with painting a sunflower field in Pawnee? What's wrong with this red Cimarron River?" He felt that Oklahoma had endless subject material that other artists overlooked and much that had yet to be touched. "My first love," he said, "was always to come back to Oklahoma and paint what we have here."[61]

During the late 1930s, American Westerns climbed in popularity, and for roughly three decades, American popular culture embraced these films and the Western genre enjoyed a golden age.[62] Taking advantage of this social backdrop, in 1954 Echohawk created the comic strip *Little Chief*. He explained the cartoon as "a way of eating and paying the bills." Although at the time he was doing freelance work for various magazines and newspapers in the East, he needed something to bolster the income those odd jobs garnered as he built his career.[63]

The *Little Chief* comic strip caught the attention of some large syndicates, and offers came in to buy it for national publication, but the syndicates had conditions. Echohawk explained his refusal to syndicate *Little Chief* by saying the "syndicate people" wanted him to have the main character, a child, "involved in war parties" and other unlikely ventures. "They wanted me to put a big nose on him and use 'wagon train' gags." Echohawk indicated that syndicate representatives upset him with instructions to include what he viewed as "corny dialog: 'Ugh, me this and that.'" The syndicates wanted to use the cartoon for children's comic books. Echohawk said, "These people missed the point of Native American culture and Indian humor. If they didn't understand, how could their children understand? Their version is the impression from TV, which is chewing gum for the mind." The cartoon strip ran in Tulsa's *Sunday World* the longest, although it gained popularity in other areas in the Southwest.[64]

When describing his inspiration for *Little Chief*, Echohawk spoke of a childhood in which he and his playmates had to entertain themselves with whatever surrounded them. He said, "Our adventures centered around the animals we saw and the older people. . . . That's where most of the material for Little Chief came from." As a child, regular activities like hunting, fishing, archery, and throwing knives appealed to him. He "rode horses, swam swollen rivers and experienced tribal ceremonies. At night heard the old ones tell stories till I fell asleep—and lived with Indian humor, which is not offensive. It is a spiritual increment." Real life offered a wealth of opportunity for humor. Although *Little*

LITTLE CHIEF By Brummett Echohawk

Echohawk's *Little Chief* comic strip published in the *Tulsa World*, December 31, 1964. Courtesy of Joel EchoHawk.

Chief's last days of steady appearances in the *Tulsa World* came in the 1960s, some appeared again in later years, and the Frye Art Museum in Seattle, Washington, created an exhibit entitled *Little Chief: The Comic Art of Brummett Echohawk* in 2001.[65]

In October of 2008, *Out of Sequence: Underrepresented Voices in American Comics* opened at the University of Illinois's Krannert Art Museum. Curators Damian Duffy and John Jennings organized *Out of Sequence* in reaction to an exhibit called *Masters of American Comics*, which Duffy wrote, "was meant to create a canon of master comics creators in an art museum context." Duffy and Jennings believed that the *Masters of American Comics* exhibit failed to recognize the diversity the field afforded, so *Out of Sequence* focused on diversity—not simply in terms of the creators, but also in terms of the types of comics created.[66]

Out of Sequence included the comic art of Brummett Echohawk for multiple reasons. First, the curators wanted to include a Native American artist for the sake of diversity. Second, they wished to help offset their University's "history of celebrating racial prejudice" with their recently retired mascot, Chief Illiniwek. Third, they found the artistic skill required to design *Little Chief* truly impressive. And, finally, they appreciated Echohawk's ability to make the comic strip with a "quietly revolutionary conviction to show Native American comics characters in a positive light, entirely outside the demeaning and diminishing depictions common to American popular culture."[67]

When he talked about his cartooning days to a group that included many hopeful young artists, Echohawk described one of his cartoons. In this particular image a group of Indians performed a war dance. He explained, "These Indians were doing a long circle, like so . . . all in line, dancing . . . kicking up dust and everything, and the last two

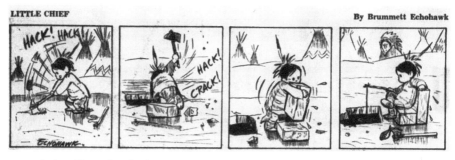

Echohawk's *Little Chief* comic strip published in the *Tulsa World*, February 7, 1960. Courtesy of Joel EchoHawk.

Indians on the end of the line were stopped in frustration. One Indian here, and the two on the end, and the one Indian was looking at the other and he was saying, 'Why can't we dance with women?' This is an example of what you must do to be a cartoonist. You must use your wit. Learn design. Put something out there."[68] Echohawk took cartooning seriously. Regardless of whether it was what he loved doing, he felt it must be done correctly—and he set a high bar.

By 1955, Echohawk had earned a favorable enough reputation as an artist to secure an invitation to serve as one of three jurists for the *Tenth Annual Exhibition of Contemporary American Indian Painting* at the Philbrook Museum of Art in Tulsa. He served with Willena D. Cartwright, the Denver Museum of Art's American Indian art curator and the winner of the previous year's grand purchase prize award (the winner automatically became a member of the following year's jury). Echohawk accepted the invitation.[69]

Shortly after the invitation from the Philbrook, Echohawk's name appeared in *Smoke Signals*, a circular published by the Indian Arts and Crafts Board, under the Department of the Interior in Washington, D.C. The issue discussed the opportunities for Indian painters, pointing out that American Indian painters had a special niche in the art world, due in large part to their comparatively small numbers. The paucity of Indian painters meant that "inferior Indian painting sometimes receive[d] acclaim just because it's different," though the author thought this would change with time. Non-Indian artists recognized the wealth of material in the field, but noted that work produced by non-Indians often depicted "unrelated or partly faked symbols jumbled together in misleading pattern." According to the author, true American Indian artists rarely made such errors. The article called

upon Native artists to lead the way in picturing the American Indian world in art.[70] In the same issue of *Smoke Signals*, an article discussed an exhibition put on by the M. H. de Young Memorial Museum in San Francisco during the winter of 1954–55. The museum touted the exhibition as "one of the most comprehensive ever assembled" and included the work of about fifty artists, including Brummett Echohawk.[71]

The All-American Indian Days in Sheridan, Wyoming, hosted an art competition for Indian painters in the summer of 1957. Promoters labeled the competition as the "first art exhibit for Indian artists . . . in the Northwest." More than one hundred paintings were entered in the competition. In the tempera category, Acee Blue Eagle (Creek and Pawnee from Oklahoma) took first place.[72] Blue Eagle and Echohawk maintained a longtime friendship, and the two men shared much in common in their theoretical approach to American Indian art. In the Sheridan competition, Echohawk placed in the top six in the same category. Five of the six top place winners in the category came from Oklahoma.[73] This stands to reason when one considers the development of American Indian art through the market in eastern Oklahoma, the art program at Bacone College, and the increased interest shown by reputable galleries in terms of competitions like the respected Philbrook Museum's *Indian Annual* exhibition in Tulsa.[74] During the 1930s, a distinctive shift had taken place moving the market interest (and thus the motivation for artists) away from traditional crafts to gallery and museum paintings. So when Sheridan held the competition in Wyoming in the late 1950s, many Oklahoma artists stepped up to participate.[75]

Perhaps one of Echohawk's more famous pieces of American Indian history, *The Trail of Tears*, an ink wash completed in 1957, recorded the historic turning point for the Five Tribes when the government removed them from their eastern homes to Indian Territory under President Andrew Jackson's Indian Removal Act of 1830. The image conveys a sense of tragedy and despair. Echohawk said he felt inspired to create this piece because, to him, it "was a black page in American history." To communicate the sense of depression and "dismalness" the people experienced, he used only black and white. Echohawk refused to put any color in the image because he felt it might detract from the mood. He darkened the sky and the horizon line and drew the people straining to continue on their journey. Off to one side, a small burial denotes another death along the way.[76]

Among the artists whom Echohawk admired and respected over the years, besides Acee Blue Eagle, was a non-Indian artist from Missouri, Thomas Hart Benton—one of the most prominent regionalist artists

of the mid-twentieth century. Like Echohawk, Benton had studied at the Art Institute of Chicago. Benton also studied for several years at the Académie Julian in Paris and taught at the Art Students League in New York and the Kansas City Art Institute and School of Design.[77] Echohawk recalled:

> Thomas Hart Benton, until 1966, I believe or 1967, was the greatest artist in America. I had a rare honor of meeting Thomas Hart Benton, because one day the telephone rang and the voice on the other end said, "This is Thomas Hart Benton." I thought it was one of my drinking buddies at the pool hall or something. Then another voice came in and said, "This is President Truman," and I thought, "Well, they *are* drinking now." But it really was President Truman and it really was Thomas Hart Benton. They wanted an artist who knew something about American history and American Indians. I felt real good because it rang a bell, because they said, "We like your name, Echohawk," and I thought, "I do too." But I met with the President, I met with Thomas Hart Benton, and we worked on a mural that took one year to do. It's the greatest mural in the United States, at the Truman Memorial Library.[78]

Little is available in the official record about Echohawk's assistance to Thomas Hart Benton. The only artist's name on the mural is Benton's. Notes exist here and there, but little thought or attention has been given to Echohawk, considering his tremendous pride in the role he played in the creation of the great mural *Independence and the Opening of the West*, which graces the Truman Presidential Library in Independence just outside of Kansas City, Missouri. An interview was once conducted with Benton to record an oral history about the mural. In the interview, he gave little credit to others. After talking for some time about the original idea for the mural and the process of its creation, Benton failed to mention much about any assistance—other than his frustration with Truman's ideas for the theme. Eventually, his interviewer asked him directly, "Did you have any help with all this?" Benton responded, "Yes. Charles Banks Wilson, the Oklahoma artist helped me find my Indians—he and Brummett Echohawk, a Pawnee Indian artist, also from Oklahoma. Echohawk knew a lot about old Pawnee customs and was a great help."[79]

Benton made two trips to research the West that he was preparing to depict in the mural for Truman. He spent most of the second trip (1959), which focused primarily on the Santa Fe Trail, in the company of Charles Banks Wilson. Wilson accompanied Benton to introduce

him to Native American contacts along the way. Benton's research indicated that the first tribe most travelers would have encountered when they left Independence would have been the Pawnee tribe, and for that reason, he wanted Pawnee models for the mural. Wilson took Benton to Tulsa, where he met Echohawk, who took the men to a church in Pawnee and introduced Benton to an old lay preacher whom Benton decided to use as his model.[80]

Although the two became friends, Echohawk remembered that their work together proved difficult at times. Meticulous about the details of their work, both wanted a truthful representation, but they understood the execution of "truthful" representation differently. Echohawk told a magazine reporter that Benton "was trying to paint a white man's version of the Indian . . . a kind of Hollywood design. I wanted to give the full blood Indian's viewpoint." Echohawk portrayed his work with Benton as "a time of fun and a time of fierce differences of opinions." He described working together on the project, saying, "Benton was painting in my field. And we hit head on. He had a flat type design in his work. And I was trying to gain in the mural a moving, third dimension that would be ignited by light. We often exchanged strong words. But his mural is the only one like it and it is the greatest in America. Working on it was a stepping stone in my career. And I will always treasure what Benton told my wife, Mary, in private. He said, 'Brummett is a real artist.'"[81]

Echohawk continued working hard. He illustrated for numerous publications, typically those including entries on the American West and American Indians. Between 1953 and 1984, *Western Horseman* used sixteen of his paintings for its magazine covers, printed many of his cartoons, and published numerous self-illustrated articles.[82] Much of his work for *Western Horseman* predictably depicted scenes of rodeos, cowboys, and horses. Occasionally, he incorporated work dealing with American Indian themes, including a cover article on the Pawnee Scouts. From time to time, he cleverly inserted a self-portrait in non-Indian themed works.

Echohawk's work also appeared fairly regularly in publications like *Oklahoma Today*. In the late 1950s and into the 1960s, he illustrated short articles with images that often appeared more cartoon-like in nature and helped bring to life the humor in these segments.[83] He also successfully illustrated more serious articles for the magazine.

In the spring of 1965, Echohawk illustrated an article by Zoe A. Tilghman, wife of the famous lawman Marshall Bill Tilghman, in *Oklahoma Today*. Mrs. Tilghman earned a reputation for her dedicated

research and attention to detail. "A Bed for God" described the tribes of Oklahoma and the desperate embrace by some of Wovoka's Ghost Dance. The Ghost Dance was supposed to be a nonviolent religious ritual, and, according to Wovoka, a Paiute man many viewed as a prophet, the observance of the dance brought hope to Indian people everywhere. The article related the story of a woman who, while participating in the Ghost Dance, had a dream in which she saw a new bed nicely made. The article explains how her people interpreted that dream and what they did as a result of the interpretation. They felt that it related to the stories they heard from Christian missionaries about Jesus coming into the world and having no place to rest his head. The people determined to fulfill the dream by collecting funds and purchasing a beautiful bed for him to lie in when the Ghost Dance prophecy was fulfilled and he returned. The people reverently carried the bed to the top of Coyote Butte, the highest point in the area, and placed a bright new tent around it. Eventually, faith in the Ghost Dance faded, and weather destroyed the tent and ruined the bed. At the end of Tilghman's article, the bed deteriorated and became covered over by earth and grass. "So Coyote Butte holds its memory of a hope and promise that was lost," she concluded. Familiar with the history, Echohawk had the ability to create appropriate illustrations of the dance and the story's key location, near El Reno, Oklahoma. His knowledge of the subject and his proven artistic ability made him the perfect candidate to illustrate this article published in memory of Zoe Tilghman shortly after her death.[84]

Similarly, in a later issue of *Oklahoma Today*, Echohawk illustrated a poem entitled "We Are the White Wolves." Historically, the Pawnees used the term *araris taka* or "white wolf society" to describe military expeditions made up of men from multiple societies, temporarily forming a new society, to go against the enemy for purposes of war rather than plunder. The poem came from an ancient Pawnee war song, which Echohawk had likely heard before. The song compares the Pawnee people to wolves in the various seasons. Echohawk created an image that not only helped bring the poem to life but served as an addition to the visual historical record of his tribe.[85]

In many ways, Echohawk's career proved comparable to that of Hochunk artist Angel DeCora, the best-known American Indian artist prior to World War I. DeCora received a formal education in boarding school at the Hampton Institute, then at private school in New England, later at Smith College, and eventually at the School of the Museum of Fine Arts in Boston. She launched her career by publishing

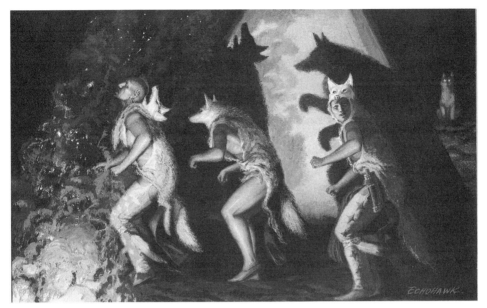

We Are the White Wolves, by Brummett Echohawk. Printed in *Oklahoma Today* 21, no. 1 (Winter 1970–71): 20–21. Reprinted with permission of *Oklahoma Today*.

self-illustrated articles in *Harper's Magazine,* and later illustrated articles and books for others, including impressive cover art—much of which went unrecognized as the work of an Indian artist. Her work demonstrated her awareness of the cultural significance art could hold and adapted "Euro-American forms" of art to "correct and humanize stereotypical imagery of Native life." Having spent so much time away from her people at home, she often conducted research in the museums and other venues around Boston to ensure accurate portrayals of the various tribes she depicted. She once wrote, in words very similar to Echohawk's, "I am not the new Indian, I am the old Indian adjusted to new conditions."[86]

More than half a century later, Echohawk's career path followed a similar trajectory. Much of his work for magazines like *Western Horseman* and *Oklahoma Today* or in the Chicago or Oklahoma newspapers depicted non-Indian images, or depicted American Indians and the American West in styles outside the realm of popular perceptions of Indian art. Because he painted in what the art world considered a European style, even his images centered on American Indians rarely fit into the preconceived notions of Indian art. Despite this, his approach

to his subjects opened the door for a more open definition of what constituted Indian art and found a way to reach wider audiences.

Brummett Echohawk's dedication to authenticity came from a desire to make an accurate record. Although he recognized the work of historians, anthropologists, ethnographers, and even other artists, he felt the need to offer truthful portrayals of the past and present. His attitude toward preservation connected, again, with the work undertaken by Blue Eagle, Crumbo, and West at Bacone. Echohawk's friend Blue Eagle reportedly made the statement, "If we have Indian customs and manners and habits and dress and games depicted in concrete form, [they] will be remembered." Blue Eagle encouraged students to enter competitions, not necessarily to win them, but to provide educational work and to remind people "you're still alive."[87] Echohawk held the same ideas about creating records, educating through art, and reminding Americans of the first Americans.

In December 1964, Tulsa's local ABC-TV station showcased three of Echohawk's pieces. In the ABC showcase, the first painting, *Peace on Earth*, showed an Indian raising a peace pipe to the Eastern Star. *The Story of Christmas in Sign Language* depicted three men in winter snow each postured in sign—"Wait, silence!" "Big and holy," and "New Chief over all." The third painting was titled *Silent Night*. Echohawk said the three paintings represented his version of Plains Indians at Christmas. A news article and the television spotlight noted that *The Story of Christmas in Sign Language* hung in the U.S. State Department at the time.[88]

The seasonal pieces Echohawk painted drew the attention of Ed Trumble, a private western art collector who cofounded Leanin' Tree greeting card company in 1949. Trumble commissioned him to create seasonal paintings for a line of American Indian–themed Christmas cards.[89] Echohawk continued providing paintings to the Leanin' Tree publishers, about twenty-eight in all. Some images served as Christmas cards, some as general greeting cards, and some became posters.[90] These, of course, drew more attention to Echohawk's work.

In the mid-1960s, the Aluminum Company of America commissioned Echohawk to do a very large painting to add to a series of paintings the company had previously commissioned to depict the history of aluminum in the region. The company wanted him to create something that depicted the history of the Tennessee Valley. In his typical fashion, Echohawk spent a great deal of time researching his project. He had instructions to depict an incident in Tennessee Valley history that overlapped with American Indian (specifically, Cherokee) history

and with the history of aluminum. The painting depicted a Cherokee chief trading a dagger-like weapon made of a metal very similar to aluminum to another chief "for the life of a young, blond white man."[91]

On numerous occasions, Echohawk worked closely with the Spiva Art Center in Joplin, Missouri, only about one hundred miles from his home in Tulsa. Spiva featured his artwork in 1974 and 1975. He spent the summer of 1976 as a cultural ambassador to Germany, and in September, shortly after his return, Spiva opened the 1976–77 season with his work. Echohawk also presented lectures and conducted workshops for Spiva.[92] He kept busy.

The Pawnee Nation's flag offers an excellent example of how Brummett Echohawk's life mirrored much of what Pawnee military men, and the Pawnee people in general, have valued. Designed by Echohawk in 1977, the flag represents various aspects of Pawnee history and culture. A small image of the U.S. flag denotes the alliance between the Pawnee Nation and the United States. A wolf signifies the Pawnee warriors' reputation for prowess. Pawnees use the symbol of the wolf in part because other tribes on the plains referred to them as wolves, and the Pawnee people believe the wolf represents cunning and courage. The wolf is often interpreted by the Pawnee Nation as an emblem of their tribe, an image that embodies their heritage as Chaticks-si-Chaticks. A crossed tomahawk and peace pipe symbolize peace and war. Arrowheads across the bottom represent the major U.S. conflicts—from the Indian Wars to Iraq—in which Pawnee men and women participated (arrowheads have been added since the original design). The design successfully demonstrates the pivotal and historic nature of the alliance made between Pawnees and the United States in the 1860s and the way in which that moment continues to inform the present. Echohawk wrote that the flag meant "Pawnee Indians, in peace and war, always courageous and always loyal to America."[93]

By 1977, the Gilcrease Museum in Tulsa, internationally renowned for its impressive collections of Western and Native American art, artifacts, and documents, officially strengthened its relationship with Brummett Echohawk when it brought him in as a member of the board.[94] He remained on the museum's board through 1982.[95] During that time, he worked with the museum both in an official capacity and as an artist. When asked in 1979 whether museums helped or hindered aspiring artists, Echohawk's response indicated that many museums (he used the Gilcrease and Philbrook as examples) failed to help local artists because those in charge lacked the knowledge to make correct decisions. He criticized the practice of bringing in easterners to judge

local American Indian artwork. "This is wrong!" he declared emphatically. Echohawk continued, "I'm on the board now, and there will indeed be changes made . . . because it is stumping the growth of Native American talent."[96]

Echohawk believed strongly that placing people with the proper educational and regional background in the driver's seat would make a significant difference for American Indian artists. He advised young, aspiring artists to work together and to get good agents so they could "bypass the museums for a while until they wake up." Echohawk indicated high hopes for the future and emphasized his willingness to fight for change. "Believe me," he told the audience, "things are taking place now differently, and we'll be working in that direction for the good of American Indian artists here in Oklahoma."[97]

Officials of the Gilcrease Museum became interested in organizing a gathering of sorts to showcase and sell artwork. With an international reputation to uphold, in 1979 officials selected Brummett Echohawk as the guinea pig for the project. Fred A. Meyers, the museum's executive director, came up with the idea to use the theme of an old western rendezvous and put a spin on it. He planned to have an art show including numerous artists but featuring one in particular each year. The trial run went well, and the museum made the yearly Gilcrease Rendezvous official in 1980, using the art of painter and sculptor Joe Beeler, member and cofounder of the Cowboy Artists of America organization. The annual event lasted more than thirty years and grew in size and scope through the years.[98]

In 1983, photographer Stephen Gambaro selected thirty American Indians, including Brummett Echohawk, for portraits. Gambaro photographed what he considered "nationally known Indian achievers" for the purpose of preserving "a record of contemporary Indian leaders." Gambaro traveled from Washington, D.C., to Oklahoma to photograph his Oklahoma subjects. (Ten of the thirty to be photographed lived in Oklahoma.) The Gilcrease Museum accepted and exhibited the photographs because of the artistic nature of the portraits and because of their historical value. Gambaro photographed Echohawk in his home studio in Tulsa.[99] That same year, Echohawk received the third annual Unknown Indian Award from the Committee for the Preservation of the Unknown Indian. The annual award promoted recognition of the accomplishments of American Indians.[100]

Roughly a year later, Echohawk's wife, Mary, was diagnosed with cancer. Although she battled bravely, her health declined quickly. "She was very spirited and very strong about [the cancer]," Brummett said.

"I just painted harder and harder." She was admitted to Saint John Medical Center in Tulsa on December 23, 1985—just before Christmas. Instead of flowers, she requested that her husband bring her one of his paintings to enjoy in her hospital room. At the age of sixty-three, after thirty-three years of marriage, Mary McInnes Echohawk died on January 8, 1986.[101] She was buried in Highland Cemetery in her husband's hometown of Pawnee, Oklahoma. Brummett designed her tombstone, though it took him until August of 1992 to finalize the design. It was a difficult and depressing project for him.[102]

In July 1985, Echohawk had a one-man show at the Indian Territory Gallery in Sapulpa, Oklahoma, to help raise funds for the medical bills for Mary's treatment.[103] In October 1986, Echohawk held his second annual one-man show at the gallery. Nearly a year after his wife passed away, he continued trying to raise money to pay off the hospital bills.[104] The gallery show, like much in Echohawk's life, reflected clearly his knowledge of history and personal appreciation of his Pawnee heritage. Of the paintings presented in the gallery guide, *all* directly related to American Indian history. Nearly half came straight from Pawnee history. One painting was titled *Kitsa-hootuks*. In the Pawnee language, "Kitsa-hootuks" means "scalped men." The description Echohawk offered read in part, "The story of this painting is not a myth—it is of Indian warriors who survived scalping. Later, however, legends and stories grew from the Kitsa-hootuks. Scalping was not fatal. But if a warrior were scalped in battle, he was a disgrace to all warriors and his tribe. He would take it upon himself to leave his people and never be seen again."[105]

The Pawnee tradition maintains that these scalped men lived in caves and dens and only went out at night. In the painting, the man's ribs protrude, as remaining concealed and hunting only at night limited the food he could procure. Echohawk described the image, explaining that the man had followed a hunting party and waited for them to sleep. He then crept closer and peered through the smoke of the campfire to try to see someone, a brother perhaps, that he had not seen in years. As Echohawk described the mood of the painting, he said, "It's a lonely-type, sort of sad-type painting. You feel for this man . . . after all these years living away from the tribe as Kitsa-hootuks. The minute someone rolls over in their blanket around the fire sleeping, maybe a twig snaps, and this Kitsa-hootuks vanishes, gone into the night again." Echohawk wanted to record an important piece of Pawnee history, but he also wanted to capture the emotion of such an event and to help explain through emotion the existence these men led.[106]

A similar historical explanation accompanied each painting in the gallery guide. Echohawk included in the show a painting of a Pawnee Scout, titled simply *Pawnee Scout, White Horse*. The historical explanation described the role played by American Indians, since the founding of the United States, as scouts, auxiliaries, and soldiers. Of course, he made mention of the Pawnee Scouts and his grandfather, Echo Hawk.[107]

In December 1986, Echohawk donated a portrait of his former World War II commander, Philip Gover, to the 45th Infantry Division Museum in Oklahoma City.[108] Although Echohawk certainly wanted Gover's painting in the museum, he demonstrated a sense of urgency about this particular donation. He became concerned that the local law might put a lien on some of his paintings due to his inability to pay his late wife's medical bills in what hospital attorneys considered a timely manner. Echohawk did his best to work with the hospital to pay Mary's hospital bills; however, the two parties had difficulty resolving the issue. "It is difficult for the opposition to fathom that I am in a creative profession; an artist, who needs time to paint and prepare for a one-man show, which usually takes six to eight months," Echohawk wrote an old friend. "I would like to save the paintings as they pertain to Oklahoma history, Indian history and American heritage," he explained.[109]

Echohawk believed that the paintings might be ruined in law-enforcement custody. He feared that they would "mold in a city hall basement or hospital storage room; and with a change of administrations all would be irrevocably lost." He believed that Gover's portrait "symbolize[d] the Oklahoma Indian tribes that fought in the 45th" and that it should be valued the same as Bill Mauldin's famous Willie and Joe cartoons. "With due respect to Friend Bill," he wrote, "we two Thunderbirds were simply not doing the same thing in WWII."[110] Eventually, he and the hospital reached a compromise wherein Echohawk created and donated a large painting to offset some of the medical bills. The painting still hangs in the Saint John Medical Center plaza in Tulsa.[111]

In March 1987, General Frederick Daugherty announced the 45th Infantry Division Museum's acquisition of the Phil Gover portrait and announced that the painting would be permanently displayed in the museum's American Indian alcove. The museum scheduled the unveiling for August and placed Colonel James R. Jones (former state representative and current president of the 45th Association) in charge of establishing the program.[112] Colonel Glenn Lyon, former commander

of B Company, 179th RCT, accepted the responsibility of speaking for the unveiling at the reunion banquet.

Speaking of Gover and Echohawk, Colonel Lyon said, "They both excelled in all of their combat endeavors but were most proficient and proud of their inherent expertise in all types of patrolling. Consequently, they were called upon to lead such missions—much more than their fair share." During just such a mission, Philip Gover lost his arm outside of Venafro, Italy. It is worth noting that in the painting, Gover wears an Indian Peace Medal featuring President Buchanan, made at the request of Buchanan in 1857. The Pawnee Scouts received these medals for their service to the U.S. government during the Indian Wars. The medals became points of pride for these men of the Pawnee military tradition. "The painting of Phillip Gover as a typical Pawnee Indian fighting man symbolizes all of the Indians who served in the 45th Thunderbird Division," Colonel Lyon told the crowd. "Sgt. Brummett EchoHawk was wounded and hospitalized 3 times but always came back to his unit for more."[113]

October 1987 marked the unveiling of Echohawk's commissioned official portrait of Oklahoma representative James R. Jones. Among those in attendance for the unveiling ceremony were Speaker of the House Jim Wright and numerous other members of Congress and congressional staff. The portrait hangs in the House Budget Committee hearing room in Washington, D.C., where Jones served as chairman from 1980 to 1984. Jones returned to practicing law in 1986, after serving fourteen years in Congress.[114]

Some of Echohawk's works reflected not only images of historical importance but images that revealed his spiritual background. In his painting *The Doctors*, he captured Pawnee history and cultural heritage as well as a sense of spirituality. In this work, he recorded a childhood memory of a doctor dance. In Pawnee culture, doctors had different roles than medicine men. A doctor's responsibilities included healing and performing miracles. The painting shows a doctor standing in a breechcloth, holding an eagle wing, and looking skyward near a large fire. Echohawk explained, "The man is praying and tears are coming down his cheeks. . . . Most of the doctoring was done through prayer. Much was done with the use of herbs and roots." The image stemmed from Echohawk's memories of the last Pawnee doctor dance held in 1927.[115]

Echohawk also created paintings that reflected his Christian background. As previously noted, he read and reread the Bible throughout his life. In 1989, he estimated that he had read the book at least

sixty-seven times. On a few occasions, he read it cover to cover three times in a single year. He did not believe that he was "holier than anybody"; he simply thought that it might make him a better person. His familiarity with the Bible inspired him to make paintings based on stories in scripture. One, for example, presented a panoramic image of Samson using a jawbone to slay the Philistines. "It's a whirlwind fight," Echohawk said. "Study human anatomy in it and the whirling patterns of light and you get the feeling of a vast . . . struggle. Samson is in the middle and he is banging these guys with brass helmets on. It is not a painting of violence. It's a design. That's really what it is."[116]

Echohawk often concocted humorous images. Sometimes he did cartoons, and sometimes his comical images illustrated stories. Occasionally, he made images "just for the good humor and enjoyment of art," as interviewer Barbara Cohenour worded it. Perhaps the most recognizable of this group of images would be what he called his "retouched" version of the *Mona Lisa*. In this painting, Mona Lisa looks almost identical to the original with a few notable exceptions. She wears a Native-style headband, a "49 shawl," a turquoise ring, and a beaded necklace. Echohawk did his own American Indian version of the famous *Blue Boy* by Gainsborough. In this case, the boy wears a roach and eagle feather on his head, bells on his knees, and carries an Indian-style drum. He also reworked the painting *Whistler's Mother*, an image of an elderly woman sitting quietly in a rocking chair and gazing into the distance. In Echohawk's rendition, she looks the same, but has a bow and arrow in her lap, and lying near her on the floor is a dead cavalryman with an arrow in his chest. Echohawk also reworked Michelangelo's *Creation of Adam*. He designed these parodies simply for the fun of it.[117]

Growing up in Pawnee, Oklahoma, Echohawk got caught up in the great rivalry between Oklahoma State University (OSU), in nearby Stillwater, and the University of Oklahoma (OU), south of Oklahoma City in Norman. The schools' rivalry dates back to the early days of the two universities. Sports fans of Oklahoma, and not only *avid* sports fans, take the competition between the two institutions seriously. The first annual "Bedlam (football) game" between OU and Oklahoma A&M College (now OSU) was held in Guthrie, Oklahoma—geographically located between the two schools—in 1904. A healthy tradition in Echohawk's day, the rivalry continues today. (Echohawk tended to support OSU.) In keeping with the Bedlam tradition, in 1958, Echohawk became the first (and would prove to be the *only*) artist to get the famed "Pistol Pete" Frank Eaton to sit for a

portrait. Echohawk and Eaton had known one another since Echohawk's childhood, and Echohawk felt that it was important that a portrait be made of his friend. "He's a part of Oklahoma history," the artist explained. "Pistol Pete" earned his reputation as a gun fighter at a very young age. As a boy, Frank Eaton's father was murdered. The murderers went unpunished. The boy vowed to avenge his father's death, and dutifully hunted down the killers. Eaton later took up a job with the U.S. marshals and became a gun showman and impressive horseman. "His exploits were well known by my family and friends," Echohawk recalled.[118]

Echohawk took over a year to complete the portrait. During the process, Echohawk said he would drive to Eaton's place, "and we would have coffee and talk for awhile. Then, he would stand there, always talking, while I worked on the drawings." Eaton passed away the same year Echohawk completed his portrait, at the age of ninety-eight, in Perkins, Oklahoma. The Indian Territory Gallery in Sapulpa, Oklahoma, showed Eaton's portrait, drawing attention to Echohawk's work and bringing him numerous potential buyers, but because of the personal and historic nature of the work, it took years before Echohawk could part with it. In 1989, he donated it to the OSU Foundation because "Pistol Pete" Frank Eaton, a man of legendary stature in Oklahoma, had been the original inspiration for the OSU mascot.[119]

The Pawnee Days Rendezvous held in Republic, Kansas, in September 1990 showcased Brummett Echohawk's artwork on the advertisements created to promote the event. At this point, Kansas State Historical Society officials discussed the possibility of having Echohawk help them in their quest to improve their museum. Officials of the state of Kansas contacted Echohawk, asking him to paint a mural depicting a Pawnee earth lodge village in the front entrance of the Pawnee Indian Village Museum in Republic, Kansas. In October 1990, Echohawk traveled to visit the museum in Republic, where he presented a print to be displayed in the museum and made clear his interest in participating in museum activities. In his personal notes, kept in a journal-type fashion, Echohawk wrote, "The project drug on for several months. The curator whom I worked with quit. The business was never resumed nor was I informed."[120] Initially interested in the Kansas mural, Echohawk became somewhat annoyed by the careless organization and communication of museum administrators, who ultimately failed to arrange the project.

Although the mural in Kansas did not pan out, another project waited. His next major undertaking turned out to be a mural

commissioned by the navy. For the next year, Echohawk invested the majority of his artistic energies in the mural project.[121]

Echohawk also completed paintings of American Indian 45th Infantry Division Medal of Honor recipients Jack C. Montgomery and Ernest Childers. Echohawk said he made drawings of Childers shortly after Salerno (1943), which a magazine published long before he made the painting. He wanted the painting to honor Childers and all Indian people. It first displayed in the rotunda in the Capitol in Oklahoma City.[122] Then Echohawk donated the Montgomery and Childers portraits to the 45th Infantry Division Museum, where they went on special exhibit before being placed in the main hall of the museum. Echohawk knew both men personally and was pleased to have the opportunity to create the portraits. In Echohawk's twist of humor, the painting of Ernest Childers includes a smaller background image of Childers as a young GI battling German soldiers. Echohawk forever immortalized the curator of the 45th Infantry Division Museum, Michael Gonzales, in that painting as a distressed German soldier.[123]

In October 1992, the 45th Division newsletter informed its readers that a number of the division's veterans attended the commissioning of the USS *Anzio* (a guided missile cruiser) at the naval base in Norfolk, Virginia. Echohawk and his old friend Charles Johnson attended the ship's commissioning ceremony for two reasons. First, the annual Anzio Beachhead Organization reunion was held alongside the commissioning ceremony, and, of course, both men were Anzio veterans. Second, Echohawk's commemorative mural, commissioned by the navy, on which he had been working so diligently over the past year, depicted the 1944 Anzio campaign. The navy placed it on permanent display in the ship's ward room.[124]

From October 1993 until May 1994, Echohawk focused primarily on completing paintings *Pawnee Bill's Old Town* and *Pawnee Bill Montage*. This time frame, of course, included his usual period of intensive research. He completed both paintings by about May 10, 1994, and on May 18, 1994, he wrote in his personal log that the paintings had been completed and delivered. He felt relieved. The log entry ends, "I was so tired."[125]

Being an artist often meant enduring financial hardship. Echohawk worked in advertising and as an announcer in the television industry, and he used his art as a tool in the children's Tulsa television show *Big Bill and Oom-A-Gog* on KVOO Channel 2 from 1959 to 1964. As a regular guest on this program, Echohawk would allow one of the children

from the live audience to come up and draw something, maybe even just a squiggle. Then, he turned that child's work into a piece of art.[126]

Echohawk found various outlets for his artistic abilities, and, in so doing, he found ways to promote himself. He truly enjoyed talking about his artwork, and as a professional artist, he developed the ability to market his work out of necessity.[127] Echohawk could do virtually any kind of art and do it well. Echohawk once said that he saw art and life the same way: "I don't see any purpose in going halfway in anything you do. Why not go all the way? Go all the way and really mean it. One thing about this: When you are sincere and dedicated to a project, and when you attack that, even the laws of average will be in your favor. You cannot fail."[128] Due to his work ethic and belief that hard work made high goals possible, he succeeded in many fields of art. Linda Greever, who runs an American Indian art gallery in Tulsa and who knew Echohawk personally, said, "He was a *marvelous* artist, and he could compete with anybody in any style." She continued, "He was obviously one of the more talented artists. To have done the things that he did. . . . He competed in *all* types of art. He wasn't held down by anything."[129]

When Brummett Echohawk spoke of his grandfather's name, he said, "We're supposed to live up to his name as warriors and as men. Here I am trying to be, very hard and dedicated so, to be an artist and historian, and I really go after what I paint. It's not a studio thing. It's not a case of piddling. You must breathe life into your canvas. You must make something happen."[130] Echohawk viewed his Pawnee heritage as a distinction, a positive quality he could harness in his various endeavors. Despite his distaste for the label of "Indian artist," he recognized his Pawnee identity as crucial in all that he did. When American newspapers wrote in their limited caption space about his combat sketches and labeled him "a full-blood Pawnee Indian," their motivation for doing so may be called into question. Newspapers did not mention the racial background when they printed an Anglo-American soldier's artwork.[131] Why was it important for them to identify Echohawk this way? Perhaps the reasoning tied into the government's promotion of American Indian military service. Perhaps it made a difference to them, in terms of racial consciousness, that he was *not* Anglo-American. Then again, given Echohawk's pride in his heritage, there is a chance that the war correspondents who presented his work to the NEA asked him to tell them about himself and he began with, "I'm a full-blood Pawnee Indian from Oklahoma." Given the racial attitudes of the day, any or

all of the above speculations are likely explanations. Regardless of any racially motivated reasons for labeling his work in this way, Echohawk maintained that his heritage as an American Indian gave him "distinction" and claimed that he did not face racial prejudice in the course of his career. Publication of his combat art should stand paramount above any issues of race in the captions. The credibility he gained from being a frontline infantryman, combined with his natural ability as an artist, laid the groundwork for publication of his combat art and future success as an artist.

Given the social state of affairs for many American Indians, it is worth considering the scenario between Brummett Echohawk and his friend Ed Hewett in that foxhole in Italy.[132] Although Echohawk had always been talented in the arts, he had never considered the possibility of pursuing a career as an artist until his friend suggested it. Might this oversight have been a consequence of generally low social expectations for minorities at the time? Was it a matter of Hewett, who thought in terms of opportunity, suggesting the possibility to small-town American Indian, who did not yet think in terms of opportunity? Encouraged by the positive responses his artwork regularly received, Echohawk considered the option presented by Hewett and aggressively pursued it, employing his background to help him in the process.

Echohawk's comic art speaks to his ability to present American Indians in a positive light and in an easy manner to the general public. Given the opportunity to make money by syndicating *Little Chief,* he turned down a significantly larger audience and the money that came with it in favor of maintaining a positive representation of American Indians, demonstrating his dedication to authenticity and truth over profit. Somehow, in a society that did not yet embrace its minorities, Echohawk found ways to reach the general population and build a successful career doing so. *Little Chief,* for example, exposed non-Indians to Indian humor and offered comedy with Native Americans as the subject—but not at the expense of stereotypical representation. He created art that appealed to the American public despite preconceived, narrow, and racially biased understandings of the world of American Indians. Through his art, Echohawk succeeded in bringing pieces of American Indian culture and history into the mainstream.

Echohawk had an amazing ability, as the expression goes, "to walk in both worlds." He demonstrated this time and again through his personal interactions as well as in his choices of art styles, subjects, venue selection, and who commissioned his work. His heritage inspired him on a very deep level, and the desire to share with and educate others

proved a driving force in his work. Echohawk's definition of heritage did not restrict him to all things Pawnee but allowed him to include landscapes and historic sites of Oklahoma as well as influential members of government and the 45th Division.

As an artist, Brummett Echohawk proved to be an impressive historian, a great comedian, an impressive painter, a civic-minded designer, and a man with an eye for beauty. Whether working in charcoal, ink wash, oil paints, or anything in between, he became the master of his canvas. His background as an American Indian deeply influenced his work—much of which now serves to educate non-Indians. His identity as an American and knowledge of American history transferred to his artwork, making most of his work a part of the American historical record. His military service and combat art provided visual and written history for American servicemen and the soldiers they encountered. His love for his Oklahoma roots inspired him to share with the rest of the world the beauty he found there. When asked about the influence of northeastern Oklahoma—the location of Pawnee County—in his life and work, he responded, "Actually, it's everything."[133]

More Than an Artist

I did one thing that I think is an ingredient, and will always carry you across any abyss. And that is: do what you know best. What I know best is about Indians. So, I paint about Indians. I write about Indians. I write about horses, rodeos, anything about the American West. This is my field. . . . Do what you can do best. I'll give you the words of Rembrandt. Rembrandt said, "Put well into practice what you already know. In so doing you will in good time discover the hidden thing which you now inquire about." Do what you do best, and you will discover things that you never knew before. The Pawnees always say, "The way to do, is to be."
—Brummett Echohawk

Brummett Echohawk's drive to excel in any given endeavor came, in large part, from his Pawnee background. To become a true Pawnee, Chaticks-si-Chaticks, one must excel in something. The "something" remained fairly open. For Echohawk, that something included military service, art, acting, writing, and public speaking.[1]

Throughout his adult life, Echohawk worked in numerous fields while simultaneously pursuing painting. To further his education beyond art school, Echohawk attended the University of Chicago's English program. He also later attended the University of Tulsa's creative writing program. Some of his most readily available works today are his writings—humorous short stories, historical accounts, letters, television scripts, and speeches. Echohawk became a masterful writer and speaker who could draw in an audience of any age or social background. He accomplished all of this through personal drive and great effort.

Echohawk's writings covered many of the same topics as his artwork. He wrote to describe and explain his art so viewers would understand the true nature of his work. He often wrote to simultaneously entertain and educate his readers. He wrote to keep a record of the things he believed held true significance. Often, the things he valued and felt he should share came directly from Pawnee and American Indian history.

Keen observation and personal experience informed his understanding and portrayals of his subjects, and, whatever the topic, he molded his writing to reach his target audience.

Unlike some of his contemporaries, such as the prominent author Vine Deloria, Jr., Echohawk generally used an easygoing approach in his writing. Where Deloria often wrote with biting wit in a rather terse, occasionally sarcastic, and very direct manner to jolt readers into thinking critically about important issues, Echohawk generally preferred more subtle methods. Humor proved an invaluable tool for him. (Vine Deloria did, however, write an entire chapter on the value of Indian humor in his book *Custer Died for Your Sins: An Indian Manifesto*.)[2] Some of Echohawk's works appear very lighthearted on the surface, entertaining readers. Successfully entertained readers often continue to think about the funny story they have just read, and, as they do, the deeper meaning behind it becomes manifest.

A perfect example of Echohawk's humor may be found in his self-illustrated, twice-published article "Cowboy Movies and Real Indians." In the amusing anecdote about Saturdays in the small town of Pawnee, Oklahoma, in the 1920s and 1930s, several important themes emerge. The story details his days as a student at the Pawnee Indian Boarding School, which was run in a militaristic fashion, as were most government boarding schools for American Indians in that day. Echohawk comically recalled the itchy wool uniforms and uncomfortable, but well-polished, shoes the students were required to wear on Saturdays, when they were allowed into town to visit their families. He wrote about Saturdays being the day when all the tribes in the area went into town to shop, to visit, and to take care of business. Saturday was a big day for another reason: it was "the day we saw a Cowboy-and-Indian matinee." Echohawk recalled that the young people often acted as interpreters for their elders, who were curious about motion pictures but did not speak or understand English. His article began describing the film by placing the opening action in a western town. He described the entrance of a white-hatted, clean-cut cowboy riding into town: "The old-time Pawnees with braids turn to the interpreters. The youngsters reply without taking their eyes off the screen, 'Chaticks-takah tudah-heh (good whiteman).'"[3]

Following the entry of the good guy came the entry of the bad guy, dressed in a stereotypically juxtaposed fashion. As anticipated, conflict followed. Echohawk's account of the movie recounted another scene with covered wagons "racing through Indian country." Sticking to the ever-predictable stock western plot, he described drums sounding in

the film. The drums caught the attention of the tribal moviegoers and made them laugh, because it was "so un-Indian." Along with the awkward drumming came the appearance of a lurking Indian. Echohawk described the skulking fellow:

> A close-up shows a Redskin in a low-foreheaded wig held in place by a headband. He needs a shave. The "Indian" has grey eyes, which appear all white like Orphan Annie. He scowls at the covered wagons, then mounts his "Indian" pony from the wrong side and rides clumsily away.
> This brings belly laughs.
> "Aw-kuh, Chaticks-takah," chides an old Pawnee. ("Aw-kuh" is an expression of disgust, something like "good grief." "Chaticks-takah" is whiteman).[4]

Echohawk explained to readers unfamiliar with Indian culture why such a scene was so problematic for the theater full of Indians. First, he noted that most Indians, especially full-blood Indians, rarely, if ever, shaved because there was no need. He pointed out the audience's objection to the screen Indian's "hairy chest and 'white eyes'" because these traits did not fit. He further explained that the Plains tribes, generally recognized as exceptional horsemen, found nothing respectable in the actor's riding abilities.

Echohawk continued:

> An "Indian chief" appears on the screen. The theater thunders with laughter. The chief is feathered and fringed from head to foot. He wears Navajo silver, a Sioux war bonnet, Cheyenne leggings, Apache moccasins, Comanche beadwork, woman's braids and a ghost dance shirt. His war paint is something else. And he, too, has "white eyes" and a 5 o'clock shadow.
> The Redskin in the seedy wig approaches the chief and points a sporting goods bow in the direction of the wagon train. . . . Pawnees, Otos, Poncas, Kaws, Kickapoos, Sac and Foxes, Shawnees and Iowas explode with laughter.[5]

In the movie, Echohawk explained, the band of Indians attacks the wagon train, and the good guy eventually catches the bad guy, who runs the town and "is in cahoots with the Indian chief with the 5 o'clock shadow." Next, he recounted, the film transitions back to the town, where the good guy finally triumphs over the bad guy before another scene change back to the wagon-train fight. With Indians dying right

Illustration by Brummett Echohawk for "Cowboy Movies and Real Indians," *Oklahoma Today* 23, no. 2 (Spring 1973): 8. Reprinted with permission of *Oklahoma Today*.

and left, they circle the wagons. Echohawk continued: "A bugle sounds. Redskins scatter. The Good Guy leads the U.S. Cavalry to the rescue."

> The theater is silent.
>> Indians squirm in theater seats.
>> We kids squirm too—squirm, because the Good Guy kisses the girl.
>> "Aw-kuh! (good grief)."
>> "Yes, Grandpa. Good grief."[6]

From this short article alone, a reader could conceivably pick up on a number of real-life issues affecting American Indians. "Cowboy Movies and Real Indians" told a story inspired by real events in Echohawk's youth. Perhaps the most apparent issue is the portrayal of American Indians in film. Bad acting proved the least of these films' problems. Clearly, movie producers did not cast Native Americans for the Indian roles, their costuming proved horribly inaccurate, their prowess as warriors in the film was laughable at best, and, of course, they were associated with the bad guys and lost the battles. One might also pick up on the militaristic orientation of the boarding schools from his article. The generational divide between the elders and the boarding-school children, not only linguistically, but conceptually, shows through. One might question the poor reasoning of providing these films for this particular segment of the population. These criticisms evidence only a few of the issues conveyed in this short, humorous article. Echohawk neither pointed fingers nor made harsh claims. He merely illustrated

some of the challenges and ironies encountered by American Indians in daily life.

Whether set in Oklahoma, New York City, or elsewhere, the American Indians in Echohawk's stories often walk away with a smile, even if their white counterparts remain unaware that they are smiling, or why. In a short story called "Con Man in Feathers," Echohawk wrote about a Pawnee with the combined Pawnee Bill and Buffalo Bill Wild West Show that toured in the early part of the twentieth century. Cowboys, cowgirls, Native Americans, and Mexican vaqueros thrilled audiences with their scripted dashing and daring and flashy tricks. In the story, some city slickers came over to a group of Indians caring for their animals in an attempt to lure one away "for a few drinks and to make sport of him." In the story, the man they enticed was a full-blood Pawnee very much aware of their intentions.[7]

"Remembering instructions from Pawnee Bill about not speaking English while on tour, the Pawnee made sign-talk only," Echohawk wrote. In many ways, this worked to his advantage. In the bar, the Pawnee man encountered the anticipated heckling and recognized that some in the gathering crowd looked upon him with "thoughts of Lo, the poor Redman." He accepted some drinks but remained wary. Echohawk described the Pawnee: "The Chief wasn't born yesterday, nor was he a reservation Redman. He had gone to school at Carlisle in Pennsylvania. Palled with Jim Thorpe. Knew the King's English. And he knew his way around." Echohawk described the way the Pawnee handled the situation: "He went along with the party. But he made sure all drank when he did." Once the crowd "had a glow on," the Pawnee began to have his fun. He put on a show for the city slickers. He took a horse hair and turned it into a snake in water—wowing his audience, who now believed he was a medicine man with magical powers. Then, with a show of great caution, he took some white painted cockleburs out of his bag: "He held them delicately in the palms of his hands and said they were porcupine eggs, then invented a legend about them. He added a sales pitch: a sales pitch that could have brought about the sale of Manhattan Island again. The Pawnee sold the cockle burs for a dollar apiece. They went like Osage oil leases."[8]

The Pawnee then began selling sumac leaves (abundant back home, and often smoked with tobacco) "in sparing handfuls for two dollars. His sales pitch: genuine Indian health tobacco guaranteed to keep you young." He even sold horse hairs, which he wrapped in cigarette paper as "do-it-yourself-snake-making kits." The kits proved a big hit. The Pawnee had a grand finale worked out before he left the enamored

audience and hit the road to catch back up to the show. The foolish Indian the city slickers thought they could take advantage of turned out to be a reasonably skilled con man who turned the tables without his hecklers ever knowing. Of course, this story made the rounds back in Pawnee, Oklahoma. Even the cowboys in the show got a laugh out of the tale. They "knew that a strand of horse hair will wiggle when soaked. When soaked in water the segments form air pockets which collapse erratically, animating the hair with a twitching motion like a wiggling snake." The New Yorkers got their show, and "paid a price."⁹

Even in Echohawk's lighthearted and amusing tales, fit for any audience, there is a moral to the story. Often, these anecdotes confirmed, for anyone who may or may not be aware, that American Indians were intelligent actors, not simply subjects waiting to be acted upon. He demonstrated that Native people had and used agency, and at least occasionally got the last laugh. These short stories derailed, or at least called into question, widely held stereotypes. Was every such story a true story? Probably not. Were most of these stories based in truth? Most likely. The previous story is a perfect example. Did Pawnee Bill and Buffalo Bill Cody travel together in the East for a time? Yes. Were Pawnees, under the direction of Pawnee Bill, a part of that experience? Yes. Did they receive instructions, like those to refrain from speaking English to spectators and potential customers, for purposes of maintaining the allure of the show? Yes. Were the Natives in the show ever heckled? Absolutely. The list goes on.

For those familiar with American Indian traditions, oral traditions played an important role in the maintenance of each groups' collective historical memory. Oral traditions could be connected to winter counts, battle records, family lineages, religious beliefs and practices, music, ceremonial practices, rules, travel routes, and more. Some of the more entertaining oral traditions in any tribe are the stories about how things came to be. Those stories range from sacred creation stories to tales about talking animals like the trickster, Coyote. These stories, sometimes told with a very serious tone and sometimes with humor, served to answer questions and to teach life lessons. Brummett Echohawk's stories, while different in content, perform the same function as the stories told in American Indian oral traditions. He used an old format in a new way for similar purposes.

A short story similar in nature to the "Con Man in Feathers" called "The Pawnees Came to Dinner" was published in the *Tulsa World* in 1954. At first glance, the story seems humorous, but random. In fact, Echohawk ended it: "There is no moral to this story, or plot either.

It's just about some Pawnees who attended a banquet and were stared at so much that—they left some of their hosts consternated. Nothing else." The story is straightforward and humorous. The general outline follows a group of Pawnees who get invited to a banquet given by the people of a small town for the dedication of a public park commemorating a bit of American Indian history—the events of Massacre Canyon in 1873 to be precise. All day, from the time of the Pawnees' arrival, the townspeople stared.[10]

Echohawk wrote, "Some Pawnees understood English, and they heard an assortment of remarks. They said little. What the Indians thought of the curious white people was something else. The Pawnees that couldn't understand English were real old timers. They read the expressions on the faces—that was enough." In an uncomfortable situation, a group of Pawnees maintained their sense of humor. They played along with their hosts' expectations, maintaining frowns and knitted brows, remaining relatively silent. They played the part until after the banquet began. Echohawk explained, "Seated side by side were two old timers. These Pawnees ate without much concern of Emily Post or anyone else." One of the elders noticed a man sitting nearby who was so busy staring that he failed to eat any of his meal. After watching the townsman stare for a while, the old Pawnee nudged his friend "and quietly grunted, 'Uhoom, uhoom.' This is a Pawnee expression, one of jest, that means, 'notice him' (or it) or 'look there' . . . better still, 'dig this crazy so and so.'"[11]

The friend did not turn to look but "merely glanced out of the corner of his eye and answered softly 'Ow-hoo.' (Yes). Whether the gentleman seated next to the Indians suspected this to be conversation or not would be hard to say, as both of these Pawnee words sound like a low growl." The game was on. The first Pawnee picked up his meat and made a show of eating it with gusto. This put the man staring on edge. Another began to stare. The two old Pawnees enjoyed the fun and kept up the ruse. Echohawk continued, "Then in one sudden motion the Indian turned in the direction of the white man, as if to grab him, and exploded with a loud growl. The second gentleman caught himself before he could topple from his chair. It took some cold water to bring the first man to. He was out like he had a touch of rigor mortis."[12]

The likelihood of this truly being a random funny story remains slim. Instead, this entertaining little scenario provides food for thought regarding the experiences of the Pawnee people, social behavior toward "others," and suggests consideration of human relations between

neighboring or co-existing peoples. In no way does the short narrative suggest that Pawnees existed as passive victims, despite the uneasy conduct exhibited by some of their non-Indian neighbors. It is highly unlikely that Echohawk chose to publish a purposeless anecdote in a large, widely-circulated newspaper. Although purely entertaining on the surface, the article contains both a social message and a historical lesson within.

Echohawk had a knack for finding humor in nearly any given situation. It might be a joke in a serious moment (as during the war), or a twist of humor on a sensitive subject in his writing. Sometimes, he simply found humor in life. Stories like "A Short Tale of the Breechcloth" took simple everyday choices, like the option to adopt new clothing styles or not, and made them into something fun.[13]

In his article "Santa Claus Wore Indian Clothes," Echohawk described someone dressing as Santa at the turn of the century to visit some Pawnee children. During some Christmas singing, Santa entered the room. Echohawk wrote, "It was the first time the Indian kids had ever seen St. Nick. Some of the parents had seen pictures of the old boy, but most of them hadn't. Shades of Gen. Custer! The kids barreled out of their seats and stampeded for the door." The children were terrified of the plump, bearded figure dressed in bright red. "That Christmas," Echohawk wrote, "Santa Claus was left holding the bag." The next year, the story went, the individual seeking to bring Christmas cheer to the children wore Pawnee clothing, and the children received him well.[14]

Echohawk did not fabricate the story of Santa's first visit to the children of Pawnee entirely. He used a story the family and Pawnee community often related around Christmastime. In fact, one of the frightened children who charged out of the room when the big red Santa appeared had been Echohawk's Uncle Leo, son of Howard Echo Hawk and Carrie West Echo Hawk. Leo admitted to helping lead the escape.[15] This tale offered a piece of history relating to mainstream cultural practices during the Christmas season, and the way something little-considered by one society could be so consternating to children in another. The Christmas anecdote recorded a piece of Pawnee and American history by showing how Pawnee culture and elements of mainstream American culture came together. The story also preserves a piece of Echo Hawk family history.

Echohawk used his writing as a tool to record historical moments, in much the same way that he considered himself a historical painter. He could paint images that could capture the eye and generate interest

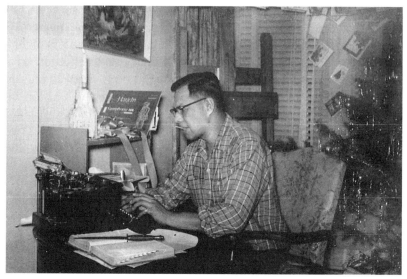

At the typewriter over Christmas, year unknown. Courtesy of Joel EchoHawk.

in the subject at hand. He did the same with his writing. He had a storyteller's gift, and the ability to capture a moment in time on paper just as he did on canvas. He did not intend everything to induce kicks and giggles. Sometimes a story simply offered a meaningful way to document the past.

Echohawk proved that he could incorporate his clever wit in historical writing on numerous occasions. One such case is "The Great Six Million Twenty-three Thousand Two Hundred and Forty-eight Yard Dash." Echohawk recounted the phenomenon officially called the "Great Cross-country Marathon Race" and labeled by the press as "the Bunion Derby." The race took runners from Los Angeles to New York City in 1928, and the prize money was substantial. All sorts of hopefuls entered that race—275 to be exact. Among the contestants were two Hopis and a Cherokee out of Claremore, Oklahoma, named Andy Payne. In this article, Echohawk tells the story of twenty-year-old Andy Payne, who, "after wearing out five pairs of shoes and running for 3½ months covering 3,422.3 miles and clocked at 573 hours, 4 minutes and 34 seconds," won the $25,000 first-place prize.[16]

Echohawk attended the Pawnee Boarding School at the time of the marathon. He recalled that when Payne won, "at school cross-country running became popular. On Sundays we had an 'Andy Payne' race." Children (from numerous tribes) from between seven and fourteen years old ran the race together. The young people truly admired and

wished to imitate the success of Payne, and they tried all sorts of things to succeed. On the return portion of the route, Echohawk wrote that the tired children would pause and "place a leather belt around the chest to 'control' breathing. It was a Ponca boy's idea. No one knew if it worked. But if you didn't sport the belt, you weren't a 'cross-country runner.'" The children fittingly dubbed the winner of the race "Andy Payne." After meeting sixty-six-year-old Andy Payne years after the race, Echohawk wrote, "My kind of hero."[17]

Echohawk's article "The Pawnee's Last Doctor Dance" offers an example of his works written with the intent of educating and adding to the historical record. He self-illustrated the article, like most of the others he published. (A description of the painting can be found in chapter 4.) By relating the events in the first person, as he experienced them, Brummett Echohawk allowed readers to gain insight to, and appreciation for, traditional practices among the Pawnee people. He began with an earnest tone: "I remember that Doctor dance of long ago. It was held at night. I was a small boy then." He continued to describe some of the tribal practices surrounding the doctor dance by explaining the actions of his parents and others. For example, his father left before the rest of the family with a string of horses. Why? Because "horses were given away in friendship there."[18]

Echohawk wrote, "The Doctor dance was a time for prayer to Ti-ra-wa Uh-tius (God the father) to ask his blessings for all growing things. It was a time for the 'Ku-ra-oo' (doctor) to show his powers; and it was a time for healing." He recorded the purpose, timing, and some of the activities surrounding the event; identified key figures; and indicated the significance the dance had long held for his people— and he did it in a way that did not irresponsibly expose the sacred. He wrote, "I remember well the date of the last Doctor dance, for it was the same time a man flew an airplane across an ocean. The man was Charles A. Lindbergh, the year was 1927." Echohawk put things in perspective for readers—the doctor dance was an ancient practice that survived into the modern world.[19]

Of course, Echohawk also wrote about the Pawnee Scouts, particularly the men he knew personally. Since his grandfather Echo Hawk had been one of the cavalry scouts, it stands to reason that his historical writing included pieces on the history of these men. The subject held cultural, historical, and personal significance. Echohawk felt that the story of the scouts offered more than family history, and more than Pawnee history. The story of the Pawnee Scouts represented a valuable piece of American history.[20]

When the material warranted, Echohawk had the ability to write in such a poignant manner that his words drew his readers into the moment, helping them realize the seriousness and importance of the subject. He could convey the intensity of a given moment in time, bringing a reader closer to an understanding of mortal fear, of grief, and of determination. He often did so when he wrote about World War II. Occasionally, a touch of humor would surface as comic relief if the intensity of events threatened to overwhelm, but not always.

More than twenty years after the Anzio campaign, Echohawk wrote an article for the *Tulsa World*, accompanied by some of his combat sketches, to commemorate what the men in the campaign had endured and sacrificed. "It Happened at Anzio," is a first-person account of his unit's attack on the Factory at Anzio, Italy. In this brief account, the author allowed readers to feel the emotion and intensity of the moment. He admitted fear in being ordered to lead a risky charge against the Factory so soon after his battle injuries had required a long stay in the hospital. He recounted how he forced himself to act despite the fear. People depended on him. Echohawk conveyed to readers the enormity of the task and the bravery of the men around him. He also made clear how important his Pawnee heritage was to him on the battlefield. Echohawk put into words the feelings of loss when friends were killed and his resentment toward the opposing German troops. His words, accompanied by his battle sketches, brought to life the grim reality of the battlefield. Readers will find no wisecracks or silver lining in this story. It offers a realistic portrayal of what Echohawk and his friends experienced on the beaches of southern Italy. He wrote the article to educate, to make a record, and to pay tribute to the fallen.[21]

Brummett Echohawk wrote for many reasons, but, just like his artwork, some of what he wrote was to put food on the table, and some proved much more personal. He kept a journal on and off in his life, writing mostly to himself. He also worked for years on a memoir-like manuscript he hoped to one day publish about his experiences in World War II. Echohawk also continued to write for newspapers and magazines.

Although news articles and published journals like *Yank: The Army Weekly* chronicled certain wartime experiences, Echohawk felt the need to write down a more detailed record of his military career. Having long since been engaged in the Pawnee Indian Veterans Organization and the 45th Infantry Division Association, he maintained contact with many of the surviving veterans of his division and company. Many of the men still lived in his hometown, or nearby. Echohawk made a

conscious decision to record in detail the exploits of the 179th RCT in Sicily and the Italian mainland. He worked on the project for years, writing when he had time away from other, more lucrative, pursuits. Again, bills had to be paid. Echohawk wrote draft after draft of his wartime memoir. He wrote many of the drafts by hand but used his typewriter for some drafts. Echohawk wanted the final product to be right.

An invaluable contribution to the historical record, if published, his record of the exploits of B Company, 179th RCT would be a great asset to anyone interested in American military history, World War II, American Indian military history, or the story behind Echohawk's distinguished art career. Written largely in the first person and in present tense, his drafts read almost like an historical novel. He included more than strategic movements and official actions. Echohawk brought to life personal relationships, particularly those among the men in his platoon—most of them American Indians. He described the bond between the men as he, time and again, referred to them as brothers or reiterated the importance of a mutual tribal background.

The way Echohawk recounted particular events provided a different world view than the standard accounts. For example, after being wounded in 1943, medics took him to a makeshift aid station on the Italian mountainside and placed him, by chance, next to a Cheyenne friend. In his writings, he referred to the man as Two Hatchets, a cousin of Echohawk's close friend Gilbert Curtis.[22] When the medics placed Echohawk next to Two Hatchets, the man's arms covered his face as he mumbled. When he turned toward Echohawk, the two men recognized one another. Back on the beach at Salerno, the Cheyenne had planted his lance in the ground and shouted "Christopher Columbus, we are here!" The two soldiers were happy to see one another. The Cheyenne explained that he had been "trying to sing an old time Cheyenne war song" before asking Echohawk the condition of the others, including Gilbert Curtis. The man calmly lit and smoked a cigarette before turning to speak to Echohawk in a quiet voice:

"Brother, try to sleep . . . try to sleep." I close my eyes. It feels good being next to another Indian. I hear Two Hatchets sing quietly. It's a mournful Cheyenne song. I am awakened by Medical Aid men attending the wounded. . . . I keep my eyes closed and try to rest. When they come to Two Hatchets, I hear them rattle his dog tags. One of them says, "This man is dead." Startled, I look at [him]. I hadn't noticed before because Two Hatchets was so calm, but his lower body is soaked with blood. Badly mangled. . . . This Cheyenne warrior has a peaceful look on his

face. Now I know why he was singing a few moments ago. Two Hatchets
was singing his death song.

I sob quietly.[23]

Countless stories exist in which soldiers meet up with friends or
lose friends. It was always nice to run into someone from home. There
tends to be a common bond between men from the same small town
when in combat. Such bonds were not entirely unique to the American
Indian soldiers in Echohawk's experiences, but readers or moviegoers
rarely think twice about a soldier reciting scripture or singing a hymn
to get through the moment. In the same spirit, how many have consid-
ered a Cheyenne man (or member of any other tribe) faithfully singing
a death song in his last moments on a twentieth-century battlefield?
In many ways, Two Hatchets's singing served the same function as re-
citing scripture or humming a hymn, but rather than hailing back to
hundreds of years of Christianity, his death song tied him to his eth-
nic heritage—something only a small segment of the world's popula-
tion, or even the nation's population, could share with him. Brummett
Echohawk's writings contribute to the creation of a fuller appreciation
for where these men came from and what they believed and held dear
as they risked their lives for a nation that some believe did not earn
their sacrifice.

In writing about the war, Echohawk used many subtle and blatant
examples that demonstrated why *his* story adds to numerous catego-
ries within the historical field. Even his tales of exploiting the fears that
many German soldiers had of American Indian soldiers are remark-
able when one considers the possible ramifications. For instance, had
Echohawk's superiors realized the psychological effects of his night-
time excursions behind enemy lines in the trenches at Anzio, they
might have been able to take advantage of the fear by having him give
his war cry and then moving their troops forward to the abandoned
frontline German trenches. The seemingly sudden compliance of the
captured German soldiers at Persano, Italy, once they realized their
captors were American Indians, provided an example of opportunities
for American troops to take advantage of those fears.[24] The character-
istics associated with American Indians by opposing forces during the
war, real or imagined, had the potential to influence their reactions to
American troops—especially divisions like the 45th with large num-
bers of Native Americans in their ranks.

Of course, Echohawk's ability to illustrate his own written material
proved one of the most impressive aspects of his writing. From his

regularly illustrated letters to friends, notes to himself, notes to his attorney, maps and images intended to accompany his book on the war, and petitions to Veterans Affairs, name it, and the man could draw a picture. Coupling his words with his art gave his writing added clarity, emphasis, and humanity that most writers could not create for themselves.

Echohawk's working journal afforded him a way to keep track of all sorts of things, from the weather, to what movie he just saw, to thoughts about his VA claims case, to how he felt that day, to how the football game went, to his goals for the day, week, month, or year. These entries rarely appeared in any sort of formal arrangement. Often, they even lacked sentence structure, but they revealed his thoughts. Many of his entries could be interpreted by others as inspirational. Some entries might even induce laughter for those attempting similar endeavors. Sometimes the thoughts he recorded reflected a sense of ambition and drive. Occasionally, they gave way to frustration, and perhaps a sense of depression, and some entries indicate his efforts to remotivate himself.

In an entry, dated December 29, 1991, in the very front of a notebook that he used as a personal working journal, he listed a number of rules for himself as he set out to resume writing the book about his military experiences. Some of the notes are in German! Included in his series of rules was the entry "Don't do anything in half measure. Either you mean it—or you don't!" Throughout the notebook he made notes of frustration, such as an entry noting four days "lost looking missing page 51 to 67! Time wasted!" Other entries were nudging reminders: "Remember target date 6 Nov. 11:00 hours 1992." In one of his more motivationally oriented entries, dated Thursday, September 6, 1990, he wrote in all capital letters: "FULL CONCENTRATION, LIKE PAINTING. ONE THING AT A TIME. TELL YOUR STORY, AS YOU SAW IT AND LIVED IT. KEEP IT SIMPLE AND VERY CLEAR. NEVER DOUBT. REMEMBER WHO YOU ARE." In a later entry, he wrote to himself, "Good luck, me!" as he made plans to forge ahead with his World War II manuscript.[25]

In an entry dated January 1, 1992, Brummett Echohawk filled a whole page. He began, "Arose at 09:15 hours. Drank prayer water. Offered prayer for Crip [his brother] and Horace; and that I might be brave and worry-free—and that I become great in ART." He then wrote about reading his favorite Bible passages. Next he mentioned seeing the new JFK movie the night before. "Was entertaining," he noted, "but fabricated." Following this, he recorded the New Year's college football scores (clearly impressed by the University of Oklahoma's win

over Virginia in the Gator Bowl). In his last section on the page, he rephrased the rule from the front of the notebook: "My heart says: EITHER I MEAN IT, OR I DON'T. BE BRAVE. DO IT WITH ALL ENERGIES OF THE HEART, MIND, AND BODY. You're B.E.H. of Gravy!"[26]

Sometimes, Echohawk demonstrated both optimism and frustration on the same page, or even on the same line. On one occasion, after detailing the progress over the past month, day by day, he wrote, "AM STILL PATHETICALLY SLOW! But I aim to be GREAT!" His writings definitely left the impression that an optimist became subject to feelings of defeat from time to time. In 1993, he wrote, "D-day, June 6 . . . DICIPLINE [*sic*]. FAITH. THINK/CREATE. **Work!**" The following day he drew an arrow up to where he had written "DICIPLINE," and wrote, "I have none. Years of nothing has sapped my drive."[27] Yet he pressed forward.

Beyond writing articles, providing cartoons for magazines and papers, or showing paintings in galleries, museums, halls of government, and personal collections, Echohawk stood before many an audience in formal and informal speaking engagements. He talked about his art, the war, and American Indian people and history. On occasion, he even spoke specifically about Indian humor. When he spoke, he did so to entertain, educate, and inspire his audiences.

Echohawk had a strong, deep, storyteller or announcer's voice, and he chose his words deliberately. His voice served him well in public speaking, as an actor and television announcer, and as an emcee at social gatherings like powwows and rodeos. He had the ability to engage young schoolchildren and big-city socialites—and to hold their attention until his message was delivered. When he spoke, his message lingered with audiences. His friend Michael Gonzales told of an incident when Echohawk spoke for a veterans' organization: "I heard him give a speech one time . . . and he said the kinds of things that make you stop and think, and then think about what he said after you've gotten out of there. That's a serious accomplishment. Not everybody can do that: to make [people] think about your words after you've left the hall."[28]

Echohawk participated in all sorts of public engagements. As a member of the Chicago Corral of the Westerners, a group of people with a common interest in the history of the American West, he made a presentation to members and their guests gathered at the "old corral, Ireland's" in April 1957. The *Westerners Brandbook* published his rather lengthy speech the following month. His topic: the Pawnee Story. Echohawk's speech offered an overview of Pawnee history from the early days, before Pawnees migrated from the south to Nebraska, to the present day in Oklahoma. Near the end of the speech, he told

his audience, "This is 'The Pawnee Story.' It is a story of a once great tribe that numbered close to 10,000 in the early 1800's and in 1900 numbered at 650. . . . It is a story of an Indian tribe that chose not to fight 'civilization,' but to fight for it. It is a story of a people who love their country."[29]

Echohawk went on to describe the current population growth of the Pawnee tribe, as his people moved forward: "The tribe is organized with its own constitution and by-laws. It has a corporate charter and an active business council. There are Pawnee businessmen. Lawyers. Teachers. Clergymen. Artists. Skilled-laborers. With all this the Pawnee tribe maintains a spiritual balance by having retained much of its old customs, traditions and ceremonies." After a long story of what the Pawnees had been through, a story that included a great deal of loss and sorrow and required a new beginning in an unpromising land, Echohawk ended his story on a high note. "In this world today," he told his audience, "the balance is good."[30] After concluding his speech, Echohawk continued with a presentation that included slides of his artwork and photographs. He gave a "chalk talk" demonstrating the similarities between Egyptian and old American Indian art and presented each of the ladies attending the lecture a peace pipe to take home. No doubt he made an impression on the crowd.[31]

In contrast to his formal presentation for the Westerners of Chicago, Brummett Echohawk had the distinction of being master of ceremonies for the All-American Indian Days events along with Joe Medicine Crow in Sheridan, Wyoming, in early August 1956.[32] In 1969, officials for the All-American Indian Days once again asked Echohawk to be their emcee. An article in the *Billings Gazette* noted that Echohawk had attended the event since its early years and that he had designed the letterhead still used by event officials.[33]

Echohawk spoke around the country in more typical guest lecture forums. His curriculum vitae listed his typical themes as "The American Indian; The American West; Western Paintings; Indian Humor; and Color Theory on Impressionist Paintings." He was frequently asked to speak on college campuses. For example, he was the special guest at Brigham Young University's Indian Week in 1975. The school chose Spiritual Roots of Indian Success as the theme for the week.[34] In 1979, he spoke alongside the renowned author N. Scott Momaday and Peter MacDonald, chairman of the Navajo Tribal Council, in the Seventh Annual Symposium of the American Indian at Northeastern State University in Tahlequah, Oklahoma. The theme for the symposium was Old and New Ways—Cultural Developments in Contemporary

Society.[35] He spoke for the third annual Indian Leadership Conference at Eau Claire State University in Wisconsin in 1965, at which the theme was Indian Leadership: Education in Action. Echohawk's name appeared under speakers and guests along with the high-profile author Vine Deloria, Jr., for the conference. Echohawk stayed in the area to speak at the Midwest Indian Youth Seminar on the same campus.[36] He helped with the National Y-Indian Guide Longhouse of the Young Men's Christian Association in Minneapolis in 1967. The organization asked him to "interpret the background of the American Indian and the character of the Indian father-son relationship which is the basis for the Y-Indian Guide program."[37] In a related vein, in 1975, he participated in the Discovery Clinic in Tulsa, designed to help youth gain a brighter outlook on the future. He provided demonstrations in both art and archery.[38]

Echohawk also spoke in local public schools, alone and with others. For instance, he and his friend Ernest Childers visited Childers Middle School in Broken Arrow, Oklahoma. At the school, Childers signed roughly six hundred yearbooks, while Echohawk "drew sketches and entertained the children." The old army buddies worked well together.[39] Also in relation to his service in the 45th Division, Echohawk participated in Tulsa's first American loyalty parade, sponsored by the Tulsa Council of American Indians in August 1967. His friends, fellow Thunderbirds, and Medal of Honor recipients, Ernest Childers and Jack C. Montgomery, led the parade, held in conjunction with the annual powwow organized by the Tulsa Pow-Wow Club.[40]

Echohawk participated in events designed to promote education and create a better understanding of cultural issues. In 1988, he participated in a symposium organized by Professor Dan Wildcat to "raise issues about how to preserve history in a way that is sensitive to Indian traditions and culture." The issue at hand dealt with a "pit" of bones, believed to be Pawnee remains, which had become a tourist attraction in Kansas. Wildcat and others were hoping to get the site closed in order for the remains to be dealt with in a more respectful manner. After years of negotiation, the two parties reached a compromise in 1990.[41]

Historically, many cultures relied heavily upon their members to mentally record events, genealogies, etc., and keep them in the form of songs and stories for remembrance in the near future as well as for future generations. These oral traditions enhanced the visual records created. Such communities typically held capable orators in

high esteem. Orators had the responsibility for keeping and passing on information. They served as educators, and at times as entertainers. An individual with the capacity to remember and to entertain had the makings of an excellent storyteller. Brummett Echohawk exemplified these characteristics.

Echohawk not only proved himself a successful artist, writer, and public speaker but also earned a reputation as an actor. By all accounts, he enjoyed acting, and, like his other endeavors, he took it seriously but also had fun with it. When asked how he got his start in acting, he related a story about his childhood. Echohawk said his "very first bit of acting" came from his experiences at the Pawnee Indian School at about five years old. The school hired a teacher from Pennsylvania who had a background in theater. Echohawk said every Thanksgiving she would come up with a play for the children to perform. "There was not exactly a wild rush for all us Indian kids to be pilgrims!" he said. "I thought, 'If I'm a turkey, they won't get me to be a pilgrim!' That was the first, if you could call it acting, because we were truly drafted. No one volunteered."[42]

The teacher did not limit theatrical productions to Thanksgiving. She also arranged other plays, including an annual Christmas play. Echohawk recalled the feelings that overtook some of the children as they attempted to fulfill their roles: "My goodness! You walk out on stage and you see Indian people looking at you with long braids and blankets, people leering at you, and you're about five years old. What do you do? You shake and you have stage fright and you crack up!" He laughed at the memory.[43]

Echohawk performed in a number of plays with Tulsa's Little Theater, including Arthur Kopit's *Indians*. Echohawk described Kopit's play as the story of Buffalo Bill and Sitting Bull and the way in which these two very different characters "merged together on the stage of history." He thought Kopit's ability to incorporate the "wrongdoings" of white Americans to American Indians into the play was clever and well done.[44]

Echohawk starred as Sitting Bull in renditions of the play in Oklahoma, Virginia, Germany, and England with great acclaim. The Tulsa Little Theater's production won Kansas's state play festival, and newspapers touted the "superb performance" of Echohawk and fellow cast members. When the Virginia Museum Theater played in Richmond, Virginia, in November of 1973, they received excellent reviews. One news article noted, "Real-life Indian Brummett Echohawk plays Sitting

Bull with a sturdy, quiet eloquence that makes one wonder what the white man might have learned from his red brother if he had been willing to listen."[45] The people of London also received *Indians* well when it played at Questor's Theatre in Ealing, England.[46]

For the twenty-fifth anniversary of the Karl May Theater in Bad Segeberg, West Germany, Echohawk performed in front of more than six thousand people.[47] The play was four hours long, but he worked hard to memorize all of his lines in German. He said he spent about a month and a half learning the entire play, but at the last minute, he had instructions to speak English while his nephew translated in German.[48] The play garnered a great deal of positive attention and press in Germany. In an unexpected turn of events, a Hamburg newspaper article brought together his war experiences, art, and acting. During the war, Echohawk had shot a German soldier in the ear then drew the man's picture and had the wounded man autograph it for him. The story that ran in the newspaper described his background as an artist and soldier and included a copy of the sketch he had made of the man he shot in the ear. The man, then residing in northern Germany, came forward because he remembered the incident of more than thirty years past.[49]

In terms of press exposure, Echohawk recalled being amazed by the attention he received in Germany. He said he saw his picture on virtually "every movie magazine there was, and they did Sunday stories on me. . . . It was strange to see my picture on these things." He participated in an interview on a German talk show where the host said to him, "Surely, Mr. Echohawk, you speak German." Echohawk responded with the only German he learned in the war—"*hände hoch* [hands up]." Years later, he laughed as he said, "That went over like a lead war dance drum." Despite the awkward moment in the television interview, Echohawk and the play continued to receive good press in Germany.[50] He even took a role in a television movie in Hamburg during his time there.[51]

Back in Oklahoma, Echohawk received similar reviews, again for a role as Sitting Bull, in the American Indian Theater Company production of *The Only Indian Left* in 1981. A local playwright named John Hansen wrote the play, earning a commendation from the local *Tulsa Tribune* as one of the best plays put on by the American Indian Theater Company, second only to its production of Kopit's *Indians*. In the same article, Bill Donaldson, critical of much of the work done by the theater, wrote positively of the play, "It had the undeniable presence of Brummett Echohawk."[52]

In 1989, Echohawk took on a prominent role in the Oklahoma Educational Television Authority miniseries *Oklahoma Passage*. The miniseries followed a fictional family through real historical events from Indian removal in the 1830s through six generations, when a family member "is in a space flight to Mars." Echohawk filled the role of Major John Ridge, a Cherokee who felt that his people should relocate rather than continue to try fighting the government. Echohawk did extensive research to master the role. He studied the history and photographs, gained weight, and grew out his hair. Despite the medical issues that still plagued him from World War II, Echohawk insisted on performing his own stunts—including falling off a horse.[53]

Although Echohawk did well in these acting endeavors, he found that he had a difficult time getting roles in Hollywood, despite his status as a full-blood Indian. The situation bothered him: "I don't look like what they [Hollywood casting agents] think an Indian should look like. They're looking for Indians with hatchet faces, and I've got a short nose, a round face, and these long legs." He felt the casting process was unfair, but he was pleased when any American Indian landed an Indian role. To this end, he helped organize the American Indian Talent Guild of Tulsa and Hollywood. He personally headed the office in Tulsa. To help bring about more accurate portrayals of American Indians in films, he also worked as a consultant for MGM and for individual stars like Clint Eastwood and Ann Margaret.[54]

Brummett Echohawk persevered through financial difficulties, managed to maintain a positive attitude toward others, and tried to stay positive himself. Though he may have seemed like a naturally cheerful and active public figure, as an adult he had to work to maintain that disposition. He battled post-traumatic stress disorder (PTSD) after the war, and as a result had to contend with episodes of frustration and depression, which worsened in his later years. He suffered from "recurrent memories" and "intrusive thoughts about combat situations." The classic symptoms of PTSD affected his daily life. He experienced heightened reactions to loud noises like fireworks or backfire from vehicles. He suffered fatigue from loss of sleep brought on by unpleasant dreams and memories. Sometimes dreams became so vivid that he would "patrol the house for hidden enemies" to reassure himself that all was well. His anxiety levels made it difficult at times to remain calm and control his temper. He also experienced "inner agitation" which made concentration difficult, and he had to overcome tendencies to isolate himself from others. Yet, overall, he maintained an optimistic outlook on life, and shared that with the world around him.[55]

Echohawk had regular words of encouragement, particularly for young people. He once told a predominately American Indian college-age audience, "Your part of heritage is moral courage and spiritual courage. Maybe you have a name like mine. Fine. Good. Use that Indian name. . . . Use the best part of you. This is the type of courage I was speaking of—moral courage, and spiritual courage, and of course, everyday courage in what you do."[56]

He constantly pushed for others, particularly the younger generation of American Indians, to set their sights high. He once said, "Try. . . . Sure you're going to fail. Don't we all? But look at it this way: Wouldn't you rather fail at something worthwhile than fail at something dumb? Really. Look at Abraham Lincoln. That guy failed about forty-eight times in the most crucial time of his life, but there's *one* Abraham Lincoln now." Echohawk knew what it meant to struggle. He understood the challenges ahead of ambitious entrepreneurs, but based on his own experience, he felt that meeting those challenges head on added to the ultimate measure of success. In terms of encouraging others to pursue their desired future, he said: "If you try hard at anything you do, the laws of average will be in your favor. And if you try harder than the laws of average, *people* will be in your favor, and things will happen for you. And if you add a magic ingredient called desire, you will win almost every time, and then you're batting around 80 to 90 percent. . . . But you must prepare yourself first. Study. Drive yourself. Always ask yourself, 'What is it I want to do? Where is it I want to go?'"[57]

Echohawk did not view his ethnicity as a burden or something others could use against him. He felt he could, and had, always used it to his benefit, and he encouraged others to do the same. In a 1979 speech at Northeastern State University in Tahlequah, Oklahoma, he told his audience: "I have never been afraid of being rejected in my job. I have never been discriminated against although I'm a full blood, and I look like it, and I have an Indian name. Prejudice is not practiced everywhere generally. As a matter of fact, Indian blood is a distinction. Again, I repeat, use this."[58] Echohawk continued to give examples from his life to reinforce his point. Over the course of his career, he worked all over the nation in various positions, and he maintained that he believed others judged him by his work. He made up his mind as a young man to do something, and he forged ahead, making no excuses. When he told an audience about his experience meeting with fifty-five art directors in one week and receiving almost as many rejections, he maintained that he had been judged the same as everyone

around him and that when he finally landed the job for Planters, he had been judged by his work and his ability to market the product.[59] Echohawk insisted,

> If you make up your mind to do these things, the laws of average will be in your favor and you will win. Failures will become stepping stones, rungs of the ladder for you. If you're an Indian, use it. Remember the higher you go, the less discrimination you will find—if you find it at all, and I never did. Truly I never did. . . . And for heaven's sake, I am a full-blood and I have an Indian name, like I said. So I believe a good part of that is a myth. Think about it. . . . The point I'm making is that you can do this anywhere. . . . I always remembered my background. Used it. Put it to work for me. Like some giant running horse; you put a harness on it. Make it work for you.[60]

Echohawk took his writing and speaking opportunities very seriously. He could be very solemn or stern when the subject matter demanded, or he could make his audience laugh when appropriate. Echohawk demonstrated that one could use entertainment as a useful tool for education. He proved that audiences formerly clueless about American Indians could be reached through a combination of humor and good history. He provided a window for outsiders to look into the world of American Indians, not in an intrusive manner, but in a way that helped bring about new awareness and respect for others. Echohawk did the same in his acting career. For example, he said of his role as Sitting Bull in Germany, "It was a good role, and I felt that it was a helpful thing to the American Indians. I felt in a way that I was an ambassador for the American Indians in theater, so that made me feel good." Smiling he said, "One could say it was a feather in my war bonnet." As for his views on writing history, he maintained that he felt the need to record history in writing and in paintings (and apparently through theater) partly because he mistrusted many historians. He believed that occupational historians often added drama to sell their story. "I feel this is wrong," he said. "Truth has its own drama. Truth, like a painting has its own longevity, and a canvas will stay forever. I feel the same way about recording history."[61]

Brummett Echohawk fulfilled the requirements of Chaticks-si-Chaticks. He excelled as a soldier, artist, writer, speaker, and actor, and he did so with integrity, always maintaining his personal values. He stood firmly in two worlds, and he served as an effective ambassador

for American Indian peoples. He clearly demonstrated that American Indian history and culture fit squarely within American history and culture. Echohawk said, "The full blood name Echo Hawk—I put this together with my tribe the Pawnees. . . . Chaticks-Si-Chaticks means men of men. To me, these are words to live by. I've always lived by them all my life. Chaticks-Si-Chaticks: Men of men. Echo Hawk: A warrior whose deeds are echoed."[62]

Epilogue

Brummett Echohawk continued working throughout his life until he had a stroke a few years before he passed away. Having excelled in many areas of life, he truly embodied his understanding of Chaticks-si-Chaticks, men of men. He succeeded as a warrior, fighting as an infantryman for the United States in the 45th "Thunderbird" Infantry Division in World War II. He left behind an impressive legacy through his art and writing, and in the influence he exerted through his public speaking engagements and acting.

His younger "brother" Myron noted that much has changed since the days of the warriors on the plains. Fewer Pawnee men join the military that he and Brummett and so many in their generations and those before them saw as an important part of becoming a warrior and successful man. Myron suggested that the martial tradition in the Echo Hawk family, traced back to the Pawnee Scouts of the 1860s and 1870s, had once been a "Pawnee thing," but over time became more of a "family thing." Pawnee pride and Echo Hawk pride overlapped, giving many family members of Brummett Echohawk's generation a sense of patriotism and duty to their family, tribe, and country.[1]

As of October 2009, when Myron Echo Hawk talked about the Pawnee martial tradition and the relationship between the Pawnee people and the United States government, as well as the way his family had participated in that relationship, he indicated that nineteen men from the Echo Hawk family had served, or had actively served, in the U.S. armed forces. He spoke proudly of Pawnee service, saying, "Army, Navy, Air Force, Marine Corps, Paratroopers, Submarines, special units like Green Berets. We had guys in all these different branches. Seals." He also recognized the importance of what that service meant in the Pawnee community.[2]

In 2008, the Code Talkers Recognition Act (H.R. 4544) became law. On November 20, 2013, the U.S. government conducted a ceremony in Washington, D.C., to honor the service and sacrifice of the

American Indian code talkers of World War I and World War II. Unfortunately, all of the Pawnee men awarded the medal were honored posthumously. Pawnee Business Council president, Marshall Gover, accepted the Congressional Gold Medal on behalf of the Pawnee Nation and the men being honored. The families of the Pawnee code talkers received Congressional Silver Medals. Brummett Echohawk and eight other Pawnee veterans were among the medal recipients. Joel EchoHawk, Brummett Echohawk's nephew, accepted the medal on his uncle's behalf.[3]

Much like Brummett Echohawk, many of the men in the family have followed the path of military service. Others have, like Brummett, served in the military and then gone on to make a name for themselves and their family in other ways. By now, most people familiar with Indian country know the names of many family members, among them Larry Echo Hawk, John Echohawk, Walter Echo-Hawk, and Roger Echo-Hawk. Not all have military experience, but each has excelled in his chosen profession. They have served as positive examples representing their family and the Pawnee Nation. They have worked continually to improve relations and understandings between American Indian people and the rest of the United States. These men, and others in the family, have clearly fulfilled Brummett's views of what Chaticks-si-Chaticks means.

Myron Echo Hawk spoke of the cultural significance of bear claw necklaces among the Pawnee people. He said that when he worked in Alaska, he had access to the materials to make bear claw necklaces, so he made them for his brothers. His father told them that "in the old days you had to do something to prove that you [were] man enough to wear them. And in my grandfather's day, you either had to go out and kill a grizzly . . . or kill someone that had them on to get it. . . . So when people seen you with these on, they knew you had done something good. Nobody just gave them to you." Echo Hawk continued, "So when I made these things for these boys, they said, 'Do you think we're qualified, or that we can wear them without shame?' And I said, 'Your grandfather, and my dad, would be especially glad because you guys proved yourself already.'" He mentioned the lawyers and doctors in the family and explained that the standard of Chaticks-si-Chaticks applied to each person in his own situation and time. What mattered was working hard and building a strong family.[4]

When asked "What would you think Old Man Echo Hawk, the one who started the family, with the Scouts would say? Would he even claim us as Indians?" Myron Echo Hawk responded: "I don't know. I

doubt it. Because he came from a different era. And we're in a different era. . . . [We're] not his kind of Indian. But then he would think that—from the way you guys was raised and what you did in this white society now—he'd be glad that you did what you did."[5]

Brummett Echohawk certainly used the old ways to succeed in the ever-evolving world around him. He used his knowledge of the past and his heritage to connect with his history, and to help connect the rest of the world to that same history. He worked to bring the two ways together as he walked the line between them. He proved that American Indians could use their heritage to their advantage in life, as well as to the advantage of others, and still embrace long-held cultural values. In 1979, when a young Mexican American asked Echohawk whether he should try to keep his cultural heritage and not completely assimilate into American society, Echohawk responded, "Yes, I believe you should keep your culture. About assimilating into American society. . . . Let someone define that point for you. What do they mean by getting into the mainstream? What's wrong with our stream?"[6] Echohawk believed that different cultures all had something worth preserving and that preserving and sharing could strengthen individuals as well as the nation.

Echohawk was the kind of man who left an impression. As his friend Michael Gonzales said, "He could say the right thing at the right time." Gonzales continued, "He was a great spokesman for his generation, and I'm sorry he didn't write more, and I'm sorry he didn't speak more. But what he *did* say, and what he *did* write, are things that really ought to be preserved."[7]

When asked about Brummett Echohawk, most who knew him well bring up two characteristics: (1) his speaking or storytelling abilities and (2) his remarkable sense of humor. Both qualities remain evident in his work. Echoing Michael Gonzales, General Ed Wheeler said, "He had a terrific sense of humor. He could find humor in almost anything." As already noted, Michael Gonzales said Echohawk had an impressive ability to gauge and engage his audiences. When Wheeler spoke about Echohawk's storytelling sessions at the 45th Infantry Division reunions, he said, "It wasn't so much what he said. It was the way he kept you enraptured. It's like his paintings and his drawings."[8]

Wheeler shared a common sentiment when he said, "He was one of the most remarkable men I've ever met. . . . I don't think that I'll ever meet anybody quite like him again. I've met a lot of people across the spectrum of human experience, but he was one of a kind. He was unique." He compared meeting Brummett Echohawk to meeting

George Armstrong Custer on the frontier. Although you would forget many of the officers you met at the forts, you would remember the bold personality and showmanship of Custer. He continued, "Brummett Echohawk fell into that category. Once you met him, you never forgot him. He was a unique, unforgettable person. Everybody who ever knew him will remember him for the rest of their lives. He was just a terrific guy."[9]

Brummett Echohawk died on February 13, 2006, in the Tulsa area. He is buried in the Highland Cemetery on the edge of Pawnee, Oklahoma. Much of his artwork remains in his family's possession and in galleries and private collections across the country. His illustrations still animate back issues of books and magazines. His life encompassed many things, but perhaps foremost among them remains his determination to maintain old values in a modern world, and to make a truthful record of history—and not just Pawnee history.

Notes

Introduction

Epigraph. Echohawk, *Indian Art.*

1. The reader may note that numerous spellings of the family name appear in the text. The descendants of the original Echo Hawk have altered the spelling of the name, creating multiple versions of the same name within the family: Echo Hawk, Echo-Hawk, EchoHawk, and Echohawk. Names will appear as each family member now spells it, or as it appears in official documents, such as government records. When referring to the family as a whole, the original form of Echo Hawk is employed.

2. Echohawk, *Indian Art.*

3. Chamberlain, *When Stars Came Down to Earth*, 211–224.

4. Weltfish, *Lost Universe*, 6–7.

5. Dunbar, "History and Ethnology," 259–264.

6. Weltfish, *The Lost Universe*, 6.

7. Ibid., 5.

8. Echohawk, *Indian Art.*

9. Calloway, "Inter-tribal Balance of Power," 35–36; Wishart, "Dispossession of the Pawnee," 386; Blaine, *Pawnee Passage*, 49–65.

10. Dunbar "Habits and Customs" (1880), 335.

11. The Iroquois League or Confederacy provided a good example.

12. White, "Winning of the West," 319–344; Calloway, "Inter-Tribal Balance of Power," 25–47.

13. White, "Winning of the West," 319–344; Calloway, "Inter-Tribal Balance of Power," 25–47.

14. Dunbar, "Habits and Customs" (1880), 334. United States, (October 9, 1833), Article 9.

15. Treaty with the Pawnee (October 9, 1833), art. 9. Treaty with the Pawnee, December 12, 1848.

16. Kappler, "Treaty with the Pawnee, 1833," 416–418. Wishart, "Dispossession of the Pawnee," 388.

17. Evans, interview.

18. Dunbar, "Habits and Customs" (1880), 334.

19. Pawnees and other tribes in the region were also affected by cholera, syphilis, and other diseases, largely because of their proximity to overland migrant trails (and settlements).

20. Dunbar, "History and Ethnology," 255.

21. The events at Massacre Canyon will be discussed further in chapter one.

22. White, "Winning of the West," 325, 337–338. Calloway, "Inter-tribal Balance of Power," 41. Wishart, "Dispossession of the Pawnee," 387.

23. Dunbar, "History and Ethnology," 254; Calloway, *Our Hearts Fell to the Ground*, 7. Calloway cites Gary Moulton's edition of *The Journals of the Lewis and Clark Expedition*, 2:467, 479, 482n.

24. Kappler, "Treaty of Fort Laramie with Sioux, etc., 1851," 594–596.

25. Connor's California Volunteers' Bear River Massacre near the Utah-Idaho border is an example of the result of one such group's actions. The Massacre at Sand Creek and the events surrounding the Navajo Long Walk serve as further examples.

26. Department of State, "Act to Increase and Fix the Military," 332–333.

27. Sherman quoted in Van de Logt. "War Party in Blue," 1.

28. Crook quoted in ibid., 1.

29. Bruce and North, *Fighting Norths*, 18.

30. White, "American Indian as Soldier," 15–25. "The United States was for the first time alarmed by large numbers of unemployed itinerants, or 'tramps.' At such a time the prospect of thousands of unemployed Indian vagabonds was an unwelcome one" (15).

31. Assimilation at this time was *not* synonymous with integration.

32. In the 2004 *Merriam-Webster Dictionary*, "assimilation" is "to make or become similar." "Acculturation" is the "cultural modification of an individual or group by borrowing and adapting traits from another culture."

33. Holm, *Strong Hearts*, 101–102.

34. Van de Logt, *War Party in Blue*, 4.

35. White, *Roots of Dependency*, 147–199.

36. Kappler, *Indian Affairs: Laws and Treaties*. Various bands of Pawnees signed treaties of peace and friendship with the United States as early as the summer of 1818 and again in 1825, 1833, and 1848. The first missionaries officially assigned to the reservation arrived in the 1830s by way of Saint Louis.

37. Treaty with the Pawnee, (1848); Kappler, *Indian Affairs*, "Table Rock Treaty."

38. This does not mean that assimilation and acculturation did not take place.

39. Van de Logt, "War Party in Blue," 2.

40. Ibid. See also Easton, "Getting into Uniform," 49.

41. Van de Logt, *War Party in Blue*, 241–246.

42. Department of the Interior, *Annual Report of the Commissioner*, 1864, 383.

43. Echo-Hawk, "Pawnee Military Colonialism"; Echo-Hawk recognized a process of syncretism within the structure of command. He noted that the Pawnee Scouts "engaged in . . . formal ceremonialism, such as name-giving ceremonies." He also pointed out that under the surface structure of military command, "the Americans acted only with the express authority of the Pawnee Confederacy Leader Council." Echo-Hawk stated that Pawnee priests and

doctors accompanied the [S]couts and that noncommissioned officers among them, often labeled "'sergeants' would have been men qualified to lead Pawnee war expeditions under the formal authority of a religious bundle" (2).

44. Ibid.

45. Easton, "Getting into Uniform," 7.

46. Bruce and North, *Fighting Norths*, 2. Patrick E. Connor is also known for his 1863 attack on the Shoshone winter camp at Bear River in Idaho, often referred to as the "Bear River Massacre."

47. Dunlay, *Wolves for the Blue Soldiers*, 44; *General Order No. 56*, August 1, 1866.

48. Dunlay, *Wolves for the Blue Soldiers*, 154. Wishart, "Dispossession of the Pawnee," 394, 396, 398.

49. White, *Roots of Dependency*.

50. Wishart, "Dispossession of the Pawnee," 390–401.

51. Department of the Interior, *Annual Report of the Commissioner*, 1864, 383. Dunlay, *Wolves for the Blue Soldiers*, 160. Blaine, *Pawnee Passage*, 98–142.

52. Milner, *With Good Intentions*; Wishart, "Dispossession of the Pawnee," 397–401.

53. Senate Committee on Indian Affairs, *Removal of the Pawnee Indians*, 1875; House Committee on Indian Affairs, *Pawnee Indian Reservation in Nebraska*.

54. For information regarding the condition of the Pawnees, see House Committee on Indian Affairs, *Pawnee Indians, Report*, March 14, 1876; and House Committee on Indian Affairs, *Pawnee Indians: Message from the President*, April 4, 1876.

55. Pawnee Harry Coons served under Major North on the Powder River campaign and under Captain W. C. Hemphill with the 4th Cavalry out of Indian Territory when the Northern Cheyennes fled the Darlington Agency to go north toward their homelands; Reeder, "Wolf Men of the Plains," 350–351.

56. White, "American Indian as Soldier," 17.

57. Ibid., 16. This way of thinking looks very much like that behind the Dawes Act, which was enacted less than ten years later.

58. White, "American Indian as Soldier," 19.

59. Roosevelt, "Raising the Regiment," 14–16. Roosevelt is quoted in the *New York Times*, August 16, 1898, as saying: "We have men from East and West—Indians, half-breeds, and whites. We judge each man purely on his merits. If he can fight and march and has the knack of commanding, he will go up."

60. Barnes, "Report of the Governor of Oklahoma, 1898," 71; Barnes, "Report of the Governor, 1900," 102.

61. *El Reno News*, May 13, 1898; Ball, "Pawnee Rough Rider," 452–453. Pawnee Indian/Agency School remained grades 1–8 until after World War II when the ninth grade was added. "Record of Pupils Transferred from Pawnee Agency, Indian Territory," 30–33.

62. Franks and Lambert, *Pawnee Pride*, 194.

63. William H. Howell, "Rough Rider of the Pawnee," *Tahlequah (Okla.) Native American Times*, November 1, 2001, 3C. War Department, "Cuban Expeditionary

Force," Company Muster-in, Roll 2, ARC No. 301282, "Compiled Military Service Record of William Pollock."

64. *El Reno News*, July 22, 1898, 6.

65. War Department, "Cuban Expeditionary Force"; Finney, "William Pollock," 509.

66. Pollock quoted in Ault, "Native Americans in the Spanish American War." Although Pollock mentions that he is the only full-blood, he was certainly not the only Indian. It is also worth noting that extensive travel and/or international travel was something still unusual for many American Indians at the time.

67. Roosevelt, "Cavalry at Santiago," 438.

68. Pollock quoted in "Death of a Good Indian: Pollock, Roosevelt's Pawnee 'Rough Rider,' Is Gone," *Kansas City Star*, March 12, 1899, 13.

69. Pawnee Indian Veterans Association, "53rd Annual Pawnee Indian Homecoming Program"; "Death of a Good Indian," 13; Roosevelt quoted in Shirley, *Red Yesterdays*, 60.

70. Echo-Hawk, "Pawnee Military Colonialism," 6.

71. Echohawk, "Pawnee Story," 23.

Chapter 1

Epigraph. Echohawk, *Indian Art.*

1. Dunbar, "History and Ethnology," 267.

2. A similar situation occurred after the failure of crops due to drought in 1864. In that instance, the Pawnees were driven from the hunting grounds but did not suffer the same heavy casualties as they did in 1873. Department of the Interior, *Annual Report of the Commissioner*, 1864, 383.

3. Dunlay, *Wolves for the Blue Soldiers*, 160; Blaine, *Pawnee Passage*, 98–142; Van de Logt, *War Party in Blue*, 174.

4. Echohawk, "Massacre Canyon on Canvas," 23.

5. Dunlay, *Wolves for the Blue Soldiers*, 160. Blaine, *Pawnee Passage*, 98–142.

6. Department of the Interior, *Annual Report of the Commissioner*, 1873.

7. Van de Logt, *War Party in Blue*, 174–185.

8. Department of the Interior, *Annual Report of the Commissioner*, 1874, 200.

9. In 1890, the government organized the western portion of Indian Territory into Oklahoma Territory. The new Pawnee reservation was situated on the Oklahoma side of the territorial border. Wishart, "Dispossession of the Pawnee," 401; Blaine, *Some Things Are Not Forgotten*, 16; Hyde, *Pawnee Indians*, 303–323.

10. Echohawk, "Pawnee Scouts," 10; Dunlay, *Wolves for the Blue Soldiers*, 161.

11. Dunlay, *Wolves for the Blue Soldiers*, 161.

12. Mark Van de Logt, *War Party in Blue*, 192.

13. Echo-Hawk, "Under the Family Tree." This information is drawn from Roger Echo-Hawk's work in progress, "Children of the Seven Brothers: Two Centuries of Echo Hawk Family History." For Pawnee translations, see also FamilySearch.org.

Echo Hawk family records are posted by various members of the Echo Hawk family. A variation on the Pawnee spelling of "Echo Hawk" is "Kit-to-wah-keets Soto-wah-kah-ah." Listed in a copy of Myron Echo Hawk's family history records is the spelling "Kutawa-kutsu-tuwaku-uh"; also listed in this record is a note that the name "Echo-Hawk" may have originated with an earlier ancestor and have been passed down as a family name (according to Owen Echo-Hawk, Brummett's older brother).

14. The General Allotment Act of 1887, also known as the Dawes Act (named for Senator Henry L. Dawes), refers to the legislation that enabled the government to divide up and assign Indian lands for individual ownership among the tribal members and for sale to the general public. Congress designed the act as follows: Each family head should be allotted 160 acres; each single member of the home eighteen or older, 80 acres; and younger single household members, 40 acres. The government held the land in trust for twenty-five years, and once the legislation passed, all tribal members had four years to select the lands to be allotted to them. Once one accepted an allotment, he (married women were ineligible to receive land until 1891) would be granted citizenship. Central to allotment was the notion that breaking up tribally or communally held lands promoted individualism and assimilation. In reality, corruption proved a real problem, and the process did not always work as planned. Otis, *The Dawes Act*, 3–7, 82–155.

15. Family history indicates that allotment was directly related to the name change of Howard Echo Hawk, but on the "Map of Mound Township" produced in 1907, published as part of the *U.S., Indexed County Land Ownership Maps, 1860–1918* for Mound, Payne County, Oklahoma, his allotment is labeled "Echo-Hawk." In Myron Echo Hawk's family history records, an entry reads: "In the 1890s the government allotting agent appointed for the Pawnees was a woman, Miss Helen Clarke, who was half Blackfoot. When Big Crow went before her to receive his allotment, she explained that he had to have a regular family name to enter, in order to identify him and his descendants on government records. At that time white people had already filtered into or near the reservation, and Big Crow apparently had several white neighbors. Miss Clarke suggested to Big Crow that he adopt the name of one of those neighbors, whose names were 'Price' and 'Barnes.' Big Crow refused to consider such a suggestion. 'I want the name I had when I was a young man: Kutawa-kutsu-tuwaku-uh,' he said to the interpreter. This name was translated as 'Echo-Hawk' although a more literal interpretation would be: 'Hawk-Echoing.'"

16. Echohawk, "Recollections of the Pawnee Scouts," 27–28.

17. Echohawk, "Pawnee Story," 23.

18. Echohawk, "Recollections of the Pawnee Scouts," 27–28.

19. Ibid., 26.

20. Echohawk, "Pawnee Scouts," 9.

21. Echohawk, "Recollections of the Pawnee Scouts," 26.

22. Echohawk, "Pawnee Scouts," 11.

23. Echohawk, "Recollections of the Pawnee Scouts," 26.

24. Various Indian census records of the Pawnee Agency. Census Bureau, Indian Census Rolls, 1885–1940; and 1920 U.S. Federal Census.

25. Myron Echo Hawk, "Elmer Price Echo-Hawk."

26. Again, the government organized Oklahoma Territory out of the western portion of Indian Territory in 1890.

27. Echohawk, "Pawnee Story," 19.

28. Ibid.

29. George and Elmer attended the Pawnee school under Superintendent George I. Harvey, whom the Indian Service eventually dismissed for abusive policies toward students and for financial dishonesty in regard to banking practices among the Pawnee Indians. Indian Rights Association, *Twenty-first Annual Report*, 50–55; Adams, *Education for Extinction*, 122–123.

30. Myron Echo Hawk, "Elmer Price Echo-Hawk." According to these family records, Elmer and Thorpe became good friends and maintained that friendship long after leaving Carlisle. According to his school records of December 1909, Elmer was in good health with three living brothers and two living sisters. Bureau of Indian Affairs, File for Elmer Echohawk.

31. Bureau of Indian Affairs, File for Elmer Echohawk.

32. Echohawk, "Pawnee Story," 19.

33. Bureau of Indian Affairs, File for Elmer Echohawk. Running away proved a common path of resistance for boarding-school children, even at off-reservation schools like Carlisle. In 1901, 45 out of 114 boys discharged from Carlisle had been runaways. Some schools even resorted to strapping down or locking up offenders. Adams, *Education for Extinction*, 224–229.

34. Echohawk, "Pawnee Story," 19.

35. Bureau of Indian Affairs, File for Elmer Echohawk.

36. Census Bureau, Indian Census Rolls, 1885–1940 and 1920 U.S. Federal Census; family history; and Bureau of Indian Affairs, Carlisle records.

37. Bureau of Indian Affairs, File for Alice Jake.

38. Ibid.

39. Ibid.; Bureau of Indian Affairs, File for Elmer Echohawk.

40. Bureau of Indian Affairs, File for Elmer Echohawk. Based on correspondence found in Elmer's school file, it appears that the couple maintained contact with the superintendent at least until 1916. A letter from the superintendent dated November of 1916 indicates that he had sent a check to Elmer for $10.35 in March but was concerned because Elmer had not cashed it. He was unsure whether Elmer had lost it or did not know how to cash it.

41. Elmer did not serve overseas. He was in New Jersey when the war ended. Correspondence with Myron Echo Hawk.

42. Reeder, *Wolf Men of the Plains*, 376; Densmore, "Songs of Indian Soldiers," 424; Densmore, "Densmore Project"; Riding In, correspondence.

43. Pawnee Indian Veterans Association, "53rd Annual Pawnee Indian Homecoming Program"; Densmore "Songs of Indian Soldiers," 422. More specific details about the music are available in Densmore,"War Songs."

44. Densmore, "Songs of Indian Soldiers," 424.

45. Private collection of Myron Echo Hawk.

46. Echohawk, "Recollections of the Pawnee Scouts," 27–28. Howard Echo Hawk died on March 6, 1924.

47. Echohawk, "Pawnee Story," 23.

48. Echohawk, "Cowboy Movies and Real Indians" (1973): 8.

49. Myron Echo Hawk, interview, 2006; Riding In, correspondence.

50. David W. Adams outlines the reasons that boarding schools, particularly the off-reservation schools, adopted militaristic approaches to Indian education. He says in part, "Part of being civilized, the logic went, was being able to follow orders in a hierarchical organization." He also noted that the militaristic approach helped with the daily organizational issues, which arose from having to "house, feed, teach, and, most significantly, control several hundred 'uncivilized' youths. Good health, neatness, politeness, the ability to concentrate, self-confidence, and patriotism were also attributed to military regimen." Adams, *Education for Extinction*, 118–121.

51. Echohawk, "Pawnee Story," 23.

52. Ibid.

53. Ibid.

54. Ibid.

55. Echohawk, *Indian Art*.

56. Ibid.; Echohawk, "Pawnee Story," 23.

57. Echohawk, *Indian Art*; Standing Bear, *Land of the Spotted Eagle*, 232–233.

58. Echohawk, "Cowboy Movies and Real Indians" (1973): 8–10; Franks and Lambert, *Pawnee Pride*, 44.

59. Echohawk, "Pawnee Scouts," 11.

60. Echohawk, "Pawnee Story," 23.

61. Lomawaima, *Prairie Light*. An anthropologist who has written extensively on American Indian boarding-school experiences, Dr. Tsianina Lomawaima wrote that "military regimentation dominated boarding-school life, and it dominates boarding-school reminiscences" (101).

62. Lomawaima, *Prairie Light*, 7–8.

63. Myron Echo Hawk, "Elmer Price Echo-Hawk," census information and family history documentation. According to the records kept by Carlisle Indian Industrial School, Alice Jake Echohawk was Episcopalian. Bureau of Indian Affairs, File for Alice Jake.

64. Myron Echo Hawk, "Elmer Price Echo-Hawk."

65. Ibid.

66. David Echo Hawk, interview, 2006; Census Bureau, Indian Census Rolls, 1885–1940. See also Walter Echo Hawk's obituary, January 21, 1973, *Jefferson City (Mo.) Sunday News and Tribune*, 2.

67. George was good friends with Mose Yellow Horse, the first Native American MLB player. Yellow Horse was noted for having struck out George Herman "Babe" Ruth.

68. Myron Echo Hawk, interview, 2006.

69. The Native American Church constitutes a pan-Indian religious group first organized around 1890 among the Kiowas. The organization combines Christian tenets with American Indian cultural values and practices.

70. Myron Echo Hawk, "Elmer Price Echo-Hawk."

71. Myron Echo Hawk, interview 2006; "Large Group of Varsity Art Students Exhibit Work Here," *Santa Fe New Mexican*, May 21, 1936, 2; "Around Albuquerque," *Albuquerque Journal*, March 6, 1938, 9.

72. Echohawk, Personal Papers, "Manuscript, handwritten," 248.

73. Wheeler, interview.

Chapter 2

Epigraph. Echohawk, *Indian Art.*

1. Nelson, *Thunderbird*, 12–13; Bishop, Glasgow, and Fisher, *Fighting Forty-Fifth*, 6.

2. Conversations with Myron Echo Hawk, David Echo Hawk, and Helen Norris, 2006.

3. Myron Echo Hawk, interview, 2009. Myron is technically Brummett's first cousin, but, because they were raised together, they referred to one another as "brother."

4. Echohawk, *Indian Art.*

5. Myron Echo Hawk, interview, 2009.

6. Echohawk, transcribed interview, 45th Infantry Division Museum Archives (hereafter 45th Archives), 8.

7. Ibid.

8. Myron Echo Hawk, interview, 2009.

9. Ibid.

10. Echohawk, Personal Papers, "Email from Larry Hickey," 2–3.

11. Ibid., 1, 3; Pawnee Indian Veterans Association, "53rd Annual Pawnee Indian Homecoming Program," 24, 37; Reeder, *Wolf Men of the Plains*, 403–404.

12. Reeder, *Wolf Men of the Plains*, 403; Pawnee Indian Veterans Association, "53rd Annual Pawnee Indian Homecoming Program," 22, 34.

13. Myron Echo Hawk, interview, 2009.

14. Ibid.

15. Nelson, *Thunderbird*, 12–13.

16. Munsell, *History of the 179th*, 1.

17. Ibid.

18. Bishop, Glasgow, and Fisher, *Fighting Forty-fifth*, 6.

19. Echohawk, Personal Papers, "Statement of Gilbert Curtis," 1.

20. Rosier, *Serving Their Country*, 91–93; Bernstein, *American Indians and World War II*, 40–46; Townsend, *World War II and the American Indian*, 69–71.

21. Kathy Griffin, "Anzio Veteran Recalls Famed 45th Battle," *Tulsa World*, January 22, 1984, B-2, B-4.

22. "A Tribute to Phillip Gover," *Pawnee Chief*, September 6, 1992, 14.

23. 45th Archives, Phil Gover, "Deposition."

24. Bernstein, *American Indians and World War II*, 44.

25. Typically, elite American infantrymen fill the ranks of the rangers. Franco, *Crossing the Pond*, 67, 135; Echohawk, transcribed interview, 6; Reeder, *Wolf Men of the Plains*, 396.

26. Echohawk, transcribed interview, 6; Reeder, *Wolf Men of the Plains*, 396.

27. "History," 45th Infantry Division Museum website; "45th Infantry Division," U.S. Army Center of Military History website; Echohawk, Personal Papers, "Manuscript, typed," 2.

28. Rosier, *Serving Their Country*, 77–79.

29. Ibid., 2.

30. Ibid., 9.

31. Department of the Army, "Morning Reports," September 16–26, 1940.

32. Brummett Echohawk, "It Happened at Anzio," *Tulsa Sunday World*, February 12, 1967, 13; 45th Archives, Chauncey Matlock, VA "Statement in Support of Claim," 1; 45th Archives, Ray Purrington, "Deposition," 1.

33. Department of the Army, "Morning Reports," April 12, 1941.

34. United States Army Transport (USAT).

35. Department of the Army, "Morning Reports," April 21–31, 1941.

36. Munsell, *History of the 179th*, 2.

37. "Big Maneuvers Test U.S. Army," 33–43; Perry, "Greatest War Games," 50–57.

38. Munsell, *History of the 179th*, 2.

39. Echohawk, transcribed interview, 13–14.

40. Ibid., 14–15.

41. Williamson, *Tales of a Thunderbird*, 51.

42. Ibid. Brummett Echohawk's nephew David Echo Hawk said that Brummett talked about the men folding their uniforms into bustles and dancing around fires, as if at a great powwow. Conversations with David Echo Hawk, 2006.

43. Records of the Pawnee South Cemetery; Department of the Army, "Morning Reports," February 17 and 23, 1942.

44. Franco, *Crossing the Pond*, 132–133; Bernstein, *American Indians and World War II*, 44–45; Townsend, *World War II and the American Indian*, 133–134.

45. Jack Durant, "Indians Are Best Fighters," *Hutchinson (Kans.) News-Herald*, November 29, 1942, 17; Durant, "Indians Are Best Soldiers in U.S. Army," *Albuquerque Journal*, December 3, 1942, 6; "Indians Called Best Fighters in U.S. Army," *Joplin (Mo.) News Herald*, December 14, 1942, 2.

46. Department of the Army, "Morning Reports," May 5 and 7, 1942. Echohawk, Personal Papers, "Appeal to Board of Veterans Appeals," 1; Gover, "Deposition." Gover stated in the same paragraph that "Brummett Echohawk was married at the time—and he never drank or smoked." There is a marriage record for Brummett Echohawk and Opal Jones in Taylor Texas, March 21, 1942. However, this and the brief comment here by Phil Gover are the only mentions found of this marriage. Texas, Taylor County Marriage Records, 17 (1880–1966), 120, Abilene, Texas; Echohawk, Personal Papers, transcript of "Response to Medical Report or

NOD," 1. The drainage issue persisted, manifesting periodically throughout his life. See also Echohawk, Personal Papers, Red Notebook "Amos, Purple Heart Power of Attorney," entry dated Wednesday, April 5, 2000.

47. Department of the Army, "General Order No. 2," August 3, 1942.

48. Franks and Lambert, *Pawnee Pride*, 205. Apparently, some of the dancers, including a Pottawatomie from Pawnee named William Lasley, garnered such impressive reputations that they were featured in a 1942 issue of the *Christian Science Monitor*.

49. "'Big Silver Wampum' of Indian Soldiers Refused in Stores," *Fitchburg (Mass.) Sentinel*, May 5, 1942, 1.

50. Personal Papers, Robert P. Rice, "VA Statement in Support of Claim," 1.

51. Department of the Army, "Morning Reports, Events" and "Morning Reports, Remarks," June 11, 1942.

52. "War Might of City on Display Today," *New York Times*, June 13, 1942, 1. "New York at War to March June 13," *New York Times*, May 19, 1942, 15.

53. "New York at War to March June 13," *New York Times*, May 19, 1942, 15; "City War Parade to Last All Day," *New York Times*, May 25, 1942, 8; "Drum to Be Leader in March of 500,000," *New York Times*, June 10, 1942, 12; "War Might of City on Display," *New York Times*, June 13, 1942, 1; "Millions Hail Marchers Here," *New York Times*, June 14, 1942, 1.

54. Holm, "Fighting a White Man's War," 73.

55. Rosier, *Serving Their Country*, 88–90; Franco, *Crossing the Pond*, 120–144; Townsend, *World War II and the American Indian*, 127–138.

56. Laureen Gibson Gilroy, "Veterans Recall Thunderbirds' Role in Sicily Invasion: Both Sides Praised 45th Infantry Division," *Tulsa World*, June 13, 1993.

57. Munsell, *History of the 179th*, 2–3.

58. Bishop, Glasgow, and Fisher, *Fighting Forty-fifth*, 6.

59. Munsell, *History of the 179th*, 4–5.

60. Department of the Army, "General Order No. 1," June 1, 1943.

61. Munsell, *History of the 179th*, 6. Note: Leonard Wood was one of the officers and recruiters for Roosevelt's Rough Riders, which included Pawnee William Pollock.

62. Ibid., 7. See also Bishop, Glasgow, and Fisher, *Fighting Forty-fifth*, 7.

63. Bishop, Glasgow, and Fisher, *Fighting Forty-fifth*, 7.

64. Munsell, *History of the 179th*, 8.

65. Ibid., 9.

66. Bishop, Glasgow, and Fisher, *Fighting Forty-fifth*, 14.

67. Ibid., 13.

68. Ibid., 13–14. The 157th Regiment assisted in securing the airfield.

69. "Manuscript, handwritten," 3.

70. Echohawk, *Indian Art*; Gover, "Deposition." Echohawk led a "sapper team": "The sappers were to destroy entanglements and pill boxes." Envelope: "Individual combat Achievements," 1; and Colonel Glenn I. Lyon "Affidavit" for Congressional Medal of Honor Recommendation, 1, both in Echohawk, Personal Papers.

71. Bishop, Glasgow, and Fisher, *Fighting Forty-fifth*, 16–17.

72. Munsell, *History of the 179th*, 12.

73. Ibid.

74. "Manuscript, typed," 4.

75. Echohawk, transcribed interview, 7. Years later, Echohawk served as the president or *laket* (leader) of the Pawnee Warrior Society.

76. Echohawk, transcribed interview, 7; Pawnee Indian Veterans Association, "53rd Annual Pawnee Indian Homecoming Program," 18; Reeder, *Wolf Men of the Plains*, 371–379.

77. Echohawk, *Indian Art*.

78. "Manuscript, handwritten," 5.

79. "Phillip Gover Portrait Donated to 45th Division Museum at Annual Meeting," *Pawnee Chief*, September 3, 1987, 3.

80. Holm, *Strong Hearts*, 137. Holm discussed the Indian scout syndrome in terms of World War II, Korea, and Vietnam.

81. Echohawk, transcribed interview, 2.

82. For a discussion of modern intertribal rivalry, see Iverson, *Riders of the West*, 81–82.

83. Echohawk, *Indian Art*; Munsell, chap. 6, "Race to the North Coast," in *History of the 179th*, 17–22; 45th Archives, Gilbert Curtis, "Deposition," 3. "I was with his patrol that reached the north coast of Sicily. We cut over mountains and dog-trotted at night. We reached a rail-road station by the sea. Echohawk left part of the patrol at the station, while the rest pumped a handcar along a sea coast rail-road, making good time. We got small arms fire from high cliffs but kept pumping. I am certain we were the first Americans to reach the north coast of Sicily, July, 1943"; "Manuscript, typed," 7.

84. Echohawk. *Indian Art*.

85. Ibid.; Munsell, "Race to the North Coast," 17–22; Curtis, "Deposition," 3. "Manuscript, typed," 7.

86. Echohawk, *Indian Art*; Curtis, "Deposition," 3.

87. "Individual Combat Achievements," 1.

88. Echohawk, *Indian Art*.

89. "Individual Combat Achievements," 1–2; Chauncey Matlock stated that Echohawk "must have set some kind of record for patrols for I think he 'spent more time behind the Enemy lines than he did in front of them'"; Matlock, "Statement in Support of Claim," 3; Lyon "Affidavit," 1.

90. Echohawk, *Indian Art*. Although maps showing the movements of troops during the Sicilian campaign place the 179th RCT in reserve during this time, multiple accounts suggest these events did take place.

91. "Manuscript, typed," 7.

92. Stokes's deposition spells it "San Morrow, or Morra," but Lyon spelled it "Morro," more like the Moro River valley in Italy.

93. "Manuscript, typed," 5.

94. Lyon "Affidavit," 1; Echohawk, Personal Papers, Sgt. Robert Stokes, VA "Statement in Support of Claim," 2.

95. Munsell, *History of the 179th*, 18.

96. Ibid., 19.

97. "Manuscript, typed," 8.

98. Ibid.

99. Munsell, *History of the 179th*, 21; Bishop, Glasgow, and Fisher, *Fighting Forty-fifth*, 39.

100. Ibid.

101. Munsell, *History of the 179th*, 21.

102. Ibid.

103. Bishop, Glasgow, and Fisher, *Fighting Forty-fifth*, 39.

104. Ibid., 39, 42.

105. Gover, "Deposition."

106. Bishop, Glasgow, and Fisher, *Fighting Forty-fifth*, 40–41; Reeder, *Wolf Men of the Plains*, 408.

107. Echohawk, Personal Papers, "Who's Who in this Issue."

108. "Manuscript, typed," 11; "Indian Chief Leaps Ashore 'To Return Columbus Visit,'" *New York Times*, September 16, 1943, 5. According to Lt. General Mark Clark, commander of the Fifth Army, the Cheyenne identified as Two Hatchets was Paul Bitchenen of Cheyenne, Oklahoma. Clark told the press Bitchenen had declared "Hi-yah! Christopher Columbus, we are here to return that little visit," at Salerno; see also Wright, "Oklahoma War Memorial," 145.

109. Bishop, Glasgow, and Fisher, *Fighting Forty-fifth*, 42; Munsell, *History of the 179th* 24.

110. Munsell, *History of the 179th*, 24.

111. "Statement of Gilbert Curtis," 3.

112. Whitlock, *Rock of Anzio*, 184.

113. Johnson quoted in Reeder, *Wolf Men of the Plains*, 409.

114. Rice quoted in ibid.

115. Ibid.

116. "Manuscript, typed," 13.

117. Ibid., 14.

118. "Manuscript, handwritten," 266, 261–262.

119. Ibid., 261–262; Echohawk, "Manuscript, typed," 14.

120. "Manuscript, typed," 15.

121. Ibid.

122. Ibid.

123. Ibid., 16.

124. "Who's Who in this Issue."

125. Townsend, *World War II and the American Indian*, 136–137.

126. "News from Old Friends" *Watertown (N.Y.) Times*, n.d.; Gilroy, "Veterans Recall Thunderbirds' Role."

127. Hitler quoted in Rosier, *Serving Their Country*, 78.

128. Townsend, *World War II and the American Indian*, 136.

129. Echohawk, *Indian Art*.

130. Myron Echo Hawk, interview, 2009.

131. Echohawk, *Indian Art*.

Chapter 3

Epigraph. Don Boxmeyer, "An Artist Who Happens to be an Indian," *Saint Paul Dispatch,* May 10, 1967, 49.

1. Though the men in Echohawk's unit did not provide a first name, according to the website findagrave.com, this was most likely Londo K. Humble, although unit rosters and morning reports have not confirmed this.

2. Matlock, "Statement in Support of Claim," 2; "Manuscript, handwritten," 259–260.

3. "Manuscript, handwritten," 268; Matlock, "Statement in Support of Claim," 2.

4. Matlock, "Statement in Support of Claim," 2.

5. 45th Archives, "Concussion Hit, Salerno, Italy," 1. This account supported by Echohawk's platoon sergeant, Phil Gover. "At Salerno Beachhead Echohawk's Squad got jumped by German Mark IV tanks. This was at the Sele river." Gover, "Deposition"; Curtis, "Deposition," 1.

6. "Concussion Hit, Salerno, Italy," 1; Matlock, "Statement in Support of Claim," 1; Purrington, "Deposition," 1; Curtis, "Deposition," 1.

7. Gover, "Deposition"; "Concussion Hit, Salerno, Italy"; Purrington, "Deposition," 1; Reeder, *Wolf Men of the Plains,* 408. Reeder states that there were hundreds of tanks involved in this German attack on the 179th RCT.

8. Matlock, "Statement in Support of Claim"; "Concussion Hit, Salerno, Italy," 2; Gover, "Deposition"; Curtis, "Deposition," 1; Echohawk, Personal Papers, Envelope: CMH, Colonel Glenn I. Lyon, "Recommendation for Award."

9. "Concussion Hit, Salerno, Italy," 2; Matlock, "Statement in Support of Claim," 1; Curtis, "Deposition," 1.

10. Echohawk, Personal Papers, "Notes for manuscript, 10-1-99," 3.

11. "Concussion Hit, Salerno, Italy," 2; Curtis, "Deposition," 1.

12. Curtis, "Deposition," 3.

13. Lyon, "Recommendation for Award." Based on information provided Lyon by his men after the war, Lyon believed that, because he was called to Regimental Headquarters right before this fighting took place, and Lt. Everes was also called to other duties, the new officer "placed major responsibilities on the NCOs I had trained. Most [were] Pawnee Indians or hometown friends. All had the highest integrity. After the war was over and we were home and discharged, I began hearing reports of the exploits of Brummett Echohawk and [G]ilbert Curtis (called Cheyenne). At reunions and during casual visits, I learned that Company command had a series of replacements, thus no reports were forwarded for citations." Echohawk, Personal Papers, Amos Harjo "Statement" for Department of Veterans Affairs: "The issue was in doubt. Had the 9 Panzers broke through others would follow. The American beachhead would have been lost" (3).

14. Middleton quoted in Bishop, Glasgow, and Fisher, *Fighting Forty-fifth,* 48.

15. Gover, "Deposition."

16. "Manuscript, typed," 18–19.

17. Townsend, *World War II and the American Indian,* 140–142; Franco, *Crossing the Pond,* 132.

18. "7th Army Indians in War Dance," *New York Times*, July 25, 1943, 30.

19. Gonzales, interview.

20. "Manuscript, typed," 20.

21. Ibid., 19–20; Echohawk, transcribed interview, 8.

22. Bishop, Glasgow, and Fisher, *Fighting Forty-fifth*, 48; Munsell, *History of the 179th*, 25–27.

23. Munsell, *History of the 179th*, 27.

24. Echohawk, Personal Papers, "Letter from Lt. Colonel Ernest Childers."

25. "Manuscript, typed," 20–21. See also John Smith, "He Went to War Armed with a Pencil, Echohawk," *London Sunday Mirror*, January 4, 1970, 9.

26. Gonzales, interview.

27. Ibid.

28. "B.A.R." stands for Browning Automatic Rifle.

29. Curtis, "Deposition," 1.

30. Purrington, "Deposition," 2; 45th Archives, "Concussion Hit, Faicchio," 2; Gover, "Deposition"; Curtis, "Deposition," 1.

31. "Concussion Hit, Faicchio," 2; Gover, "Deposition."

32. Gover, "Deposition"; Stokes, "Statement in Support of Claim."

33. Ibid.; "Concussion Hit, Faicchio," 2; Purrington "Deposition," 2.

34. "Manuscript, typed," 21.

35. 45th Archives, Sgt. Charles "Hook" Johnson, "Deposition."

36. Curtis, "Deposition," 1; Gover, "Deposition"; Purrington, "Deposition," 3.

37. Gover, "Deposition."

38. Purrington, "Deposition," 3; Curtis, "Deposition," 3.

39. Curtis, "Deposition," 3.

40. Curtis, "Deposition," 2; Gover, "Deposition." "All of us knew B Company was in need of men after Salerno. Echohawk did not hold back as Squad leader. He stayed on and toughed it out even though that concussion did something to him."

41. Gover, "Deposition." Purrington, "Deposition": "[He] was unable to hear good and he said his stomach hurt and that he was draining fluid from his front and back. [I was] never more than 10 yards from him, I knew he was hurt. But since the concussion hit drew no blood, he would not let himself be evacuated (lesser men and 'gold bricks' would jump at this opportunity to get a Purple Heart and get out of fighting). I guess he didn't go back cause we were short handed" (3).

42. Department of the Army, "War Journal/History 179th Infantry RCT," October 1–28, 1943; Munsell, *History of the 179th*, 33.

43. Munsell, *History of the 179th*, 35.

44. Gover, "Deposition."

45. Curtis, "Deposition," 3; Lyon, "Affidavit," 1.

46. Chuck Wheat, "Tulsan Recalls Own 'Death,'" *Tulsa World*, November 7, 1963; Curtis, "Deposition," 4.

47. Wheat, "Tulsan Recalls Own 'Death'"; Department of the Army, "Morning Reports, Remarks," November 6, 1943, and December 6, 1943. The Morning Report from the station one mile south of Carrete, Italy, listed Echohawk as absent or sick in the 94th Evacuation Hospital to be evacuated and dropped from the rolls

and sent to an unknown hospital. Department of the Army, "Reconstructed Personnel File, Service No. 20825105." In January 1944, while in the hospital in North Africa, Brummett was with his old friend from Pawnee, Sgt. Charles "Hook" Johnson, who recalled that Echohawk mentioned being hit in the legs, but had also talked about getting a concussion that "banged his ears and stomach pretty hard." Johnson said "Echohawk went back to the front. Later I was released from the hospital and went back too. The 45th was fighting at Anzio then." Johnson, "Deposition"; "Manuscript, typed," 23–24.

48. 45th Archives, "Letters of Recommendation."

49. 45th Archives, "Letter from Brummett Echohawk to Harlas Hatter."

50. "Manuscript, typed," 26.

51. Wheat, "Tulsan Recalls 'Own Death.'"

52. "Manuscript, typed," 26. Bill Mauldin worked as an artist for the army. Mauldin created the famous Willie and Joe cartoons, which circulated widely among soldiers and civilians, both overseas and in the states. He spent more than fifty years as a successful, high-profile cartoonist.

53. "Manuscript, typed," 27.

54. Wheat, "Tulsan Recalls 'Own Death.'"

55. Gonzales, interview.

56. Wheat, "Tulsan Recalls 'Own Death'"; "Manuscript, typed," 27.

57. Ibid.

58. Department of the Army, "War Journal/History, 179th Inf. Regt.," January 1944, 1. Munsell, *History of the 179th*, 45.

59. Reeder, *Wolf Men of the Plains*, 412.

60. Munsell, *History of the 179th*, 50–51. Note: Brummett Echohawk's Combat Infantry Badge was awarded effective January 1, 1944. Department of the Army, "General Order No. 6," 5.

61. "Shelter half," refers to a simple tent.

62. Transcript of "Response to Medical Report or NOD," 3–4; Red Notebook, "Amos, Purple Heart Power of Attorney."

63. Department of the Army, "War Journal/History, 179th Inf. Regt.," January 1944, 2. Munsell, *History of the 179th*, 51.

64. Griffin, "Anzio Veteran Recalls Famed 45th Battle," B-2.

65. Smith, "He Went to War Armed with a Pencil," 9.

66. Whitlock, *Rock of Anzio*, 146. The Italians built Aprilia out of redbrick, geometric buildings in a manner that reminded many Americans and historians of an industrial complex.

67. Munsell, *History of the 179th*, 53.

68. Department of the Army, "Morning Reports," February 8, 1944. Echohawk was in an evacuation hospital and released to duty on February 7, 1944.

69. Gonzales, interview.

70. Ibid.

71. Department of the Army, "Unit History-Italian Camp-179th Inf. Regt.-45th Inf. Div. 1–29 Feb 44," 1.

72. Whitlock, *Rock of Anzio*, 169.

73. Ibid., 170. Johnson, "Deposition": "Echohawk was in some of the heaviest fighting of Anzio—a place the Allies called 'The Factory.'"

74. Department of the Army, "Unit History-Italian Camp-179th Inf. Regt.-45th Inf. Div. 1–29 Feb 44," 1; Whitlock, *Rock of Anzio*, 170; Munsell, *History of the 179th*, 54; 45th Archives, "Operation of the Forty-Fifth Infantry Division in Italy: Anzio Beachhead, February 1–29, 1944," 1–3, 9–10.

75. Whitlock, *Rock of Anzio*, 171; Reeder, *Wolf Men of the Plains*, 112, states that 55 percent of the RCT was lost in a single week in February 1944.

76. Echohawk, *Indian Art*; 45th Archives, "Operation of the Forty-Fifth Infantry Division."

77. Whitlock, *Rock of Anzio*, 171.

78. Department of the Army, "Unit History-Italian Camp-179th Inf. Regt.-45th Inf. Div. 1–29 Feb 44," 1; Whitlock, *Rock of Anzio*, 171; Munsell, *History of the 179th*, 54; 45th Archives, "Operation of the Forty-Fifth Infantry Division," 1–3, 9–10.

79. Department of the Army, "Morning Reports," February 12, 1944. Various sources put the dates either February 11 or 12. The records are inconsistent.

80. Echohawk, *Indian Art*.

81. Echohawk, "It Happened at Anzio," 12; 45th Archives, "Operation of the Forty-Fifth Infantry Division in Italy: Anzio Beachhead, February 1–29, 1944," 1–3, 9–10.

82. Echohawk, "It Happened at Anzio," 12.

83. Ibid.; 45th Archives, "Operation of the Forty Fifth Infantry Division," 1–3, 9–10.

84. Echohawk, "It Happened at Anzio," 13.

85. Lyon, "Affidavit," 1–2. The water-filled culvert was Ficoccia Creek east of the Factory. Transcript of "Response to Medical Report or NOD," 4; "Operation of the Forty Fifth Infantry Division," 1–3, 9–10.

86. Munsell, *History of the 179th*, 54.

87. Department of the Army, "Morning Reports," February 12 and 23, 1944. "Manuscript, typed," 29.

88. Echohawk, *Indian Art*.

89. Gonzales, interview.

90. Wheeler, interview.

91. 45th Archives, Vertical files.

92. Wheeler, interview.

93. Department of the Army, "Unit History-Italian Camp-179th Inf. Regt.-45th Inf. Div. 1–29 Feb 44," 2.

94. Ibid., 4.

95. "Manuscript, typed," 31.

96. Ibid., 31–32; Department of the Army, "Reconstructed Personnel File, Service No. 20825105."

97. Department of the Army, "Unit History-Italian Camp-179th Inf. Regt.-45th Inf. Div. 1–29 Feb 44," 4.

98. Department of the Army, "Morning Reports," February 27, 1944; Department of the Army, "Morning Reports," April 4, 1944; Department of the Army,

"Morning Reports," April 2, 1944. From the 17th General Hospital he was set to be transferred to Personnel Center Number 6. "Manuscript, typed," 33.

99. "Manuscript, typed," 33.

100. Department of the Army, "Reconstructed Personnel File, Service No. 20825105." Echohawk's reconstructed military personnel file indicates that he was re-admitted to a hospital on July 27, 1944, in the "European Area," due to previous injuries treated in April of 1944. "Manuscript, typed," 33.

101. "Manuscript, typed," 33.

102. Franks and Lambert, *Pawnee Pride*, 207–208.

103. Department of the Army, "Reconstructed Personnel File, Service No. 20825105, 'Final Payment Roll'"; Echohawk, Personal Papers, "Army of the United States Honorable Discharge."

104. The Gustav Line formed part of the German Winter Line.

105. Whitlock, *Rock of Anzio*, 277, 280.

106. Ibid., 285.

107. Lantz, "Warriors of the Red White and Blue," 41; "Anzio Was Day of the Thunderbird," *Tulsa Sunday World*, January 22, 1984, B-4.

108. Holm, "Fighting a White Man's War," 70.

109. Echohawk, *Indian Art.*

110. Echohawk quoted in Lantz, "Warriors of the Red White and Blue," 41–42; Echohawk, transcribed interview.

111. Echohawk, transcribed interview, 10, 25.

112. Ibid., 9–11, 25–26, 28.

113. Ibid., 26, 28.

114. Conversations with David Echo Hawk and Helen Norris, 2006; 45th Archives, Vertical file, "Brummett Echohawk (Pawnee) Artist."

115. Gonzales, interview.

116. Ibid.; "Manuscript, typed," 19–20.

117. Gonzales, interview.

118. Matlock "Statement in Support of Claim," 2–3.

119. Echohawk, Personal Papers, Edward J. Hewett "Statement in Support of Claim" for VA, 3–5.

120. Stokes "Statement in Support of Claim," 2; Gover, "Deposition."

121. Purrington "Statement in Support of Claim," 3.

122. Curtis "Deposition."

123. Echohawk, Personal Papers, Wayne L. Johnson "Affidavit."

124. "Manuscript, typed," 35.

125. 45th Archives, Brummett Echohawk "Profile."

126. Reeder, *Wolf Men of the Plains*, 418.

127. Rosier, *Serving Their Country*, 10–11.

Chapter 4

Epigraph. Echohawk, *Indian Art.*

1. Ibid.

2. Correspondence with Sara Bevan; Franks and Lambert, *Pawnee Pride*, 208; Echohawk, Personal Papers, "3 March, 1999," from VA WWII P.H. Envelope for Amos Harjo, Purple Heart Association; Smith, "He Went to War Armed with a Pencil," 9; *London Sunday Mirror*, December 7, 1969, Letters page; *London Sunday Mirror*, December 14, 1969, Letters page; *London Sunday Mirror*, December 21, 1969, Letters page; *London Sunday Mirror*, December 28, 1969, Letters page.

3. The same article appeared with the title "Tell the Folks Back Home."

4. "What We Should Know," *Cumberland (Md.) Evening Times*, April 26, 1944, 4. Mead represented the state of New York in the U.S. House of Representatives from 1919 to 1938 and then in the U.S. Senate from 1938 to 1947.

5. "What We Should Know," 4.

6. "Anzio Advance Pictured by Fighting Artist," *Statesville (N.C.) Daily Record*, May 2, 1944, 8.

7. "These Men Fight on Our Side," *Detroit Free Press*, December 17, 1944, 10–11.

8. Echohawk, *Indian Art*.

9. Ibid.; Cohenour, "Focus on Art."

10. Franks and Lambert, *Pawnee Pride*, 208; "These Men Fight on Our Side," 10–11; Helen Bower, "Anzio Veteran-Artist Studies Here What He Practiced at Front," *Detroit Free Press*, November 5, 1944, 8–9.

11. Echohawk, *Indian Art*.

12. Ibid.

13. "Native American Studies Program"; Calloway, *Indian History of an American Institution*.

14. Echohawk, *Indian Art*; Cohenour, "Focus on Art."

15. Echohawk, *Indian Art*.

16. Records and Registration, Art Institute of Chicago. Brummett Echohawk often said he spent four years at the Art Institute of Chicago, and the dates are listed as 1944–48 in several artist profiles; Bill Kelly, "Former Combat Artist Paints Indians, Old West," *Eau Claire (Wis.) Daily Telegram*, June 16, 1965, 6; Brummett Echohawk, CV, various years are included in Personal Papers, Frye Art Museum archives, Gilcrease Museum archives, and 45th Archives, etc.

17. Echohawk, *Indian Art*; Echohawk, "Discussion with All Guest Speakers."

18. Echohawk, *Indian Art*; Brummett Echohawk, CV.

19. Echohawk, *Indian Art*.

20. Van Deventer, "Brummett Echohawk: Artist Who Creates His Own Challenges," 25.

21. Echohawk, *Indian Art*.

22. Yvonne Litchfield, "Echohawk Adapts His Bowie Knife to a Variation on Van Gogh's Art," *Tulsa World*, March 1, 1967, 10.

23. Wydeven and Klaphake, "Art and Eloquence," 104–106.

24. Ibid., 108.

25. Vern Stefanic, "Noted Artist an Indian, But Not an Indian Artist," *Tulsa World*, March 18, 1977, D-1.

26. Echohawk quoted in Wydeven and Klaphake, "Art and Eloquence," 104–106.

27. Echohawk, "Discussion with All Guest Speakers." Dick West also voiced his frustration with the narrow confines prescribed for Indian artists by museums, galleries, and judges. In 1949, he deliberately set out to challenge the current conceptions of Indian art by displaying numerous three-dimensional paintings. In the 1950s, West continued to challenge the standards for such competitions. In so doing, he helped develop a category for "non-traditional" Indian painting at the Philbrook Museum's *Indian Annual*. Lisa K. Neuman, "Painting Culture," 186. Dakota artist Oscar Howe also challenged the limitations placed on artists by the rules for the Philbrook competition as he blended traditional styles with cubism.

28. Stefanic, "Noted Artist an Indian," D-2.

29. Ibid., D-1; Cohenour, "Focus on Art."

30. "Brummett Echohawk—A Classical Artist," 3.

31. Van Deventer, "Brummett Echohawk: Artist Who Creates His Own Challenges," 25.

32. Val Cooper, "Pawnee Artist Rebuffs Compromise with Truth," *Farmington (N.Mex.) Daily Times*, Ed Ainsworth Papers, Box 75, Folder 20 "Brummett Echohawk," Charles E. Young Research Library, University of California at Los Angeles.

33. Van Deventer, "Brummett Echohawk: Artist Who Creates His Own Challenges," 27.

34. Cooper, "Pawnee Artist Rebuffs Compromise with Truth."

35. Echohawk, *Indian Art*.

36. Ibid.

37. Echohawk, "Massacre Canyon on Canvas," 20.

38. Ibid., 21.

39. Gene Curtis, "Only in Oklahoma: Soldier's Sketches Led to Career in Art," *Tulsa World*, September 14, 2007, A4.

40. Echohawk, "Massacre Canyon on Canvas," 23.

41. Cohenour, "Focus on Art."

42. Neuman, "Painting Culture," 182–186. The new trend in Indian art of asking tribal members first and then going to archives and other printed materials linked to a new trend in Indian history whereby historians began viewing oral history as a valuable tool.

43. Ibid., 181–186.

44. Don Boxmeyer, "An Artist Who Happens to Be an Indian," *Saint Paul Dispatch*, May 10, 1967, 49.

45. Litchfield, "Echohawk Adapts His Bowie Knife," 10.

46. Gonzales, interview.

47. Lichtfield, "Echohawk Adapts His Bowie Knife," 10.

48. Van Deventer, "Brummett Echohawk: Artist Who Creates His Own Challenges," 26–27.

49. Echohawk quoted in Cohenour, "Focus on Art."

50. Ibid.

51. 45th Archives, Letter to Judge (General) Fred Daugherty.

52. Iron Hail also used the English name Dewey Beard.

53. David MacKenzie, "Tulsa Artist Donates Portrait to Gilcrease," *Tulsa World*, September 18, 1981, B-4; Echohawk, "The Best Horse I Ever Rode," 27, 47–48. At the time the Gilcrease received the drawing of Iron Hale, Echohawk and the private collector served on the museum's board.

54. Cohenour, "Focus on Art."

55. Loan request-receipt-shipping form, Amon Carter Museum archives; "Exhibit of Indian Artist's Works to Open Oct. 6 at Art Center," *Joplin Globe*, September 29, 1974, 8A.

56. Cohenour, "Focus on Art."

57. Stauffer, *Mari Sandoz*, 5–6.

58. Echohawk to Sandoz, December 5, 1952, Mari Sandoz Collection; Sandoz to Echohawk, June 9, 1952; Echohawk to Sandoz, June 20, 1952; Echohawk to Sandoz, December 5, 1952; Sandoz to Echohawk, December 7, 1952, all in Mari Sandoz Collection.

59. "Mary Echohawk, Wife of Tulsa Painter, Dies," *Tulsa World*, January 9, 1986.

60. Curtis, "Only in Oklahoma," A4.

61. Cohenour, "Focus on Art."

62. Price, "Still Facing John Wayne," 83; Lenihan, "Teaching the Western," 30.

63. "Brummett Echohawk—A Classical Artist," 3.

64. Echohawk to Richard West, March 17, 2001, in *Little Chief* exhibition folder.

65. "Brummett Echohawk—A Classical Artist," 3; Echohawk to West.

66. Duffy, correspondence.

67. Ibid. The *Out of Sequence* exhibit showed in Illinois, Colorado, and New Hampshire.

68. Echohawk, *Indian Art*.

69. "Pawnee Painter on Art Jury," *Tulsa Daily World*, January 28, 1955, 32.

70. Dunn, "Opportunities for the Indian Painter," 1.

71. "Exhibition of Indian Painting," 8–9.

72. Acee Blue Eagle helped build the Indian arts program organized by Mary "Princess" Ataloa McLendon in the 1920s. He filled her position in 1935 and remained until 1938, when he was succeeded by Woody Crumbo. Neuman, "Painting Culture," 176.

73. "Art Exhibition Winners Named," *Billings Gazette*, August 26, 1957, 14.

74. The Philbrook's *Indian Annual* organizers intended the event to foster creativity and competition to develop Indian art in Oklahoma. The creators of the *Indian Annual* drew inspiration from their concern for American Indian World War II veterans unable to find work after the war. At the time, "no national annual exhibition of Indian painting . . . existed." Neuman, "Painting Culture," 179–180.

75. Neuman, "Painting Culture," 173–192.

76. Cohenour, "Focus on Art"; Kammen, *Meadows of Memory*, 46. *The Trail of Tears* hangs as part of the Gilcrease Museum's permanent collection in Tulsa, Oklahoma.

77. "Thomas Hart Benton," in *Encyclopedia Britannica Online*.

78. Echohawk, *Indian Art*.

79. Perry, "Oral History Interview with Thomas Hart Benton," 11.

80. Wolff, *Thomas Hart Benton*, 300–301.

81. Van Deventer, "Brummett Echohawk: Artist Who Creates His Own Challenges," 26; Wolff, *Thomas Hart Benton*, 13.

82. Correspondence with Kate Bradley, *Western Horseman*; White, "Looking Back," 194.

83. Gordon, "Best of Joanne Gordon," 26.

84. Tilghman, "Bed for God," 27–29. This article is referenced in Jenkin Lloyd Jones, "The Buffalo are Gone Forever," *Ames Daily Tribune*, July 2, 1965, 4, which was syndicated elsewhere in papers around the United States as "Last Wild Hope."

85. Privett, "We Are the White Wolves," 20–21; Van de Logt, *War Party in Blue*, 25.

86. Hutchinson, "Modern Native American Art," 740–743, 749, 755.

87. Blue Eagle quoted in Neuman, "Painting Culture," 186–189.

88. Chuck Wheat, "Wheat's Field," *Tulsa World*, December 9, 1964, 21; 45th Archives, Brummett Echohawk "Profile," 1.

89. McGarry, "Collector Extraordinaire," 115, 139; "History and Goals," Leanin' Tree Publishing Company website.

90. Manly, correspondence.

91. Stefanic, "Noted Artist an Indian," D-1; Kelly, "Former Combat Artist Paints Indians, Old West," 6.

92. The exhibit advertisements promised, "Echohawk's work reflects his interest not only in the Indian but in the entire history of the American West. A selection of his paintings for the exhibit at Spiva will include portraits, landscapes and a variety of works from all periods of the artist's life." "Spiva Art Center to Launch Annual Membership Campaign," *Joplin Globe*, June 2, 1974, 5A; "Spiva Art Center," *Joplin Globe*, August 25, 1974, 36; "Exhibit of Indian Artist's Works to Open Oct. 6 at Art Center," 8A; "Spiva Art Center Opens Annual Membership Drive," *Joplin Globe*, June 15, 1975, 5A; "Spiva Art Center Launches Annual Membership Drive," *Joplin Globe*, June 30, 1976, 8A; "Spiva Art Center Opens its Annual Membership Drive," *Neosho (Mo.) Daily News*, July 1, 1976, 2; "Spiva Art Center," *Joplin Globe*, August 22, 1976, 21; "Echohawk Art Exhibit Scheduled at Spiva Center," *Joplin Globe*, September 5, 1976; "Echohawk to Present Lecture and Workshop," *Joplin Globe*, September 12, 1976, 12.

93. "Flag of the Pawnee Nation of Oklahoma." Adams, correspondence. The Pawnee Tax Commission began using the same image on their tribal license plates around 1997.

94. "Gilcrease Museum houses the world's largest, most comprehensive collection of art and artifacts of the American West. The museum also offers an unparalleled collection of Native American art and artifacts, as well as historical manuscripts, documents and maps." The Gilcrease Museum, as of 2008, works in partnership with the City of Tulsa and the University of Tulsa. "About Us," Gilcrease Museum website.

95. Harvey, correspondence. Past board member information is listed unofficially in the museum's administrative office and is printed on the front inside covers of *Gilcrease Magazine* issues.

96. Echohawk, "Discussion with All Guest Speakers."

97. Ibid.

98. James D. Watts, Jr., "The Show of Shows," *Tulsa World*, April 18, 2004, H-1. Echohawk conducted a two-day workshop for Claremore College in Oklahoma in March 1980, held in conjunction with the college's exhibit *Indian Art: From Cave to Gallery*. Not everyone interested could participate in the workshop; rather, those wishing to attend were required to submit resumes for review, as only twenty seats were available. "Echohawk Plans Two Day Workshop at Claremore," 4.

99. Malvina Stephenson, "Stephen Gambaro Takes Portrait of Native America," *Tulsa World*, July 8, 1983, B-4.

100. "Echohawk to Get Indian Award," *Tulsa Tribune*, May 30, 1983, 6; "Artist Wins Unknown Indian Award," *Orange County (Calif.)Register*, May 13, 1983, 71. Officials presented Echohawk with the award in North Platte, Nebraska. The Lincoln County Historical Society sponsored a ceremony that recognized both Echohawk's contributions to the art world and his writing.

101. "Mary Echohawk, Wife of Tulsa Painter, Dies."

102. Echohawk, Personal Papers, "1991–1997 Log," August 14, 1992. See also Echohawk, Personal Papers, "Funeral Program for Mary Frances EchoHawk."

103. Heard Museum, "Artist Biography, Brummett Echohawk."

104. 45th Archives, Invitation to Echohawk Show, Indian Territory Gallery.

105. *Guide to Echohawk Show at the Indian Territory Gallery*, 5; Cohenour, "Focus on Art."

106. *Guide to Echohawk Show at the Indian Territory Gallery*, 5; Cohenour, "Focus on Art."

107. *Guide to Echohawk Show at the Indian Territory Gallery*, 7.

108. The portrait's estimated value came in at $10,000.

109. "Letter to Daugherty." At the time he wrote the letter, Echohawk owed $22,000.

110. "Letter to Daugherty." Echohawk tried for years to get Phil Gover recognized with the Medal of Honor. Gonzales, interview.

111. Greever, interview.

112. Phil Gover attended the event with his family, but, unfortunately, Echohawk's car broke down, precluding his presence at the ceremony. Roughly six hundred members of the division were in attendance, and, according to General Daugherty, the unveiling proved the highlight for those in attendance. "Letter from Brig. General Fred Daughtery"; and "Letter from General Fred Daugherty to Col. Glenn Lyon," both in 45th Archives; "Phillip Gover Portrait Donated."

113. "Phillip Gover Portrait Donated."

114. "Jones Portrait," *Tulsa Tribune*, October 8, 1987, provided by Gilcrease Museum; "Jones Picture Unveiled in Ceremony," *Daily Oklahoman*, October 8, 1987, 28.

115. Cohenour, "Focus on Art."

116. Ibid.

117. Ibid.

118. Echohawk quoted in Hill, "Pistol Pete Portrait Presented," 12.

119. Ibid.; Steve Wieberg, "Oklahoma State's Emergence Promises More Bedlam in Oklahoma," *USA Today*, August 5, 2011, n.p.

120. "1991–1997 Log," December 29, 1991; "Historical Society Makes Improvements at Pawnee Indian Village Museum at Republic," *Belleville (Kans.) Telescope*, August 16, 1990; "Pawnee Celebration Recognizes Famous Pawnee Artist," *Belleville Telescope*, September 6, 1990, 14; "Pawnee Friends May Expand Programs," *Belleville Telescope*, October 11, 1990, 11A.

121. "1991–1997 Log," December 29, 1991; "Historical Society Makes Improvements"; "Pawnee Celebration Recognizes Famous Pawnee Artist," 14; "Pawnee Friends May Expand Programs," 11A.

122. Cohenour, "Focus on Art."

123. Letter from Brig. General Fred Daugherty.

124. In November 1992, the Department of Defense dedicated its *Indian Exhibit*. The 45th Infantry Division Museum, with archives under the direction of Fred Daugherty, provided a substantial collection of images and information for the exhibit and for a booklet to be published in relation to the exhibit. Included in the collection were photographs of Echohawk's paintings of Gover, Childers, and Montgomery and a brief biographical sketch of Brummett Echohawk. 45th Archives, *45th Division Newsletter*, 1993.

125. "1991–1997 Log," May 18, 1994.

126. "Big Bill and Oom-A-Gog," TulsaTVMemories.com/oomagog.html.

127. Gonzales, interview.

128. Cohenour, "Focus on Art."

129. Greever, interview.

130. Cohenour, "Focus on Art."

131. Similarly, in 1966, Echohawk received a commission for a portrait of the outgoing president of nearby Oklahoma State University, Oliver S. Willham. The school paper advertised in April that "a full-blooded Pawnee Indian" would be on campus doing sketches of the president in preparation for the painting.

132. Native Americans did not generally gain citizenship until the Indian Citizenship Act of 1924. In New Mexico and Arizona, they were denied suffrage until 1948, and in Utah their voting rights remained restricted until 1957. While African Americans fought the Double V campaign during World War II (victory at home and abroad), many American Indians, particularly in the West, confronted similar circumstances at home.

133. Cohenour, "Focus on Art."

Chapter 5

Epigraph. Echohawk, *Indian Art*.

1. Litchfield, "Echohawk Adapts His Bowie Knife," 10.

2. Deloria, *Custer Died for Your Sins*. Joseph Medicine Crow also wrote a chapter on Crow Indian humor. Medicine Crow, *From the Heart of Crow Country*.

3. Echohawk, "Cowboy Movies and Real Indians" (1986): 42.

4. Ibid.

5. Echohawk, "Cowboy Movies and Real Indians" (1973): 8–10.

6. Ibid.

7. Echohawk, "Con Man in Feathers," 25–26. This article was reprinted by *Oklahoma Today* with permission from the *Tulsa Sunday World*. L. G. Moses discussed the issue of American Indian participation in the Wild West shows and their ability to act intelligently for themselves, suggesting that they were not often passive victims but contributed to popular perceptions. Moses, *Wild West Shows*, 6–9, 37–41, 55–59.

8. Echohawk, "Con Man in Feathers," 25–26.

9. Ibid.

10. Brummett Echohawk, "The Pawnees Came to Dinner," *Tulsa World*, March 21, 1954, 16.

11. Ibid.

12. Ibid.

13. Brummett Echohawk, "A Short Tale of the Breechcloth," *Tulsa World*, May 2, 1954, 6.

14. Brummett Echohawk, "Santa Claus Wore Indian Clothes," *Tulsa World*, December 19, 1965, 3.

15. Ibid.

16. Echohawk, "Great Six Million," 10–11.

17. Ibid.

18. Echohawk, "Pawnees' Last Doctor Dance," 36–38.

19. Ibid. See also Cohenour, "Focus on Art."

20. Echohawk, "Pawnee Scouts, 1864–1877," 9–12.

21. Echohawk, "It Happened at Anzio," 12–13.

22. Two Hatchets's name appeared on army rolls as Paul Bitchenen of Cheyenne, Oklahoma. "Indian Chief Leaps Ashore 'To Return Columbus Visit,'" 5.

23. "Manuscript, typed," 22. Paul "Red Bird" Bitchenen was the first member of the Cheyenne and Arapaho tribes of Oklahoma killed in action in World War II when he died November 6, 1943. Wright, "Oklahoma War Memorial," 145.

24. Gonzales, interview.

25. "1991–1997 Log."

26. Ibid.

27. Ibid.

28. Gonzales, interview.

29. Echohawk, "Pawnee Story," 17–19, 22–23.

30. Ibid.

31. Ibid., 23.

32. "Official Program, All American Indian Days." It appears that Echohawk and Medicine Crow shared a similar sense of humor. Iverson, *When Indians Became Cowboys*, 188–190; Medicine Crow, *From the Heart of Crow Country*, 124–133.

33. Gertrude Spomer, "Indian Days Coming," *Billings Gazette*, July 25, 1969, 53.

34. "Church President to Deliver Speech at BYU on Tuesday," *Provo (Utah) Daily Herald*, February 21, 1975, 1.

35. "Echohawk to Speak at NSU April 6," *Stillwell (Okla.) Democrat-Journal*, March 29, 1979, 6; Echohawk, *Indian Art*.

36. "Indian Leaders Conference Set at Eau Claire U," *Wisconsin State Journal*, June 9, 1965, sec. 2, 5; Kelly, "Former Combat Artist Paints Indians, Old West," 6.

37. "To Attend Pow-Wow," *Valparaiso (Ind.) Vidette-Messenger*, April 25, 1967, 7; "Webster Men Attend Midwest Pow-wow," *Webster (N.Y.) Herald*, April 26, 1967, 8A.

38. Gerri Ausmus, "Young People Attend 'Discovery Clinics,'" *Stillwell Democrat Journal*, May 15, 1975, 7.

39. 45th Archives, "Tidbits," *45th Division Newsletter*, 5.

40. "2 Medal Winners to Lead Parade," *Joplin Globe*, August 18, 1967, 13.

41. Sharon Montague, "Indians Seek Support for Bone Issue," *Salina (Kans.) Journal*, October 30, 1988, 3; Erin Eicher, "Pawnees, Other Officials Feast so Spirits of the Dead Can Be at Rest," *Salina Journal*, April 15, 1990, 1, 11.

42. Cohenour, "Focus on Art."

43. Ibid.

44. Ibid.

45. David Stuart Hudson, "'Indians' Recalls Era's Tragedies," *Harrisonburg (Va.) Daily News-Record*, November 12, 1973, 11.

46. "Echohawk Profile," in Frye Art Museum archives.

47. Karl May had a very large following in his home country of Germany as an author of nineteenth-century fiction popularizing American Indians. Reputedly, May was one of Adolph Hitler's favorite authors. Rosier, *Serving Their Country*, 77.

48. "Lawtonians Elected to OCTA Offices," *Lawton (Okla.) Constitution*, March 5, 1973, 13; "Tulsa Little Theatre to Present 'Indians' Here April 7," *Lawton Constitution*, March 30, 1973, 26; "'Indians' Scheduled Saturday," *Lawton Constitution*, April 1, 1973, 54; "Indian Artist Stars as Sitting Bull," *Lawton Constitution*, April 5, 197, 2-D; "Tulsa Production Well Received Here," *Lawton Constitution*, April 9, 1973, 16; Hudson, "'Indians' Recalls Era's Tragedies," 11; Jeanne Forbis, "Brummett Echohawk Puts on Acting Hat for OETA Miniseries," *Tulsa World*, April 16, 1989, 12-H.

49. Echohawk, *Indian Art*.

50. Cohenour, "Focus on Art."

51. "Echohawk Profile."

52. Bill Donaldson, "'The Only Indian Left' Best AITC Offering to Date," *Tulsa Tribune*, February 19, 1981, 3-F.

53. Forbis, "Brummett Echohawk Puts on Acting Hat," 12-H.

54. Ibid.; "Indians form Talent Guild in Tulsa," 13; "Echohawk Plans Two Day Workshop at Claremore," 4; Echohawk, "Cowboy Movies and Real Indians" (1986): 43.

55. Echohawk, Personal Papers, "Letter to Veterans Affairs from Austin A. Harjo." Michael Gonzales also noted that Echohawk had a tendency to refrain

from answering the phone and to wait for voicemail to pick up, not wanting to be bothered. Gonzales, interview.

56. Echohawk, *Indian Art.*

57. Ibid.

58. Echohawk, "Discussion with All Guest Speakers."

59. Echohawk, *Indian Art.*

60. Cohenour, "Focus on Art."

61. Ibid.

62. Echohawk, *Indian Art.*

Epilogue

1. Myron Echo Hawk, interview, 2009.

2. Ibid.

3. Hill, "Pawnee Code Talkers," 12–14.

4. Myron Echo Hawk, interview, 2009.

5. Ibid.

6. Echohawk, "Discussion with All Guest Speakers."

7. Gonzales, interview.

8. Wheeler, interview.

9. Ibid.

Bibliography

Government Documents

Barnes, Cassius McDonald. "Report of the Governor of Oklahoma to the Secretary of the Department of the Interior for the Fiscal Year Ended June 30, 1898." Washington, D.C.: Government Printing Office, 1898.

———. "Report of the Governor of Oklahoma to the Secretary of the Department of the Interior for the Fiscal Year Ended June 30, 1900." Washington, D.C.: Government Printing Office, 1900.

Department of the Army. "Morning Reports," September 1940–January 1942. Office of the Adjutant General. 179th Inf. Regt., B Company, HQ DET (microfilm reel 18.175), Box 1825, RG 64. National Archives at Saint Louis.

———. "Morning Reports," February 1942–July 1943. Office of the Adjutant General. 179th Inf. Regt., B Company (microfilm reel 18.176), Box 1826, RG 64. National Archives at Saint Louis.

———. "Morning Reports," September 1943. Office of the Adjutant General. 179th Inf. Regt., B Company, Items 21453–21457 (microfilm reel 4.61), Box 594, RG 64. National Archives at Saint Louis.

———. "Morning Reports," October 1943. Office of the Adjutant General. 179th Inf. Regt., B Company, Items 28899–28912 (microfilm reel 5.54), Box 630, RG 64. National Archives at Saint Louis.

———. "Morning Reports," November 1943. Office of the Adjutant General. 179th Inf. Regt., B Company, Item 35446 (microfilm reel 9.31), Box 581, RG 64. National Archives at Saint Louis.

———. "Morning Reports," December 1943. Office of the Adjutant General. 179th Inf. Regt., B Company, Item 37892 (microfilm reel 3.71), Box 695, RG 64. National Archives at Saint Louis.

———. "Morning Reports," February 1944. Office of the Adjutant General. 179th Inf. Regt., B Company, Item 18254 (microfilm reel 12.70), Box 453, RG 64. National Archives at Saint Louis.

———. "Morning Reports," March 1944. Office of the Adjutant General. 179th Inf. Regt., B Company, Item 18368 (microfilm reel 18.22), Box 549, RG 64. National Archives at Saint Louis.

———. "Morning Reports," April 1944. Office of the Adjutant General. 17th General Hospital, Item 21834 (microfilm reel 8.81), Box 521, RG 64. National Archives at Saint Louis.

————. Office of the Adjutant General. Folder 345INF(179)-1.13. General Orders—179th Infantry Regt—45th Infantry Division 1940–43, Box 9439, Entry 427, RG 407. National Archives at College Park, Md.

————. "Reconstructed Personnel File, Service No. 20825105." Office of the Surgeon General. National Archives at Saint Louis.

————. "Unit History-Italian Camp-179th Inf. Regt.-45th Inf. Div. 1–29 Feb 44." Office of the Adjutant General. Washington, D.C.: Departmental Records Branch, February 1944. Box 9431, Entry 427, RG 407. National Archives at College Park.

————. "War Journal/History 179th Infantry RCT." Office of the Adjutant General. Folder 345INF(179)-0.3 History-179th Inf. Regt.-45th Inf. Div. (Italian Campaign), October 1943; Box 9430, Entry 427, RG 407. National Archives at College Park.

————. "War Journal/History, 179th Inf. Regt." Office of the Adjutant General. Folder 345INF(179)-0.3 History—179th Inf. Reg.-45th Inf. Div. (Italian Campaign), January 1944, Box 9430, Entry 427, RG 407. National Archives at College Park.

————. "World War II Rosters," January 1940–December 1943. Office of the Adjutant General. 179th Inf. Regt., Item 15539 (microfilm reel 7.438), RG 64. National Archives at Saint Louis.

"Map of Mound Township." Produced in 1907, published as part of the *U.S., Indexed County Land Ownership Maps, 1860–1918*, for Mound, Payne County, Oklahoma. Collection G&M_26, microfilm reel 26.

Taylor County, Texas, Marriage Records, 17 (1880–1966). Abilene, Tex.: Taylor County Clerk's Office.

"Treaty of Fort Laramie with Sioux, etc., 1851." In *Indian Affairs: Laws and Treaties*, compiled and edited by Charles J. Kappler. Vol. 2. Washington, D.C.: Government Printing Office, 1904.

"Treaty with the Pawnee, 1833." In *Indian Affairs: Laws and Treaties*, compiled and edited by Charles J. Kappler. Vol. 2. Washington, D.C.: Government Printing Office, 1904.

U.S. Bureau of the Census. Indian Census Rolls, 1885–1940.

————. 1920 U.S. Federal Census.

U.S. Bureau of Indian Affairs. Carlisle Student File for Alice Jake. File 1327, Folder 2797, Box 56, RG 75. National Archives, Washington, D.C.

————. Carlisle Student File for Elmer Echohawk. File 1260, Box 27, RG 75. National Archives, Washington, D.C.

U.S. Congress. House Committee on Indian Affairs. *Pawnee Indian Lands in Nebraska.* 43rd Cong., 2d sess., 1874. H.R. Doc. 140.

————. House Committee on Indian Affairs. *Pawnee Indians: Message from the President of the United States Transmitting a Communication from the Secretary of the Interior in Reference to the Necessities of the Pawnee Indians.* 44th Cong., 1st sess., 1876. H.R. Doc. 154.

————. House Committee on Indian Affairs. *Pawnee Indians, Report.* 44th Cong., 1st sess., 1876. H.R. Doc. 241.

———. House Committee on Indian Affairs. *Pawnee Indian Reservation in Nebraska.* 51st Cong., 1st sess., 1890. H.R. Doc. 1175.

———. Senate Committee on Indian Affairs. *Letter from the Secretary of the Interior, to the Chairman of the Committee on Indian Affairs in Relation to the Removal of the Pawnee Indians from the State of Nebraska to the Indian Territory, and the Sale of Their Lands in Said State.* 43rd Cong., 2d sess., 1875. Misc. Doc. 35.

U.S. Department of the Interior. *Annual Report of the Commissioner of Indian Affairs.* 38th Cong., 2d sess., 1864. H.R. Exec. Doc. 1.

———. *Annual Report of the Commissioner of Indian Affairs.* 43rd Cong., 1st sess., 1873. H.R. Exec. Doc. 1.

———. *Annual Report of the Commissioner of Indian Affairs.* 43rd Cong., 2d sess., 1874. H.R. Exec. Doc. 1.

———. *Annual Report of the Commissioner of Indian Affairs.* 45th Cong., 3d sess., 1878. H.R. Exec. Doc 1.

———. *Report of the Secretary of the Interior.* 39th Cong., 1st sess., 1865.

U.S. Department of State. "Act to Increase and Fix the Military Peace Establishment of the United States of America." *Statutes at Large, Treaties and Proclamations, of the United States of America from December, 1865, to March 1867.* 39th Cong., 1st sess., 1866. Boston: Little, Brown, 1868.

———. "An Act to Regulate Enlistments in the Army of the United States." *Statutes at Large of the United States of America, from August, 1893 to March, 1895.* 53rd Cong., 2d sess., 1894.

U.S. War Department. Office of the Adjutant General. *General Order No. 56.* August 1, 1866.

———. Office of the Adjutant General. "Compiled Military Service Record of William Pollock, documenting service in the 1st U.S. Volunteer Cavalry (Rough Riders) during the Spanish American War, May 1898–September 1898." Entry 522, RG 94. National Archives, Washington, D.C.

Archival Sources

"Artist Biography for Brummett Echohawk." In "Biographies written by Jeanne Snodgrass King for Gambaro Studio Photography Exhibition." Native American Artists Resource Collection, Heard Museum, Phoenix.

"Artist File, Brummett Echohawk." Imperial War Museum, London.

"Brummett Echohawk." Box 75, Folder 20. Ed Ainsworth Papers. Charles E. Young Research Library, University of California at Los Angeles.

"Brummett Echohawk," NMAI.AC.010. Correspondence: Name Files. National Congress of American Indians Records. National Museum of the American Indian Archive Center, Smithsonian Institution.

Echohawk, Brummett. Personal Papers. In possession of Echo Hawk family. Tulsa, Oklahoma.

Echo Hawk, Myron D. "Hobe." Family history records, "Elmer Price Echo-Hawk." In possession of Myron Echo Hawk.

Echo-Hawk, Roger. "Pawnee Military Colonialism." July 2007. Accessed November 12, 2011, www.echohawk.com/roger/pawnee_mil_colonialism.pdf.

Finney, Thomas McKean, and Frank Florer Collection. Box 2, No. 6. Western History Collections, University of Oklahoma Libraries, Norman.

45th Infantry Division Museum Archives. 45th Infantry Division Museum, Oklahoma City.

Frye Art Museum archives. Frye Art Museum, Seattle.

Guide to Echohawk Show at the Indian Territory Gallery. Gilcrease Museum, Tulsa.

Indian Rights Association. "Superintendent Harvey and the Pawnees." In *Twenty-first Annual Report of the Executive Committee of the Indian Rights Association*, Philadelphia: Office of the Indian Rights Association, 1904.

Letters between Brummett Echohawk and Mari Sandoz, June 9, 1952, June 20, 1952, December 5, 1952, and December 7, 1952. Mari Sandoz Collection. Special Collections, University of Nebraska Libraries.

Little Chief: The Comic Art of Brummett Echohawk exhibition folder. Frye Art Museum, Seattle.

Loan request-receipt-shipping form. Amon Carter Museum archives. Amon Carter Museum, Fort Worth, Texas.

"Official Program, All American Indian Days." Western History Collections, University of Oklahoma, Norman.

Pawnee Indian Veterans Association. "53rd Annual Pawnee Indian Homecoming Program." Pawnee Nation, Pawnee, Oklahoma, July 1999.

Record of Pupils Transferred from Pawnee Agency, Indian Territory. September 19, 1884. Haskell Cultural Center and Museum Archives, Lawrence, Kansas.

Registration and Records. School of the Art Institute of Chicago.

Newspapers

Albuquerque Journal

Ames Daily Tribune

Belleville (Kans.) Telescope

Billings Gazette

Cumberland (Md.) Evening Times

Daily Oklahoman

Detroit Free Press

Eau Claire (Wis.) Daily Telegram

El Reno (Okla.) News

Farmington (N.Mex.) Daily Times. Ed Ainsworth Papers, Box 75, Folder 20, "Brummett Echohawk," Charles E. Young Research Library, University of California at Los Angeles.

Fitchburg (Mass.) Sentinel

Harrisonburg (Va.) Daily News-Record

Hutchinson (Kans.) News-Herald

Jefferson City (Mo.) Sunday News and Tribune

Joplin Globe
Kansas City Star
Lawton (Okla.) Constitution
London Sunday Mirror
Neosho (Mo.) Daily News
New York Times
Orange County (Calif.) Register
Pawnee (Okla.) Chief
Provo (Utah) Daily Herald
Saint Paul Dispatch
Salina (Kans.) Journal
Santa Fe New Mexican
Statesville (N.C.) Daily Record
Stillwell (Okla.) Democrat-Journal
Tahlequah (Okla.) Native American Times
Tulsa Daily World
Tulsa Sunday World
Tulsa Tribune
USA Today
Valparaiso (Ind.) Vidette-Messenger
Watertown (N.Y.) Times
Webster (N.Y.) Herald
Wisconsin State Journal

Interviews and Correspondence

Adams, Gordon. Tribal history preservation officer. Correspondence with author. February–August 2012.

Benton, Thomas Hart. Oral History Interview with Thomas Hart Benton. By Milton F. Perry. April 21, 1964. Harry S. Truman Library, Kansas City, Mo.

Bevan, Sara. Imperial War Museum curator. Correspondence with author. July 2012.

Duffy, Damian. Krannert Art Museum curator. Correspondence with author. June 2012.

Echohawk, Brummett. Transcribed interview, ca. December 1977. 45th Infantry Division Museum Archives.

Echo Hawk, David D. Interview with author. April 7, 2006.

EchoHawk, Edward. Interview with author. October 24, 2009.

Echo Hawk, Myron D. "Hobe." Interview with author. April 7, 2006.

———. Interview with author. October 24, 2009.

Echohawk, Rodney. Correspondence with author. 2006.

Echo Hawk, Roland. Interview with author. October 24, 2009.

Evans, Gene. Interview with author. July 5, 2009.

Fields, Jim. Interview with author. October 23, 2009.

Gonzales, Michael. Interview with author. May 8, 2012.

Gover, Marshall. Interview with author. October 23, 2009.

Greever, Linda. Interview with author. May 16, 2012.

Harvey, Renee. Gilcrease Museum archivist. Correspondence with author. June 2012.

Howell, William. Interview with author. October 23, 2009.

Manly, Gwen. Leanin' Tree Publishing. Correspondence with author. June 2012.

Morris Solomon, Rowina. Interview with author. October 23, 2009.

Riding In, James. Correspondence with author. April 30, 2007.

Shunatona, Baptiste. Interview with author. October 23, 2009.

Wheeler, Ed. BG (USA-Ret.). Interview with author. April 6, 2006.

Books, Theses, and Dissertations

Adams, David Wallace. *Education for Extinction: American Indians and the Boarding School Experience, 1875–1928*. Lawrence: University Press of Kansas, 1995.

Baugh, Timothy G., and Stephanie Makseyn-Kelley. *People of the Stars: Pawnee Heritage and the Smithsonian Institution*. Washington, D.C.: Repatriation Office, National Museum of Natural History, Smithsonian Institution, July 1, 1992.

Bernstein, Alison R. *American Indians and World War II: Toward a New Era in Indian Affairs*. Norman: University of Oklahoma Press, 1991.

Bishop, Leo V., Frank J. Glasgow, and George A. Fisher, eds. *The Fighting Forty-Fifth: The Combat Report of an Infantry Division*. Baton Rouge, La.: Army and Navy Publishing, 1946.

Blaine, Martha Royce. *Pawnee Passage: 1870–1875*. Norman: University of Oklahoma Press, 1990.

———. *Some Things Are Not Forgotten: A Pawnee Family Remembers*. Lincoln: University of Nebraska Press, 1997.

Bruce, Robert, and Luther H. North. *The Fighting Norths and Pawnee Scouts: Narratives and Reminiscences of Military Service on the Old Frontier*. Lincoln: Nebraska State Historical Society, 1932.

Calloway, Colin G. *The Indian History of an American Institution: Native Americans and Dartmouth*. Hanover, N.H.: University Press of New England, 2010.

———. *Our Hearts Fell to the Ground: Plains Indian Views of How the West Was Lost*. New York: Bedford Books, 1996.

Chamberlain, Von Del. *When Stars Came Down to Earth: Cosmology of the Skidi Pawnee Indians of North America*. College Park, Md.: Ballena Press, 1982.

Deloria, Vine, Jr. *Custer Died for Your Sins: An Indian Manifesto*. New York: Macmillan, 1969.

Densmore, Frances. "War Songs." In *Pawnee Music*. Smithsonian Institution Bureau of American Ethnology bulletin 93 (Washington: Government Printing Office, 1929), 59–68.

Dunlay, Thomas W. *Wolves for the Blue Soldiers: Indian Scouts and Auxiliaries with the United States Army, 1860–1890*. Lincoln: University of Nebraska Press, 1982.

Easton, Karen M. "Getting into Uniform: Northern Cheyenne Scouts in the United States Army 1876–81." Master's thesis, University of Wyoming, 1985.

Franco, Jere Bishop. *Crossing the Pond: The Native American Effort in World War II*. Denton: University of North Texas Press, 1999.

Franks, Kenny A., and Paul F. Lambert. *Pawnee Pride: A History of Pawnee County*. Oklahoma City: Western Heritage Books, 1994.

Grinnell, George Bird. *Pawnee Hero Stories and Folk-Tales*. Lincoln: University of Nebraska Press, 1961.

Holder, Preston. *The Hoe and the Horse on the Plains: A Study of Cultural Development among North American Indians*. Lincoln: University of Nebraska Press, 1970.

Holm, Tom. *Strong Hearts, Wounded Souls: Native American Veterans of the Vietnam War* Austin: University of Texas Press, 1996.

Hyde, George E. *The Pawnee Indians*. Norman: University of Oklahoma Press, 1951.

Iverson, Peter. *Riders of the West: Portraits from Indian Rodeo*. Seattle: University of Washington Press, 1999.

———. *When Indians Became Cowboys: Native Peoples and Cattle Ranching in the American West*. Norman: University of Oklahoma Press, 1994.

Kammen, Michael. *Meadows of Memory: Images of Time and Tradition in American Art and Culture*. Austin: University of Texas Press, 1992.

Kappler, Charles J., comp. and ed. *Indian Affairs: Laws and Treaties*. Vol. 2. Washington, D.C.: Government Printing Office, 1904.

Lacey, Theresa Jensen. *The Pawnee*. New York: Chelsea House, 1996.

Lester, Patrick D. *The Biographical Directory of Native American Painters*. Tulsa: Sir Publications, 1995.

Lomawaima, Tsianina. *They Called It Prairie Light: The Story of Chilocco Indian School*. Lincoln: University of Nebraska Press, 1995.

Medicine Crow, Joseph. *From the Heart of Crow Country: The Crow Indians' Own Stories*. New York: Orion, 1992.

Milner, Clyde A., II. *With Good Intentions: Quaker Work among the Pawnees, Otos, and Omahas in the 1870s*. Lincoln: University of Nebraska Press, 1982.

Morris, Edmund. *The Rise of Theodore Roosevelt*. New York: Coward, McCann and Geoghegan, 1979.

Moses, L. G. *Wild West Shows and the Images of American Indians, 1883–1933*. Albuquerque: University of New Mexico Press, 1996.

Munsell, Warren P., Jr. *The Story of a Regiment: A History of the 179th Regimental Combat Team*. San Angelo, Tex.: Newsfoto Publishing, 1946.

Nelson, Guy. *Thunderbird: A History of the 45th Division*. Oklahoma City: 45th Infantry Division Association, 1970.

North, Frank J. *The Journal of an Indian Fighter: The 1869 Diary of Major Frank J. North*. Lincoln: University of Nebraska Press, 1958.

Otis, D. S. *The Dawes Act and the Allotment of Indian Lands*. Edited by Francis Paul Prucha. Norman: University of Oklahoma Press, 1973.

Reeder, William Spencer, Jr. "Wolf Men of the Plains: Pawnee Indian Warriors, Past and Present." PhD diss., Kansas State University, 2001.

Roenigk, Adolph. *The Pioneer History of Kansas*. Denver: privately published, 1933.

Rosier, Paul C. *Serving Their Country: American Indian Politics and Patriotism in the Twentieth Century*. Cambridge: Harvard University Press, 2009.

Rushing, W. Jackson, III, ed. *Native American Art in the Twentieth Century*. New York: Routledge, 1999.

Shirley, Glen. *Red Yesterdays*. Wichita Falls, Tex.: Nortex Press, 1977.

Snodgrass, Jeanne O. *American Indian Painters: A Biographical Directory*. New York: Museum of the American Indian Heye Foundation, 1968.

Standing Bear, Luther. *Land of the Spotted Eagle*. Lincoln: University of Nebraska Press, 1978.

Stauffer, Helen Winter. *Mari Sandoz*. Boise, Idaho: Boise State University, 1984.

Townsend, Kenneth William. *World War II and the American Indian*. Albuquerque: University of New Mexico Press, 2000.

Van de Logt, Mark. "War Party in Blue: Pawnee Indian Scouts in the United States Army 1864–1877." PhD diss., Oklahoma State University, 2002.

———. *War Party in Blue: Pawnee Scouts in the U.S. Army*. Norman: University of Oklahoma Press, 2010.

Weltfish, Gene. *The Lost Universe*. New York: Basic Books, 1965.

White, Richard. *Roots of Dependency: Subsistence, Environment and Social Change among the Choctaws, Pawnees, and Navajos*. Lincoln: University of Nebraska Press, 1983.

Whitlock, Flint. *The Rock of Anzio, From Sicily to Dachau: A History of the 45th Infantry Division*. Boulder: Westview Press, 1998.

Williamson, Kenneth D. *Tales of a Thunderbird in World War II: From Oklahoma to Munich and Back Again: With a Detour through Paris*. Saint Albans, W.Va.: Kendwil Publications, 1994.

Wolff, Justin. *Thomas Hart Benton: A Life*. New York: Farrar, Straus and Giroux, 2012.

Articles

Alley, John. "Oklahoma in the Spanish-American War." *Chronicles of Oklahoma* 20, no. 1 (1942): 43–50.

Ball, Helen W. "The Pawnee Rough Rider." *Midland Monthly* 10, no. 5 (December 1898): 452–453.

"Big Maneuvers Test U.S. Army." *Life Magazine* 11, no. 14 (October 4, 1941): 33–43.

"Brummett Echohawk—A Classical Artist." *Talking Leaf* (October 1978): 3.

Calloway, Colin G. "The Inter-tribal Balance of Power on the Great Plains, 1760–1850." *Journal of American Studies* 16, no. 1 (April 1982): 25–47.

Densmore, Frances. "The Songs of Indian Soldiers during the World War." *Musical Quarterly* 20, no. 4 (October 1934): 419–425.

Dunbar, John B. "The Pawnee Indians, Their Habits and Customs." *Magazine of American History* 5, no. 5 (November 1880): 321–342.

———. "The Pawnee Indians, Their Habits and Customs." *Magazine of American History* 8, no. 11 (November 1882): 734–754.

———. "The Pawnee Indians, Their History and Ethnology." *Magazine of American History* 4, no. 4 (April 1880): 241–281.

Dunn, Dorothy. "Opportunities for the Indian Painter." *Smoke Signals* 14 (February 1955): 1–2.

Echohawk, Brummett. "The Best Horse I Ever Rode: Iron Hail and His Small Buckskin Horse." *Western Horseman Magazine* 21, no. 1 (January 1956): 27, 47–48

———. "Con Man in Feathers." *Oklahoma Today* 24, no. 1 (Winter 1973–74): 25–26.

———. "Cowboy Movies and Real Indians." *Oklahoma Today* 23, no. 2 (Spring 1973): 8–10.

———. "Cowboy Movies and Real Indians." *Oklahoma Today* 36, no. 2 (March–April 1986): 42–43.

———. "The Great Six Million Twenty-three Thousand Two Hundred and Forty-eight Yard Dash." *Oklahoma Today* 25, no. 1 (Winter 1974–75): 10–11.

———. "The Man Who Scratched Himself." *Oklahoma Today* 9, no. 1 (Winter 1958–1959): 8–9.

———. "Massacre Canyon on Canvas." *Western Horseman Magazine* 48, no. 7 (July 1983): 20–23.

———. "Pawnee Scouts, 1864–1877." *Oklahoma Today* 27, no. 3 (Summer 1977): 9–12.

———. "The Pawnees' Last Doctor Dance." *Oklahoma Today* 26, no. 2 (Spring 1976): 36–38.

———. "The Pawnee Story." *Westerners Brandbook* 14, no. 3 (May 1957): 17–19, 22–23.

———. "Recollections of the Pawnee Scouts." *Western Horseman Magazine* 38, no. 1 (January 1973): 26–28, 133–135.

———. "The Spotted Horse Alone." *Western Horseman Magazine* 29, no. 8 (August, 1964): 43, 99–103.

"Echohawk Plans Two Day Workshop at Claremore." *Cherokee Phoenix and Indian Advocate* 4, no. 2 (March 1980): 4.

"Exhibition of Indian Painting at De Young Museum." *Smoke Signals* 14 (February 1955): 8–9.

Finney, Frank F. "William Pollock: Pawnee Indian, Artist and Rough Rider." *Chronicles of Oklahoma* 33, no. 4 (1955): 509–511.

Gordon, Joanne. "The Best of Joanne Gordon." *Oklahoma Today* (Winter 1958–59): 26.

Henderson, Sam. "William Pollock—Roughest of the Rough Riders." *Golden West* (February 1974): 18–20, 56–59.

Hill, Steve. "Pistol Pete Portrait Presented." *Oklahoma State University Outreach Magazine* (Summer 1989): 12.

Hill, Toni. "Pawnee Code Talkers Honored by U.S. Congress." *Chaticks si Chaticks* (Winter 2014): 12–14.

Holm, Tom. "Fighting a White Man's War: The Extent and Legacy of American Indian Participation in World War II." *Journal of Ethnic Studies* 9, no. 2 (Summer 1981): 69–81.

Hutchinson, Elizabeth. "Modern Native American Art: Angel DeCora's Transcultural Aesthetics." *Art Bulletin* 83, no. 4 (December 2001): 740–756.

"Indians form Talent Guild in Tulsa." *Cherokee Phoenix and Indian Advocate* 111, no. 11 (December 1979): 13.

Klaphake, Clem, and Joseph Wydeven. "Art and Eloquence." *Nebraskaland* 62, no. 1 (January–February 1984): 102–110.

Lantz, Gary. "Warriors of the Red White and Blue." *America's 1st Freedom* (December 2002): 40–42, 60–61.

Lenihan, John H. "Teaching the Western." *OAH Magazine of History* 16, no. 4 (Summer 2002): 27, 29–30.

McGarry, Susan Hallsten. "Collector Extraordinaire." *Southwest Art* 38, no. 5 (October 2008): 114–118, 139.

Murie, James R. "Pawnee Indian Societies." *Anthropological Papers of the American Museum of Natural History* 11, pt. 7 (New York: American Museum of Natural History, 1914).

Neuman, Lisa K. "Painting Culture: Art and Ethnography at School for Native Americans." *Ethnology* 45, no. 3 (Summer 2006): 173–192.

"Oklahoma Scrapbook, Souvenirs of Our Bicentennial Birthday Party." *Oklahoma Today* 26, no. 4 (Autumn 1976): 29.

Perry, Mark. "The Greatest War Games: America Forged an Army During the 1940–41 Louisiana Maneuvers." *Military History* 25, no. 6 (February 2009): 50–57.

Petete, Timothy, and Craig S. Womack. "Thomas E. Moore's *Sour Sofkee* in the Tradition of Mouskogee Dialect Writers." *Studies in American Indian Literatures* 18, no. 4 (Winter 2006): 1–37.

Price, Jay M. "Still Facing John Wayne after All these Years: Bringing New Western History to Larger Audiences." *Public Historian* 31, no. 4 (Fall 2009): 80–84.

Privett, Katharine. "We Are the White Wolves." *Oklahoma Today* 21, no. 1 (Winter 1970–71): 20–21.

Riding In, James. "Six Pawnee Crania: The Historical and Contemporary Significance of the Massacre and Decapitation of Pawnee Indians in 1869." *American Indian Culture and Research Journal* 16, no. 2 (1992): 101–117.

Roosevelt, Theodore. "The Rough Riders: The Cavalry at Santiago." *Scribner's Magazine* 25, no. 4 (April 1899): 420–440.

———. "The Rough Riders: Raising the Regiment," *Scribner's Magazine* 25, no. 1 (January 1899): 3–20.

Tilghman, Zoe A. "A Bed for God." *Oklahoma Today* 15, no. 2 (Spring 1965): 27–29.

Van Deventer, M. J. "Brummett Echohawk: An Artist Who Creates His Own Challenges." *Oklahoma Home and Garden* (October 1985): 25–27.

Walker, Francis A. "The Indian Question." *North American Review* 116, no. 239 (April 1873): 329–289.

White, Randy. "Looking Back." *Western Horseman* 71, no. 5 (May 2006): 194.

White, Richard. "The Cultural Landscape of the Pawnees." *Kansas and the West: New Perspectives* (2003): 62–75.

———. "The Winning of the West: The Expansion of the Western Sioux in the Eighteenth and Nineteenth Centuries." *Journal of American History* 65, no. 2 (September 1978): 319–343.

White, W. Bruce. "The American Indian as Soldier, 1890–1919." *Canadian Review of American Studies* 7, no. 1 (Spring 1976): 15–25.

Wiltsey, Norman B. "The Sweet Revenge of Willie Gray Fox." *Oklahoma Today* 14, no. 3 (Summer 1964): 30–32.

Wishart, David J. "The Dispossession of the Pawnee." *Annals of the Association of American Geographers* 69, no. 3 (September 1979): 382–401.

Wright, Muriel H. "Oklahoma War Memorial—World War II, Part III." *Chronicles of Oklahoma* 22, no. 2 (1944): 145.

Wydeven, Joseph, and Clem Klaphake. "Art and Eloquence." *Nebraskaland* 62, no. 1 (January–February 1984): 104–106.

Electronic Sources

"About Us." Gilcrease Museum website, accessed June 2012, http://gilcrease.utulsa.edu/About-Us.

Ault, Jon. "Native Americans in the Spanish American War." Spanish-American War Centennial website, http://www.spanamwar.com/NativeAmericans.htm.

"Big Bill and Oom-A-Gog." Tulsa TV Memories website, accessed January 2012, TulsaTVMemories.com.

"Dartmouth Native American Studies Program." Dartmouth College website, http://www.dartmouth.edu/~nas/.

Densmore, Frances. "The Densmore Project: Music of the Native Peoples of North America." Bureau of American Ethnology of the Smithsonian Institution. http://musiccog.ohio-state.edu/Densmore/.

Echo-Hawk, Roger. "Under the Family Tree: An Introduction to Echo Hawk Family History." Myspace website, accessed March 2012, http://www.myspace.com/hilleleh/blog/243093660.

"45th Infantry Division." U.S. Army Center of Military History website, http://www.history.army.mil/documents/ETO-OB/45ID-ETO.htm

"History." 45th Infantry Division Museum website, 45thdivisionmuseum.com/history.

"History and Goals." Leanin' Tree Publishing Company website, accessed June 2012, http://www.leanintree.com/historyandgoals.html.

Pawnee Nation. "Flag of the Pawnee Nation of Oklahoma." Pawnee Nation Tax Commission website, accessed April 2006, www.pawneenationtaxcommission.com.

Records of the South Indian Cemetery, Pawnee County, Oklahoma. Oklahoma Cemeteries website, accessed March 2012, http://www.okcemeteries.net/pawnee/souind/souind.htm.

"Thomas Hart Benton." In *Encyclopedia Britannica Online.* Accessed June 2012, http://www.britannica.com/Ebchecked/topic/61202/Thomas-Hart-Benton.

Films

Cohenour, Barbara. *Focus on Art: Brummett Echohawk.* Presentation of the Rogers State College Art Department. RSU Public Television. Claremore, Oklahoma, October 1989.

Echohawk, Brummett. "Discussion with All Guest Speakers." Seventh Annual Symposium of the American Indian. Presented by Northeastern State University, Division of Social Science. Tahlequah, Oklahoma, 1979. VHS.

———. *Indian Art.* Second Session of Seventh Annual Symposium of the American Indian. Presented by Northeastern State University, Division of Social Science. Tahlequah, Oklahoma, 1979. VHS.

Index